Anatomy of Game Design

People have played games forever, but it's only in the past few decades that people really started thinking about what games are, how they work, and how to make them better.

Anatomy of Game Design takes some of the most popular and beloved games of all time and dissects them to see what makes them tick. By breaking down the systems and content of each game, the underlying systems of game design are laid bare.

Eight games are analyzed – including *Settlers of Catan*; *Centipede*; *Candy Crush Saga*; *Papers, Please*; *Magic: The Gathering*; and more – each representing a different genre or era of game design. Each game is discussed in detail, using the same methods for each game. What are the verbs of the game that give the player agency? How do those verbs fit together to form a core loop that makes the game engaging? What are the systems that power the gameplay? What is the larger flow that makes the game interesting over and over again?

Each game is then used as an example to tie back to one or more larger topics in game design, such as systems design, randomness, monetization, game theory, and iterative approaches to game development.

Key Features

- Uses well-known games to provide specific, discrete examples of broader game design theory

- Discusses eight popular games using the same methodology to allow comparison of different types of games

- Includes both high-level theory and academic perspective and practical, real-world guidance from a working game designer who has created these games for commercial release

- Provides clear direction for deeper inquiry into game design or related fields such as psychology, anthropology, game development, or systems thinking

Anatomy of Game Design

Tom Smith

CRC Press
Taylor & Francis Group
Boca Raton New York London

CRC Press is an imprint of the
Taylor & Francis Group, an **informa** business

First edition published 2025
by CRC Press
2385 NW Executive Center Drive, Suite 320, Boca Raton FL 33431

and by CRC Press
4 Park Square, Milton Park, Abingdon, Oxon, OX14 4RN

CRC Press is an imprint of Taylor & Francis Group, LLC

ISBN: 978-1-032-38755-0 (hbk)
ISBN: 978-1-032-38738-3 (pbk)
ISBN: 978-1-003-34658-6 (ebk)

DOI: 10.1201/9781003346586

Typeset in Minion
by SPi Technologies India Pvt Ltd (Straive)

Access the Support Material: https://www.routledge.com/9781032387550

I dedicate this book to my lovely wife, Wendy, who has been there for me every day and who I love more than anything in the world. You are beautiful and clever and wise in ways that I will never be, and I'm so blessed to have you in my life. And the kids – Duncan, Griffin, Sophie – who make it worthwhile. I'm so proud of each of you.

Contents

Acknowledgments

Thanks to my family for putting up with me: Wendy; Duncan, Griffin, Sophie; Mom and Dad; Ken and Pam; Ed and Dena; Daniel and Amy and Evan.

Thanks to my friends who took a look at early drafts.

Thanks to my mentors Eric, Michael, Cynthia, and many others who helped me formulate the ideas you see here.

Thanks to my many co-workers who learned these lessons alongside me. Game development is a team effort, and I've had the luxury of working on many great teams with talented people who care.

Thanks to all my Moorpark students over the years who were the anvil upon which this book was forged.

Thanks to my publisher for accepting my imperfect process.

Thanks to the game creators and publishers who generously gave permission to discuss their games.

Thanks to everyone who has made a game. It's hard, and I appreciate the fruits of your labors.

Author

Tom Smith was born the same year as the first home video game console. Tom Smith is not the folk musician of the same name.

Tom Smith was raised near Chicago and received early arcade training at Galaxy World. His first home console was an Atari 2600.

Tom Smith has an Ivy League degree that only slightly applies to his career in that they're both about systems.

Tom Smith has been a game designer for a long time and worked on a lot of different types of games. Here are a few of the ones he contributed the most to:

- 1995-1997: Mayfair Games: *Settlers of Catan* (board game), *Fantasy Adventures* (trading card game), *Unknown Providence* (RPG sourcebook)

- 1997-2005: High Voltage Software: *Paperboy 64* (Nintendo 64), *Ground Control: Dark Conspiracy* (PC), *Disney's Stitch: Experiment 626* (PS2), *Hunter the Reckoning* (Xbox), *Disney's The Haunted Mansion* (PS2, Gamecube, Xbox), *Duel Masters* (PS2), *Leisure Suit Larry: Magna Cum Laude* (PS2, Xbox, PC), *Charlie and the Chocolate Factory* (PS2, Gamecube, Xbox), *Codename: Kids Next Door - Operation V.I.D.E.O.G.A.M.E.* (PS2, Gamecube, Xbox)

- 2005-2007: THQ: *The Sopranos: Road to Respect* (PS2), *Conan* (PS3, Xbox360), *Drawn to Life: Spongebob Squarepants Edition* (DS)

- 2009-2014: Disney Mobile: *Pirates: Master of the Seas* (mobile), *Where's My Water?* (mobile), *Where's My Perry?* (mobile), *Where's My Water? Featuring XYY* (mobile), *Where's My Water? 2* (mobile), *Alice in Wonderland* (DS), *Cars 2* (mobile), *Disney Fairies: Fly!* (mobile, tablet), *Tron Legacy* (mobile)

- 2014-2015: Disney Imagicademy: *Mickey's Magical Math World* (tablet), *Frozen Early Science* (tablet), *Mickey's Magical Art World* (tablet)

- 2015-2017: Zindagi Games, acquired by Zynga: *Crazy Cake Swap* (mobile), *Games With Friends* (messenger), *Disney Dream Treats* (mobile)

- 2017: PierPlay: *Scrabble Go* (mobile)

- 2017-now: *Imbellus*, acquired by Roblox: assessment games

Tom Smith has been teaching game design at Moorpark College for many years.

Tom Smith lives near Los Angeles with his wife, children, and cats.

Game Dissections

Hi, I'm Tom.

I've been a game designer for a very long time. I've worked on all sorts of games on all sorts of platforms – see the Author section a few page ago if you want a list. I also teach a class on game design. I love it.

Game design is a relatively new discipline. People have played games forever, but it's only in the past few decades that people really started thinking about what games are and how they work and how to make them better.

There are already lots of good resources on the underlying concepts of games (*Rules of Play, Book of Lenses*) and practical advice on how to make games (*Level Up!*). I want this book to fall somewhere in between. A very practical look at specific games and what makes them work. But looking at those specifics is a great way to better understand the deeper underlying ideas. When I teach, I usually start each class with a dissection and I've found it's a good way to introduce ideas.

This is written for an introductory level. It is intended for someone who loves games but hasn't spent a lot of time thinking critically about them, or someone whose primary interest is in another aspect of games but is curious about game design. If you've been designing games for a few years, many of these lessons will be more of the "nod your head in agreement" type of insight, not the "I've never thought of it that way before" type. But in my experience, both types of insights are good.

WHAT IS A GAME?

One theme that will come up in these discussions is that terminology around games is not very precise. Because games are a new field of study, people are still struggling to find the right terms for things. A definition may be thrown around for a while before it finally settles down somewhere.

So, there are terms like "fun" that most people know but don't define, terms like "mechanic", which people generally seem to agree on but some use slightly differently, and terms like "game" that seem like they make sense until you think about it. You would think that if I'm going to spend a whole book talking about how games work, I would at least tell you exactly what a game is. But often the simplest words are the hardest to define. It's the same with words like "art" or "life" in other fields.

When confronted with these tough-to-define words, I generally take a very broad approach. If it might be a game, I'll call it a game. When you're trying to understand what someone else is saying, assume they mean the broadest possible definition until they indicate otherwise. Don't stress out about it if their definition isn't the same as yours.

But to understand games, we must understand what makes something a game. What makes a game different from other forms of entertainment? I like to read books and watch movies and have deep conversations and go on hikes. These are all fun ways to pass the time. But a game is the only one you can win. It may seem like you can win a conversation, but that hardly ever actually works. A game is the only one with clearly defined rules that participants agree to follow. "Don't talk at the movies" is a rule, but not a consistent one, unfortunately. A game is the only one where the things that make it difficult are artificially and intentionally added. A hike may be hard, but you don't add spikes and bottomless pits along the way.

So for me, the word "game" includes lots of things:

- Video games like *Centipede* (1981)

- Board games like *Settlers of Catan* (1995)

- Card games like poker

- Solo games like Klondike

- Digital worlds like *World of Warcraft* (2004)

- Playground games like tag
- Sports like basketball

What do all these things have in common?

- **Interactive**: The player can change what happens.
- **Goals**: The player wants something.
- **Rules**: There are explicitly defined rules on how to do the thing.
- **Uncertainty**: The outcome is not predetermined.
- **Challenge**: Achieving the goal requires some effort, usually by making the right choices and/or demonstrating a skill.
- **Pretend**: This isn't real.

This doesn't really lead to a cleanly packaged definition. "Games are interactive goals where players choose to follow rules that use uncertainty to create a challenge". Feel free to work on a dictionary definition of your own if that's important to you. What's important to me is understanding each of these concepts and how they relate to games.

Let's talk about each of these words.

Interactivity

The most important quality that makes something a game is **interactivity**. The player needs to be able to change the outcome of the activity based on the player's actions. The player's actions can be conscious choices ("I want to turn left, not right") or reactions ("There's a ball flying toward my head!") or tests of skill ("I want to catch the ball, but it's moving very fast").

This is very different than most other forms of entertainment. When you watch a movie, you can't change what happens in the movie. Sure, you can change your perception and in that respect the observer is part of the process. But with games, the player is an active participant whose input can change the outcome. The same cannot be said for paintings, books, statues, or really any other type of art. The intersection of games and fine art is a fascinating space that people have been playing with for a while (see: dada) and continue to poke at in interesting ways. Pay attention to this – I predict great things as the gaming generations get older.

Choices

Player input can come in many forms. In many games, interactivity is based on choices. When you're playing checkers, you pick a piece and choose where to move it. When you're playing a strategy game like *Civilization* (1991) on a PC, you choose where to build things or how to spend your resources. When you're playing a fighting game like *Street Fighter 2* (1991), you choose where to move your character and which attacks to use at what times. These choices are what drive the game forward and determine the outcome. Good choices lead to a win, bad choices lead to failure.

There's a quote from Sid Meier, the designer of many amazing games including *Civilization*, about this: "a game is a series of interesting choices". This isn't a precise definition and doesn't include all games, but it's a concise and insightful reminder of what the job of a game designer is. If you're not giving the player choices, and/or if those choices aren't interesting, then you're not doing a great job.

While I consider choices the most important part of any game, there are exceptions. *Candyland* (1948) is a classic example of a game where the player makes no choices. You don't choose which card to take, and you don't choose where to go when the card is flipped. *Candyland* is interesting to me because I do think there are important interesting decisions in the game, but they're all outside of the rules. For the target audience of three- to five-year-olds, the real challenge of *Candyland* is learning how to play a game. Speaking as a parent, I can attest that the target audience is adequately challenged by drawing the correct number of cards, moving to the correct space, and only taking a turn when it is the correct time. Often, the real challenge and interactivity of the game is only visible when you understand the game's audience and how they interact with the game.

Skill

Choices aren't the only way success can be determined in games.

Baseball is a game with lots of decisions. What type of pitch should the pitcher throw? Where do you throw the ball when you field it? But a large part of a team's success in baseball is separate from those decisions. The individual skill of each player has a huge effect. Choosing where you want to throw the ball doesn't mean it'll get there, or that it'll get there in time. In baseball, the outcome of a choice is determined largely by the player's skill at making that happen.

This is not only true in sports. The same could be said for hand–eye coordination in a first-person shooter or even in certain physical board games like tiddlywinks or marbles. If I choose to shoot someone in a first-person shooter, my ability to aim precisely and quickly is going to have more effect on the outcome than my choice of targets. Which is why I don't play a lot of competitive first-person shooters. Even before I got old, I wasn't great at twitch gameplay.

It's rare to find a game that is entirely skill with no decision-making. Some games get close – a 50-yard dash, a carnival strength-tester, or certain old arcade games like *Track and Field* (1983). Even when it seems like a game is all about skill, you can find subtle decisions that have a large impact. Talk to a runner, and they'll tell you how they chose when to exert themselves or their choice of breathing patterns. Skill is often the way to determine the result of a decision more so than a replacement for a decision.

The important thing for our definition is that the player brings something to the table (choice or skill) that has a meaningful effect on the game. The player has the agency to change outcomes.

Goals

If being a game means that the player can "change outcomes", that means there should be an outcome. A **goal**. Something the player is trying to do or accomplish to guide the player's actions. A way to win the game. In most games these are clearly defined. Most board game rulebooks start with a quick summary of the goal, as that is the context necessary to understand all the other rules.

This draws the line between games and other activities. In English, we say that you "play" a game. In many languages, the word for "play" and "game" are the same. So, play is definitely a key part of games. But if you're bouncing a ball against a wall, you might say that you're playing with the ball, but you wouldn't say you're playing a game. It's only once you set a goal for yourself – "how many times can I bounce this ball before the teacher stops me" – that it becomes a game. Goals are a mindset. Anything can be a game if you think of it as a game – this is the concept behind using gamification to make tedious or unappealing tasks more engaging for people.

Not all games explicitly provide a goal. Some games let the player make up their own goals. Most tabletop role-playing games (like *Dungeons & Dragons* (1974)) are never-ending stories told by a group. The players may

have different goals each session, but the goals will change all the time and continuously layer on top of each other, so there's usually not a way to "win" the game. But the goals are still present to guide players' interactivity.

Similarly, in the digital space, some games don't tell the player much about what they should do. The classic PC game *SimCity* (1989) is famous for this. The player is clearly intended to build a city, but the game doesn't tell the player what type of city to build or ever tell the player "You Win!".

> When I started working on *SimCity*, I showed it to Brøderbund and they said, "Sure, let's do it." But they kept wanting to change it. I'd kind of programmed it to the point where I thought it was done, and they didn't think it was nearly done. They kept wanting a win/lose. They were expecting more of a traditional game out of it. But I always wanted it to be much more open-ended, more of a toy. So they never published it. (The Replay Interviews: Will Wright (gamedeveloper.com))

Will Wright wants to give players a toy, and let them decide how many times to bounce it on the wall. The goal still exists, but the power and responsibility to create it move to the player. The vast majority of *SimCity* players know what they're trying to do. And the small percentage who really aren't trying to achieve anything can enjoy *SimCity* as a toy. They're just bouncing their ball, which can be really fun and doesn't detract from the value of the experience – but does change the categorization.

And you can see this in other modern games. Massively Multiplayer Online Role-Playing games are endless layers of goals similar to a tabletop role-playing game. The game provides never-ending goals, and picking which ones to care about creates a personal path through the game. *Minecraft* (2011) lets you find your own goals, in the same way that *SimCity* does. Many games on Roblox like *Adopt Me* (2017) or *Bird* (2019) provide the structures of a game but let the player decide if they want to build, progress, collect, or just socialize.

But that's not to say these games don't have goals. A goal that the player makes up on their own has as much validity as a goal that is stated by the game. Either way, the goal exists in the player's mind. And that's where it should be. The goal of a goal is to guide the player as they make decisions.

As a game designer, trusting the player to make their own goals is actually harder than pre-generating the goal for the player. You need to provide

all the necessary building blocks of fun goals and trust the player to assemble them on their own. As with many things in games, player goals don't happen by accident and require careful thought ahead of time to get right.

Goals are there to make your player's choices interesting. Human minds love the feeling of a goal. Being able to measure progress and check off accomplishments is something that we're built to do. Psychology has shown that this is true in reality. In games, we simulate controlled experiences in order to trigger those same responses without the accompanying risk that makes risk-taking in reality more complicated. Games provide a safe space to try out different goals and trigger those positive responses.

In order to trigger those positive responses, games need to define those goals in a way that makes sense and makes fun. That's where rules come in.

Rules

Rules provide the structure of a game to make the interactivity and goals interesting.

Games are about changing outcomes. Players use abilities to strive toward goals. Rules are the network of pieces that make this possible. Rules determine how the player's controls function, and how the game responds when the player does something. Good rules make that process fun.

In checkers, players express their agency by moving pieces. But players aren't allowed to do whatever they want with those pieces.

- You can only move pieces of your color.

- You can only move one piece per turn.

- You can only move one space per turn (usually).

- You can only move diagonally.

- You can jump over enemy pieces.

These constraints on the player action are necessary for the game to function and for the player to have fun. If I could move all my pieces anywhere I wanted as often as I wanted, I could win the game on my first turn and then it's no fun for anyone. Limits on the player's actions are what make them fun. Being all-powerful is boring. Games have rules to provide a structure that makes the experience interesting.

Another type of rule defines outcomes of player actions. In checkers, these are pretty simple.

- If your piece jumps over an enemy piece, remove it from the game.
- If your piece moves onto the opponent's back row, upgrade the piece.
- If you remove the opponent's last piece, you win.

These rules are as strict and controlling as the limits on the player's actions. You can't remove pieces unless you meet the conditions set forth in the rule. You can't upgrade unless you're in the back row.

In a video game, these reaction rules get much more complicated. When I move in a first-person shooter, there can be lots of consequences, and the code needs to instantly account for all of them:

- The player's character may bump into a wall and stop moving.
- The player's character may move over a power-up and acquire it.
- The player's character may collide with a projectile and start a hit reaction.
- Every AI character needs to adjust their behavior based on the player's new position.

Video game rules can also get complicated because there are often two layers to these reactive rules. Rules are there to guide the player to their goal and display the results of their actions. But in many modern video games, there is also an attempt to "feel" like the real world. This verisimilitude is only possible with a large swath of rules. Getting 3D objects to move in a way that convincingly feels like real-world physics takes a lot of rules. When we're talking about rules in this book, we're usually not talking about those rules. But those rules are a big part of game development, so it's important to keep them in mind. Modern game engines like Unity or Roblox do a great job of handling many of these basic background rules for you, but it's important to consider them when designing a game that wants to feel like reality.

A large part of a video game designer's job is thinking of all of these reactions. And coming up with the player's actions and how they work before

any reactions occur. Defining the rules of the game defines a big chunk of the player's experience and also defines the possibility space of what can happen in the game. The job of a game designer is to find the right balance of rules so the game creates an enjoyable set of actions and reactions.

Uncertainty

Designing a game involves adding uncertainty to a system. Being all-powerful is boring. Players want to have actions they can do, with clear rules that define how those actions work, but without knowing ahead of time how all the actions and rules are going to combine. If you know how it's going to end, it's not a game. Or at least not a fun game.

For interactivity to work, there need to be multiple possible outcomes. If the player has three choices, and all of them lead to the same result, then it's not really a choice.

Remember that Sid Meier quote from earlier? "Games are a series of interesting choices". What makes those choices interesting? A big part of that is the uncertainty. If you tell me that there are three doors and they all open up to a big ballroom, then my choice of which door to open isn't very interesting (Figure 1.1). It lacks uncertainty. If instead (Figure 1.2) you tell me that there are three doors, and one leads to treasure (represented here by the letter A) and one leads to a hungry tiger (here represented by a poorly drawn face), that makes the choice much more interesting. The range of possible outcomes has increased, and the cognitive difference between those outcomes has also increased. Three similar outcomes are not as interesting as three outcomes with different positive and negative effects.

Actually, making a player feel like they're in a game doesn't even require three real results. It just has to feel like there might be three results before

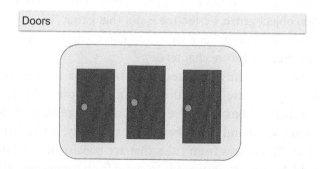

FIGURE 1.1 Three doors.

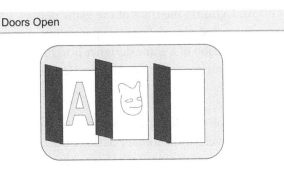

FIGURE 1.2 Three doors, open, with different things behind each.

the player opens the door. This is how a lot of narrative games work. The story always ends up in the same place, but the player doesn't know that. Each door seems different and consequential, and in the player's mind, each leads to a completely different room. So, the player opens one, finds a room on the other side, and doesn't think too hard about what was behind the other doors. It's only when the player goes back and replays the game again that they realize how little the story changed as a result of their choices. But by that point, the player has already had a positive experience and is willing to forgive the game for some necessary limits. The important thing is that it felt uncertain that first time.

Another way to look at this is tic-tac-toe (aka Noughts and Crosses). There aren't a lot of adult fans of tic-tac-toe because the game lacks uncertainty. When playing with two relatively knowledgeable players, the only uncertainty is whether or not one player makes a mistake. It becomes a game about attention to detail rather than a game about strategic thinking. And while you can build a fun game around attention to detail, such as the hidden object genre, tic-tac-toe is not that game.

The uncertainty that makes a game fun can come from many sources. We'll discuss these in future chapters.

Generating uncertainty requires more than just actions, goals, and rules. Especially because uncertainty in any of those areas is not fun. Players want their actions to behave predictably and reliably. Players want goals that make sense and don't change unexpectedly. And a large part of why games are fun comes from rules that are consistent and fair, unlike the real world. So, uncertainty needs to come from somewhere else. That's why games include challenges.

Challenges

There's a book I really like called *Grasshopper*. It's a philosophy book about games. At one point, there's a discussion of golf. Golf is a game where to goal is to get a ball into a hole. Given that goal, then logically the player should pick up the ball, walk to the hole, and drop it in. That's the most efficient way to achieve the goal. But that's not golf. Golf has a structure of rules that limit the player's ability to achieve the goal efficiently, including "you can't pick up the ball". The only way you can interact with the ball in golf is by hitting it with a stick. This is terribly inefficient, but it makes the activity fun. Constraining the player's agency makes the activity challenging, which makes it fun.

This ties back to another book I (generally) like called *Flow*. Mihaly Csikszentmihalyi was interested in what similarities he could find in people who were the top of various fields. So, he interviewed concert pianists and top scientists and business leaders. A key thing he found was they were always pushing themselves. They would engage in activities that would challenge their skills and abilities but were still within their skill range. And when their activities fit these definitions, they were so engaged that the real world melted away and they completely lost track of time while pushing against these challenges.

Flow was written for psychology, but professional game designers found it fascinating. This is exactly what games had been doing all along. Games create scenarios where a player is tested and challenged and has to work hard to achieve a victory. But the player always knows that victory is possible. A game where the player knows they can never win is not fun (sorry, Kobayashi Maru). The best games find that perfect balance of difficult but possible that aligns perfectly with the psychology described in *Flow*.

The challenges of a game are what make it fun. Without challenge, goals don't matter and the player's decisions don't really have meaning. This doesn't need to be a high bar – there's a growing genre of "cozy games" like *Animal Crossing* (2001) or *Cozy Grove* (2021) that strive to be more relaxing than challenging. There are still goals to accomplish and economic limits that prevent the player from doing anything at any time, but the progression from goal to goal doesn't take a lot of complex decision-making or advanced skills. There are still challenges and uncertainty, but they're toned down to focus on other things. It's more about the progression than the challenge, which creates a relaxing mellow experience in contrast to the high-energy mood of many other games.

Pretend

What's the difference between a game and a presidential election? Both have rules that have to be followed. Both have a goal. Both have challenges to overcome. But no one would seriously consider the election to be "just a game". The difference is the outcome of the election has real consequences that matter.

When something is real, it's not a game. Games are inherently imaginary.

The book *Rules of Play* does a nice job of covering this idea. They apply the concept of the "Magic Circle" from anthropology – specifically, Johan Huizinga in *Homo Ludens: A Study of the Play-Element in Culture*. Inside the circle, the rules of the game take effect and the objects of the game take on special meaning. Outside of the circle, they're just part of reality. So outside of the circle, it's a painted block of wood. Inside of the *Settlers of Catan* circle, it's a village with a thriving community life and backstory, which is important because it is worth one Victory Point. Once you leave the circle, that Victory Point is meaningless and the thriving village becomes a piece of wood again, but inside the circle it's all that matters.

The important thing about the Magic Circle is that it is imaginary and it is voluntary. No one can make you play a game if you don't want to. If you don't agree that the piece of wood is a village, it's going to remain a piece of wood for you no matter how hard your friend tries to convince you otherwise. And if you insist that Victory Points aren't a real thing, you're not playing a game.

Even when games have other goals than just fun, there's still a magic circle that separates gameplay from reality. When a teacher uses a game to illustrate an idea in a class, during play the gameplay creates separate meanings and roles from imagination that make the goals and rules of the game work. Once the game ends, the class might talk about the game from outside the Magic Circle to connect it back to reality and learn a valuable lesson. But the meanings and imagination that existed inside the game are still separate.

This creates some interesting questions when people play games for money. Is a professional football player playing a game, or is the thing they're doing more like a presidential election where the player is following rules to achieve a real-world goal? I would argue that the NFL player's motivation might be outside of the Magic Circle, but during the game

they're still agreeing that moving the ball a certain number of yards has special meaning that it doesn't have in reality. They may be motivated to play a game for money, but they're still playing a game. The experience of football is trying to create a fun activity, even if outside goals are being added outside of the Magic Circle.

WHY DISSECTION?

This book uses dissection as a tool to discuss various game design topics. But dissection is also a valuable skill in its own right. Game designers are often asked to dig into other games and understand how they work. The dissection tools discussed in this book will make you better at this type of analysis.

Even if you're not planning on becoming a game designer or game developer, dissection skills can make your life better. When you're playing games for fun, you'll get more out of them if you understand them better. The more you know about the craft, the more you can appreciate the art.

Some people complain that analyzing games makes it harder to enjoy games. I enjoy analysis, but the best analysis occurs after play. The only time my analytical skills override my inherent ability to have fun in a game is when the game isn't doing its job. It's the responsibility of the game to keep the player immersed and engaged in the fun – inside the Magic Circle. I only slip into deep analytical mode on accident when the game is failing at that. And in that case, analysis is probably going to be more interesting than the game itself. The best part about bad games (to me) is that they can provide insights on what doesn't work, which is immensely valuable as a game designer.

Pre-Dissection

Dissection is also useful for games that don't exist. When you're trying to come up with an idea for a new game, it's useful to understand that idea in great detail. The process of defining a game idea in enough detail to build it is very similar to the dissection process. You need to see each piece of the system on its own, and also see how they all fit together into something greater.

The better you get at dissecting, the better you'll be as a game designer. Game development is just game dissection in reverse. If you can break an existing game apart and identify everything that makes it work, you can apply those insights into games that don't exist yet.

Game Design Is Thievery

Part of the value of dissection is it makes you a better thief. All games are built on concepts pioneered by previous games. A good game designer needs to be able to identify good ideas from other games and convert them into new forms for new games. This second part is important – you don't want to copy and paste an entire game. That is actually thievery. The best game designers pick and choose carefully, taking interesting ideas and presenting a new perspective on them by combining them in new ways. The more you understand about dissection, the easier it is to identify which ideas from other games make sense for yours.

Meta-Dissection

Part of the value of dissection is it helps you see how each game connects to game design as a whole. If you can tear apart a game into its component parts, you can see how those parts relate to the parts of other games. If you're working in an established genre with multiple successful games, it's important to understand the connective tissue that defines the genre and makes it work. As a game designer, you don't want to re-invent the wheel. Being able to cross-reference successful features across multiple games is one of the few ways to predict what's going to work at the start of the design process. So, embrace it and steal the best ideas you can find.

For years, game designers have been trying to call out these ideas and determine the general rules for how games should work. This is sometimes called "Game Design Patterns", a term borrowed from programming. This is an interesting line of thought that has yet to provide many universal rules. Identifying patterns can provide good insights into what works and what doesn't for a particular game or genre. Patterns can be a useful way to discuss and compare these insights. But it's proven difficult to extrapolate these learnings to all games.

Generalizing game design insights to encompass all games is a futile endeavor that only fools would attempt. So, let's go do it.

Shovel Knight / Verbs

Shovel Knight is a great game.

Shovel Knight came out in 2014 when indie games were just becoming a thing. *Shovel Knight* is a great example of the retro movement, where games are created to honor the classic games of old. *Shovel Knight* evokes the feel of old-school 2D platforms like *Super Mario Bros* or *Castlevania* but also adds its own unique twists.

This dissection is specific to *Shovel Knight: Shovel of Hope*, the original game in the series (Figure 2.1). Sequels and spinoffs usually require their own dissections, even if some aspects may be the same.

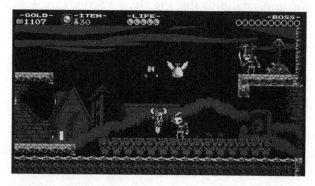

FIGURE 2.1 *Shovel Knight* screenshot.

DOI: 10.1201/9781003346586-2

SHOVEL KNIGHT: GAMEPLAY DISSECTION

Verbs

To understand a game, the best place to start is the verbs. What actions can the player take?

Games are different from other forms of entertainment like books and movies. The biggest difference is that in games, the player gets to do things. The player can change what happens in the experience through their choices and other actions. When you're reading *Hamlet* (Shakespeare 1604), it's always going to end the same way, and Hamlet's always going to drag his feet to get there. When you're playing a game of *Go* with a friend, you don't know who's going to win or how they're going to do it. That combination of agency and uncertainty is what makes games fun. Games are interactive.

So, when you're trying to understand a game, start with questions about interactivity. What does the player do? What actions can the player take? There's more to understand than just that, but it's a good place to start.

In *Shovel Knight*, the player can move around and hit things with a shovel. Movement is a combination of running and jumping. The core gameplay is Run, Jump, and Attack. The player can complete 90% of the game by just doing these three things. These are the core actions of this game.

But how do we know that? Let's dig a little deeper.

Advanced Verb-ing

One theme throughout this book is that game dissections depend on your goals as a dissector. If you're just trying to get a rough understanding of *Shovel Knight*, understanding that the player's actions are Run, Jump, and Attack is enough. Stop there, move on. That's a completely valid approach and you can pat yourself on the back.

But sometimes you need to know more. If you're going to start work on the a 2d platformer team, or you're going to make a game inspired by *Shovel Knight*, or you're writing a dissertation on it, you need to understand player actions at a deeper level.

And sometimes the verbs may not be as obvious. If you're not sure what counts as a core action, you may need to spend a little more time analyzing before you can say that with authority.

When you're doing a deep analysis of a new game, it's useful to start with every verb you can think of. Go through the controller diagram.

Think about what you do when you play the game, especially the choices that you deliberate over. Ask your friends "What do you do in this game?" Read the wiki if there is one. Write it all down as a starting point.

Let's do that for *Shovel Knight*:

- Run

- Run Right (right on the controller while on the ground)

- Run Left (left on the controller while on the ground)

- Attack (press the attack button, officially called "Dig Slash")

- Jump (jump button while on the ground)

- Jump Right (jump button while moving right)

- Jump Left (jump button while moving left)

- Fall (what happens after you jump or are in the air for another reason)

- Air Control (moving right/left while in the air)

- Drop Attack (a combination of falling and attacking triggered by pressing down while in the air, officially called "Shovel Drop")

- Dodge (move or jump to avoid an enemy or other hazard)

- Fight (move and attack against an enemy, with a combination of different actions mixed together)

- Boss Fight (fight, but with more complicated things going on)

- Wait (don't do anything, sometimes important to get timing right)

- Dig (attack a pile of dirt to get things out of it)

- Break (attack an object like a chest or wall to destroy it)

- Loot (technically pulling things out of a chest is a different action than breaking the chest open)

- Juggle (hit something that is falling, which sends it up again)

- Die (lose health or fall in a pit)

- Talk (press up while near a Non-Player Character (NPC) to initiate dialog)

- Buy (choose a text option to spend money or otherwise acquire a thing)

- Fish (use an inventory item to try to get stuff)

- Use Relic (use an inventory item at the cost of Magic, with about a dozen different ones that can be acquired)

- Drink (use an inventory item to gain a bonus)

- Play Music (select music via a conversation with an NPC)

- Charge Slash (a modified attack earned later in the game)

- Uncover (sometimes when you destroy something, there is another object or enemy behind it that enters the scene)

- Mini-Game (there are places where you can play little sub-games with different goals)

- Explore (look around and move around to find something new)

- Find (basically the same as Explore, but possibly referring to a specific thing you were looking for)

- Gather (pick up coins or other things, which happens naturally when the character touches them)

- Collect (usually used to mean the same thing as Gather but can also refer to Feats or other more abstract things)

- Plan (connect a series of actions in your mind and think about using them together, possibly with specific timing)

- Position (place yourself in the right place)

- Observe (watch how the objects in the world work)

- Learn (uncover the systems of the game and how they work)

- Predict (use what you've learned to come up with a theory about what will happen next)

- Watch (cut scenes)

- Travel (move on the map view that is used to select level)
- Showdown (a separate play mode that I'm ignoring for this dissection)
- Challenge Mode (another separate play mode)
- New Game (UI action to start a game)
- Enter Name (UI action to label a game save)
- Body Swap (change avatar appearance)

You can see how this list can get pretty long. Let's talk about how to turn this big list into a smaller list that is more useful.

To start, let's analyze these words. Which verbs relate to each other? Which do you think of together when you're playing?

PRE-VERBS

If you're dissecting an idea for a new game you're thinking about, you won't have a controller diagram to get you started. Instead, you need to identify the verbs based on the information you do have.

- When you're describing the idea to people, what actions do you talk about?
- When you play the game in your head, what is it that you're doing?
- Picture the game on a controller. What would the buttons do?

This might be hard. The inspiration for a game idea can start with a story or a cool new feature or other things. But if you find that your game idea doesn't have clear verbs, that's a sign that your idea isn't really complete yet.

Understanding the core loop is a key part of early ideation. You can't pitch a game if you can't describe what the player is going to actually *do* in that game. If this happens, you need to spend some more time thinking this through before moving on.

Direct Action Verbs

Since we're trying to understand interactivity, we want to focus on verbs that are about the player directly doing something. Look for verbs where

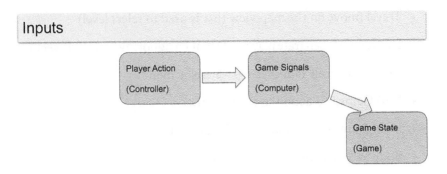

FIGURE 2.2 Flow chart showing how the player does something, foreshadowing bigger flow charts coming up soon.

the player does something that sends input to the computer – this can be pressing a button, pushing on a stick, touching a touchpad, or anything else. When the player does this, the game responds. The game rules recognize the player's action as something important, and something in the game's model of the world changes (Figure 2.2). These are key to interactivity.

Once we identify things the player can do, we can look for verbs that all relate to the same type of action. Any player actions that result in the same response from the game can be grouped together. That's what we're looking for.

Looking over the big list, we can group a bunch of movement-related verbs together. All of these are used by the player to change the position of their avatar character.

- Run
- Run Right (right on the controller while on the ground)
- Run Left (left on the controller while on the ground)
- Jump (jump button while on the ground)
- Jump Right (jump button while moving right)
- Jump Left (jump button while moving left)
- Air Control (moving right/left while in the air)

The important thing here is to recognize that the player controls an avatar in a 2D space by changing the avatar's position (and orientation) in the world. There are a lot of different movement controls with slight nuanced differences. The diversity of specific movement controls is a good sign that navigating through the world is important in this game.

Each of these is important to understand if you're really trying to dig deep on how *Shovel Knight* works. Doubly so for other games with more complex controls to navigate more complex 3D scenes. But for right now, we can group them all together as "Move". We'll talk about more ways to differentiate these types of overlapping verbs later.

DEEPER DIVES: RESEARCH

When I start working on a game that fits into an existing genre or has a clear relationship with another game, it's important to start by doing a deep analysis of that related game.

- Play the game thoroughly yourself and reflect on the experience.

- Play related games.

- Watch other people play the game. Social media can be great for this.

- If it happens to be a game with an active fandom, read up on what they think. Try to build the knowledge that a fan would have. There will always be fans with deeper knowledge than you – some fans are great with details – and that's OK.

The next set of verbs is combat related:

- Attack (press the attack button, officially called "Dig Slash")
- Drop Attack (a combination of falling and attacking triggered by pressing down while in the air, officially called "Shovel Drop")
- Charge Slash (a modified attack earned later in the game)
- Dodge (move or jump to avoid an enemy or other hazard)

- Fight (move and attack against an enemy, with a combination of different actions mixed together)

- Boss Fight (fight, but with more complicated things going on)

There are lots of ways to inflict damage on enemies. The player provides an input and then the game rules decide if an enemy takes damage and how much. I think we can comfortably group these verbs together and talk about "Attack" as one of the big concepts in *Shovel Knight*.

The final set of direct player actions are all object-related. The player has an inventory of special actions they can take (by pressing up and attack). There are about a dozen different Relics the player can acquire over the course of the game with various different effects, ranging from healing to attacks to earning money. Most of these deplete the player's Magic stat when used.

- Use Relic (use an inventory item at the cost of Magic, with about a dozen different ones that can be acquired)

Indirect Action Verbs

Action Verbs that describe what the player can do are the most important for understanding the core of a game, but there are a variety of other verbs that happen during a game that are important to understand.

- Die (lose health or fall in a pit)

- Gather (pick up coins or other things, which happens naturally when the character touches them)

- Collect (usually used to mean the same thing as Gather, but can also refer to Feats or other more abstract things)

- Uncover (sometimes when you destroy something, there is another object or enemy behind it that enters the scene)

There are verbs that happen in the game but are not directly triggered by the player. These are more of a consequence of a player action than the action itself. The player never presses "Collect" in *Shovel Knight* – they just walk over to an object and if it's the right type of object, like a gem, it just gets collected. The player might do that intentionally, but the "do" the player does is just movement.

There are also object actions the player can take based on the items in the world around them. These use the existing controls but change the results based on the objects in the world when the player performs their action. These are important to understand but are less core than the actions.

- Talk (press up while near an NPC to initiate dialog)

- Fall (what happens after you jump or are in the air for another reason)

- Dig (attack a pile of dirt to get things out of it)

- Break (attack an object like a chest or wall to destroy it)

- Juggle (hit something that you've previously hit to keep it in the air)

- Buy (choose a text option to spend money or otherwise acquire a thing)

- Play Music (select music via a conversation with an NPC)

- Loot (technically pulling things out of a chest is a different action than breaking the chest open)

The most common type of object interaction is talking with NPCs. I know it's a bit rude to call NPCs objects, but from the perspective of the code there's not much difference.

Technically you could call combat an indirect action because it only makes sense if there's an enemy nearby and there isn't always an enemy nearby. This is a clever point, but given the frequency of enemies in the level design, I think it's fair to call "Attack" a core gameplay action. If someone re-made *Shovel Knight* with significantly fewer enemies and more depth to the NPC interactions, it would be an interesting way to make an entirely different game in a different genre without changing the core engine or code or player actions of *Shovel Knight*. But it wouldn't be *Shovel Knight*. More on content and how it changes the game in a later chapter.

Abstract Verbs

- Dodge (move or jump to avoid an enemy or other hazards)

- Explore (find something new)

- Find (basically the same as Explore, but possibly referring to a specific thing you were looking for)

- Plan (connect a series of actions in your mind and think about using them together, possibly with specific timing)

- Position (place yourself in the right place)

- Observe (watch how the objects in the world work)

- Learn (uncover the systems of the game and how they work)

- Predict (use what you've learned to come up with a theory about what will happen next)

- Mini-Game (there are places where you can play little sub-games with different goals)

There are a number of potential verbs we identified that aren't things the player can *do*. These are things the player thinks about when doing other things – these are why the player does things, not what the player does. So, these are important to consider, but I would categorize these as goals, not actions. These are incredibly important to understand and are fundamental to understanding the core game loop, but I'd put them in a different category than direct player actions, and we'll cover them in a later chapter.

Interface Verbs

- Watch (cut scenes)

- Travel (move on the map view that is used to select level)

- Showdown (a separate play mode that I'm mostly ignoring for this dissection)

- Challenge Mode (another separate play mode)

- New Game (UI action to start a game)

- Enter Name (UI action to label a game save)

- Body Swap (change avatar appearance)

There are a number of actions that the player takes entirely in the UI (User Interface), outside of core gameplay. In a game like *Shovel Knight*, it's easy to distinguish when the player is controlling an avatar (*Shovel Knight*) in

the game world versus when the player is selecting words in a menu. The UI is something outside the illusion of the game, which is necessary but not part of the fun. If you're working on designing the UI, definitely think these through and consider all the options. But for this game, they are not core gameplay.

DEEPER DIVES: FRAME BY FRAME

For fast-paced games, one technique I find very useful is to record a short video of the core gameplay, then step through the video frame by frame. Watch closely, and you'll see lots of little things that the developer does to make things work. Visual effects that communicate important information to the player, little tricks of physics to make things flow better, and complex camera behaviors so the player's attention is on the right things. These are great when you need to know everything about a game. But most of this chapter is for when you're just starting to understand a game.

Games as Input/Output

To help understand why these different types of verbs are different, let's talk about how games work. As with most things, games can be understood in a lot of ways. This is one of those ways.

When a player plays a video game, they are participating in an exchange with a computer. The player provides inputs through a device of some sort – a game controller, a keyboard, a touch screen – and the computer processes that inputs and then provides an output for the player – pixels on a screen. The computer uses a set of rules and logic and code to determine how the player's input changes the pixels. The rules and logic and code are what the game designer controls. That is what we call the game. But everything else is important to understand as it creates the full experience.

This can be represented in a diagram like Figure 2.3.

The left side of this image represents the player. What they see, what they think, what they do. The right side of this image represents the computer. All the electrical impulses tickle the microchips based on the code of the game.

Let's step through a simple single-game action based on this model. The player is enjoying a pleasant time in *Shovel Knight* (Figure 2.4). They notice some gems above and to the left, so they decide to jump to gather them.

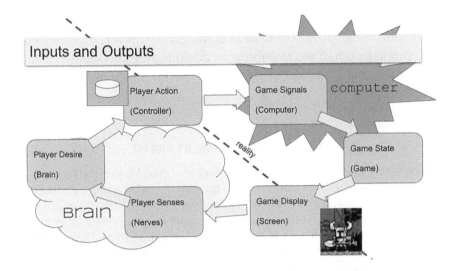

FIGURE 2.3 Input Output.

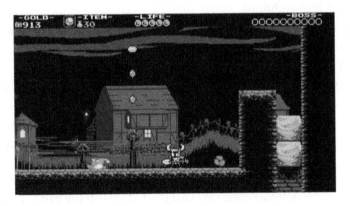

FIGURE 2.4 *Shovel Knight* game screen showing the moment before the player makes a decision.

We start by noting that the player has made a decision (Figure 2.5). This is how things start in games – things happen in the player's brain. The root of all gameplay is imagination.

In order for the game to do anything, this thought needs to get from the player's brain to the computer (Figure 2.6). There are all sorts of useful input devices designed to make this happen. The nature of the input device

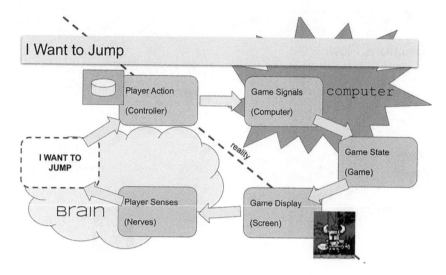

FIGURE 2.5 I want to jump.

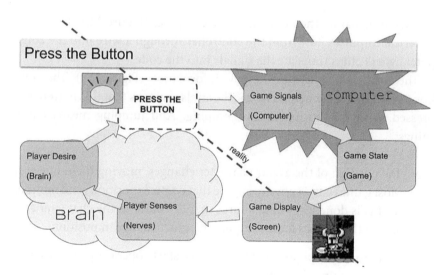

FIGURE 2.6 Press the button.

has a large impact on the player's experience, and new types of input devices like the iPhone's touch screen or the Wii's motion controller can lead to huge changes in the video game industry.

For our current discussion, it doesn't really matter what input device is being used. The important thing is that the player presses a button on the PC or game controller that indicates that the player wants the character (*Shovel Knight*) to jump.

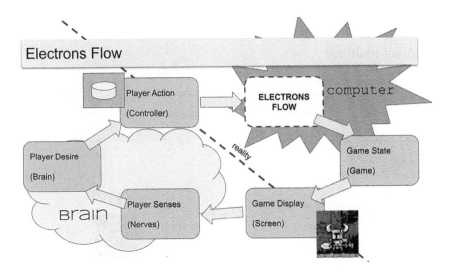

FIGURE 2.7 Electrons flow.

This information then flows into the computer (Figure 2.7). A series of electrical impulses flow from the controller through a wire into the computer, where chips translate the signals into the code.

The code then processes the new information (Figure 2.8). The code knows that this sequence of electrical impulses means that this button was pressed. And this button means jumping. And jumping means many things:

- The position of the avatar character changes, moving them upward. Most games have a physics engine that controls positions and motion, so this is done by adding a force in a direction to the character and letting the physics logic compute the exact change in position.

- Because of the physics engine, gravity starts operating on the character, changing their motion over time.

- The character's animation changes from a standing animation to a jumping animation.

- This changes the character's state – the character is now in the air. Now different inputs and outputs are possible. If the player presses down now, the character will go into a downward attack state, as

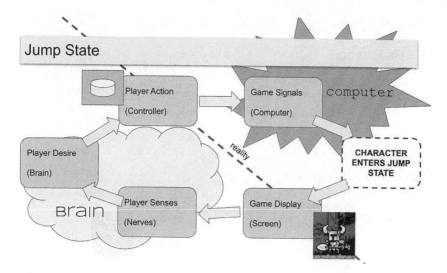

FIGURE 2.8 Character enters jump state.

defined by the game rules written into the code. Pressing the jump button again won't do anything.

- And all of this needs to be reflected in the pixels on the screen.

This last point is important. The state changes in the code only matter if the player can understand them. Most video games can only communicate their internal changes through a screen. Any change to the internal state and logic of the game needs to be expressed in pixels so the player can process it (Figure 2.9). Setting up the right pixels is a combination of game art to reflect changes in the game world and UI/UX design to reflect changes in the data presented by the game. Both are important and ideally both work together to produce the best result.

The player has their own complex system of input devices that they use to process incoming information – eyes, ears, noses, etc. Good games will reinforce their messages using as many senses as possible (Figure 2.10). Starting with visual, often using audio, and occasionally adding some vibration so the player can feel what is happening. Smell and taste don't come up as often, but I'm sure smell-o-vision will be everywhere in a few years.

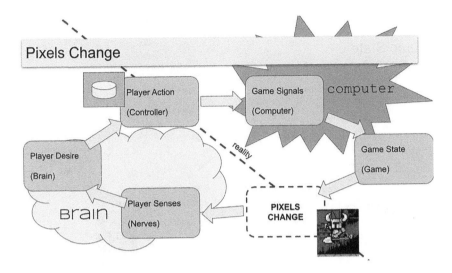

FIGURE 2.9 Pixels change.

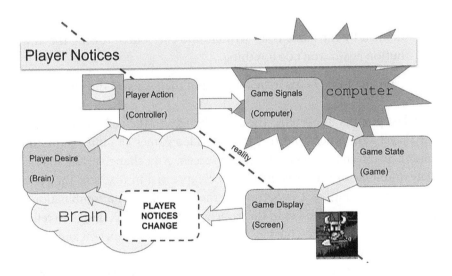

FIGURE 2.10 Player notices change.

And then the cycle begins anew. Once the player processes this new information, they want new things (Figure 2.11). For example, that frog might be a problem, so the player may need to change their direction or enter an attack state to avoid taking damage (Figure 2.12). The full game experience is a long sequence of very quick input/output cycles that add up to create something greater than each part.

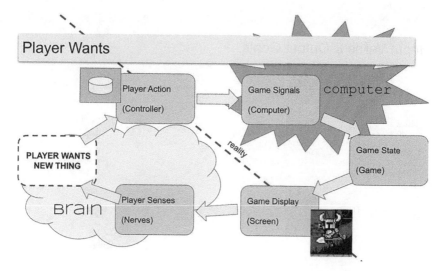

FIGURE 2.11 Player wants new thing.

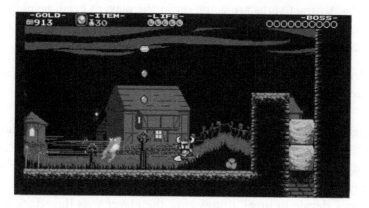

FIGURE 2.12 Screenshot of *Shovel Knight*, showing a jump has begun.

Verbed Input/Output

This Input/Output flow gives us a way to understand the differences in different types of verbs. Each verb operates on a specific step of the diagram as seen in Figure 2.13.

- The Direct Action verbs are controller inputs delivered by the player.

- The Indirect Action verbs are things that happen in the computer based on the player actions.

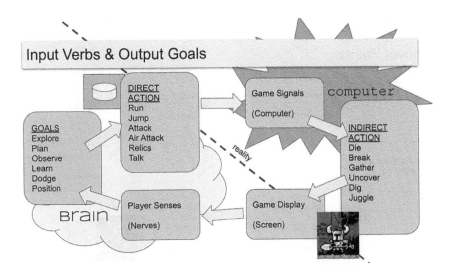

FIGURE 2.13 Input verbs and output goals.

- The Abstract verbs are going on in the player's head, helping them plan out their next action but not happening as a direct result of a controller input.

- Interface verbs affect things the player sees in the Game Display that are not part of the game world.

This helps explain why the Direct Action verbs are the most important for an initial understanding of the game. They are the simplest and most clear actions that shape the range of options for everything else. They are where the player that exists in the real world interacts with the game. The game rules only decide to break things after the player uses the attack action. And the player's desires are similarly shaped by the range of inputs the game allows. The player may want to build a bridge or get a drink at the bar but without a related button that desire is going to go unfulfilled.

The actions the player can take shape everything about the game. So, start there if you want to understand the game.

UNDERSTANDING VERBS

Verbs are just the first step.

If *Shovel Knight* is about Moving and Attacking, so is *Halo* (2001). So is *Super Mario Bros* (1985). So is *God of War* (2005). But these are all very different games.

The second step in a game dissection is to understand the nature of the verbs and how they fit together. We'll talk more about systems later, but the core ideas of systems thinking is that the relationships between things (in this case verbs) can be as complex and interesting as the things themselves.

So, let's start with our two core verbs.

OVERLAPPING VERBS WITH DIFFERENT RULES

So, we've broken *Shovel Knight* into the Core Verbs of "Move" and "Attack" but want to understand more about them.

Going back to our definition of games in the first chapter can help. We've already covered Interactivity – the choices and skills that make up the Big Verbs. Next on the list is Rules.

So, our Verbs are what the player can do. The Rules are how the game responds to those prompts from the player (Figure 2.14). "When the player does X, the game does Y"

In a board game, these are written out explicitly. "When you pass GO, collect $200". A core verb in *Monopoly* (1935) is move, so "pass GO" is something that can happen naturally as a result of the player's action.

The same sort of thing happens in a video game like *Shovel Knight*. When you touch an enemy, you lose health. When you walk over a health pack, there are fewer health packs in the level and you have more health. The player does something, and the game responds.

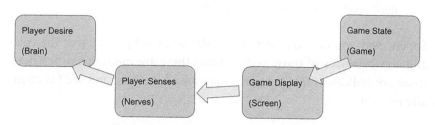

FIGURE 2.14 Outputs.

Moving in *Shovel Knight* is about position, and position interacts with a lot of game rules.

- Where you are relative to an enemy determines whether or not you get hit by an enemy attack.

- Where you are and where you're pointing determines if your attack hits the enemy when you trigger an attack.

- Where you are determines when you pick up gems, powerups, or other items.

- Where you are determines what you can see – the game only shows you one screen at a time, based on player position.

- Where you are triggers progression through levels, including triggering cut scenes that advance the story.

This is similar in a 3D first-person shooter but with some important differences:

- Where you are determines whether or not you get hit by an enemy attack.

- Where you are and where you're pointing determines if your attack hits the enemy.

- Where you are determines when you pick up ammo, weapons, powerups, or other items.

- Where you are and where you're pointing determines what you can see, using a first-person perspective.

- Where you are triggers progression through levels, including triggering cut scenes that advance the story.

So, one way you can differentiate similar verbs is by looking at the rules and consequences of those verbs. When there are mechanic differences, those are indicators that the verbs may sound the same but are functionally very different.

OVERLAPPING VERBS WITH DIFFERENT GOALS

Looking at how verbs interact with rules is helpful. The processes going on in the computer can change how the verbs work. But the processes going on in the player's head are even more important.

Why does the player use verbs?

Verbs are used to achieve goals.

Verbs only mean something in the context of the player's goals.

What are the player's goals in *Shovel Knight*? Let's do a quick brainstorm like we did for verbs.

- Rescue Shield Knight.

- Help the characters you meet.

- Defeat enemies.

- Reach the end of the level.

- Trigger the next cut scene.

- Unlock new areas.

- Get to the end of the game.

- Don't die.

Some of these ("Rescue Shield Knight" and "Help the characters you meet") are story, not gameplay. Story is an important part of most games, but when we're still assembling a core loop, it's not the most important thing to understand. Story motivates players to complete the game, it doesn't motivate the players' actions from moment to moment. At least for a game like this – some games like *Baldur's Gate* (1998) or *Life Is Strange* (2015) make story a key part of every level of gameplay. But a game like *Shovel Knight* does not weave the story into every moment of gameplay like this.

The goals that are woven into every moment of gameplay are the ones like "Defeat enemies" or "Reach the end of the level" that guide player actions in every moment. This is what the player is trying to do during

gameplay, and this is why the player engages with the verbs of the game. The player attacks to defeat enemies and moves to reach the end of the level.

The next few goals ("Trigger the next cut scene", "Unlock new areas", and "Get to the end of the game") are just "Beat the level" phrased slightly differently. When you're considering goals or verbs, keep an eye out for overlapping terms like this.

The final objective "Don't die" isn't really a goal per se but is more of a fail case. If the player dies, they have to reset a little ways back. Death never stops you from progressing, but it can definitely slow you down.

VERB TO THE GOAL

So how does the player turn "Move" and "Attack" into completed levels? They move through the level to find a route that gets to the next area while avoiding or attacking any threats. Most areas have a little challenge or puzzle to advance. Some areas require jumping over pits. Some require jumping off objects to get up high. Each area has a different combination of challenges that makes it interesting and different. More on that later.

BIG VERBS

OK, so we've defined the big verbs in *Shovel Knight* as Move and Attack. That feels right. When I play the game, I spend most of my time doing those things. And thinking about those two things and how to do them better.

If you want to understand a game, understand the things the player spends most of their time doing. Sometimes there are other features that are splashy and interesting and become the focus of the marketing and discussion around the game. But a game designer needs to think about the thing the player is actually investing their time on.

You can see this in lots of different types of games. Platformers spend a lot of time perfecting their jumping and running. In an open world game, you spend most of your time moving from place to place. The open world games that succeed are the ones that this travel fun and engaging.

VERB AS GENRE

As we'll see in future chapters, verbs are a good way to differentiate and organize games. All first-person shooters start with move and attack. Platformers like Mario focus heavily on move, with varying amounts of attack depending on the platformer.

But a game like *SimCity* doesn't have move as a verb at all – the primary verb there is build. This makes sense – I think most people would agree that platformers have more overlap with shooters than with builders.

This can be useful to know. If you're looking for inspiration on your city builder, it might not be best to start by playing some *Halo*. Maybe find a puzzle game like *Triple Town* that shares "Build" as a verb to see how it's done differently there.

More to Come

We're going to stop our *Shovel Knight* gameplay analysis here. I know we've barely scratched the surface of *Shovel Knight* and platformers in general. But we're building foundations here. It'll get crazier in later chapters.

The last part of this analysis pulls some ideas from future chapters, but I like showing a version of the same diagram for each game, so forgive me for the spoilers. This diagram represents each game as a formula. The player has verbs they can use to reach goals but are blocked by challenges.

Figure 2.15 shows the simplest level of detail, breaking each step into a single element. Figure 2.16 is a bit more useful in that it breaks each of these categories into multiple entries, showing the different actions and challenges of the game:

Each level is a package of these different pieces, as shown in Figure 2.17. In *Shovel Knight*, most of the variation comes from changing out the challenges, but other games can handle this differently.

Multiple levels can be added together to represent the full flow of the game, as players work on larger goals and larger challenges. See Figure 2.18.

We'll dig into these ideas in more detail in later chapters, but before we leave *Shovel Knight*, let's talk about other things that influence gameplay.

FIGURE 2.15 *Shovel Knight* flow diagram showing Verbs, Challenges, and Goals.

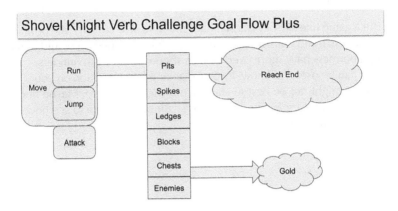

FIGURE 2.16 *Shovel Knight* flow diagram with more boxes.

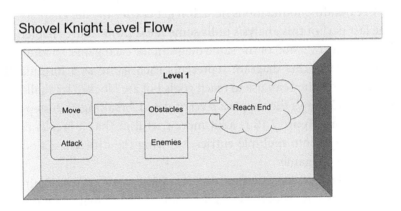

FIGURE 2.17 *Shovel Knight* flow as a level.

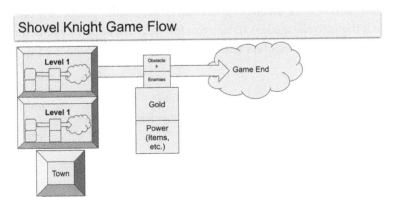

FIGURE 2.18 *Shovel Knight* flow from level to level.

SHOVEL KNIGHT: NON-GAMEPLAY DISSECTION

When dissecting, it's not just about gameplay. Even for a game designer.

If you want to understand the gameplay of a game, you have to understand everything about it. How do the non-gameplay aspects of the game tie into the gameplay? Where did the gameplay ideas come from? What led to the gameplay decisions you see in the game? The game itself makes much more sense if you understand the context that led to those decisions.

To be clear, I did not work on (most of) the games I talk about in this book. I do not know how decisions were made by the teams that did. We're talking about these things as an outsider, piecing things together from what we can see in the game and generally available knowledge. I'm sure there are interesting stories there, and I encourage those who were present to write them down so I can read those books. I love to know authorial intent, but unless that's you, the rest of us are left with the work itself. And there's plenty to see there.

Senses

Gameplay is influenced by the look and feel of the game.

Shovel Knight has a very clear and distinct style. It's a retro game trying to emulate the feel and visuals and sounds and complete experience of a classic platformer. In this sense, the style fits very clearly with the gameplay. People who are familiar with the references will expect the gameplay and style to both align with their perception of those earlier games. And people who don't know the classics will still understand that both gameplay and style evoke an earlier age, so don't expect integrated AI and vast open worlds and high-fidelity graphics.

The simplicity of the game also makes it easy to see where gameplay and graphics intersect. Remember our input/output diagram – the output part of the diagram is made up of pixels on a screen that the computer manipulates. This is the player's only source of information on what is going on in the game (well, that plus sound and sometimes vibration). As a game designer, these pixels are all you have to get your ideas across to the player. A player who might not really be paying attention and who most likely hasn't played every previous game that you (the game designer) did. This is a difficult and momentous responsibility for a few measly pixels.

Every game has to create a visual vocabulary of what matters to the player and to gameplay – using the same size, shape, color, or whatever

consistently helps the player learn what to do and then quickly process new scenes. *Shovel Knight* does a great job of quickly establishing what the player needs to know and sticks with that throughout the game:

- The ground you walk on is flat – usually rectangles – and high contrast against the rest of the background.

- Objects you can interact with are also high contrast and often include movement. The game intentionally doesn't create separate vocabularies for enemies and rewards, as it wants to play with that in the gameplay. Sometimes bouncing on an enemy's head is the only way to reach a reward. Sometimes a reward is in a dangerous place making it more of a problem than a pure benefit.

- Combat actions and results are always clearly punctuated. Enemies don't just disappear – they vanish in a little cloud of smoke. If the player missed the frame where they died, the game is still communicating for a few frames after.

- *Shovel Knight*'s shovel provides a nice strong indicator of where the character is facing. This is especially handy for communicating the difference between "falling" and "falling with intent to kill". The downward shovel attack is important and might not be noticed without the big bright object that moves around the character.

History and Influences

I'm a big fan of stealing ideas from other games. No game is an island. Every game is inspired by the ideas and execution of games (and other things) that came before.

There's an important distinction to be made here. All games are inspired. All games borrow and "steal". But when you draw inspiration from something, you need to be careful to not draw too heavily. If your game is just a copy of someone else's idea, that's actual stealing, not the tongue-in-cheek way I sometimes use the term. If your game gets all its features and ideas from another game and doesn't add or change them in a way to make something new, then you need to rethink and start over to add your own twist on the thing.

You can see this in *Shovel Knight*. *Shovel Knight* is a wonderful and unique game. But almost every aspect of *Shovel Knight* comes from somewhere else.

- *Super Mario Bros* (1985) is generally credited with popularizing the 2D side-scrolling platformer genre.

- But many of the ideas from *Super Mario Bros* were first developed in the *Mario Bros* (1983) arcade game, and borrowed from earlier games like *Space Panic* (1980).

- Many 2D side-scrollers after Mario added attacks like *Shovel Knight's* shovel, including popular games like *Metroid* (1986) and *Castlevania* (1986).

- Once the seeds of the genre had been planted there are many great games that took those ideas and adapted them for PC gaming, including *Lode Runner* (1983), *Commander Keen* (1990), and *Cave Story* (2004).

- *Braid* (2008) and *Spelunky* (2008) popularized the idea of using 2D platformers as a simple and nostalgic base to experiment with interesting indie game ideas.

As a game designer, it's important to know the history of not just the games but also the features. Jumping from platform to platform in *Shovel Knight* is interesting but is informed by many other games before, and feeds into many other games after. Dissecting each of those games, at least in terms of that specific feature, helps you see how to use that feature in your own games. Johnnemann Nordhagen took this idea even further and built a game that collects all the different ways that a specific mechanic has been executed over the years. *Museum of Mechanics: Lockpicking* (*Dim Bulb Games*, 2022) is an interesting way to see how games borrow and share and innovate on specific ideas.

Monetization

How a game makes money has a huge effect on the design of the game.

There are a few major trends in monetization that had huge impacts on the types of games we associate with each era:

1. Arcade games. Monetization is quarter-based. (Technically monetization for the developer is by selling arcade cabinets, but the cabinet buyers were very interested in quarter throughput, so the developers developed to that metric.) The goal was to get the player to notice the game in a crowded arcade, and then plug in as many quarters as

possible in as little time as possible. This led to game with very quick session lengths, very steep difficulty curves, and little to no thought about ongoing long-term play.

2. Console games. Monetization is based on selling boxes in stores, with no internet to provide updates or live services after that. At first early consoles tried to mimic games that players knew from the arcade, but soon the focus became value. Games were reviewed based on hours of play. Look at the difference between *Mario Bros* and *Super Mario Bros* to see a clear example of this change.

3. Mobile games. Monetization is based on downloads and (after the first few years) in-app purchases. The goal is to get a player in quickly and easily, then keep them around for long enough that they get comfortable spending money. The growth of big data plays a big part here, as game developers start to analyze what actually gets people to stick around and spend money. Game sessions are short, but players are expected to stick around for months or years.

This is not an exhaustive list by any means. Early PC games resembled console games but with a lot of their own twists. Console has been changing with the growth of downloadable upgrades. Most of this doesn't apply to educational games or other games for change, which have entirely separate monetization goals and pathways. Each game's monetization needs to be analyzed separately but with an understanding of how it fits into the standard monetization schemes of its time.

Shovel Knight makes most of its money through downloads on PC game services like Steam. This is currently the dominant sales platform on PC, and the growth of independent routes to sell and market games without interacting with big publishers and retailers is a big part of why indie games like *Shovel Knight* exist and succeed. A successful Steam game can support a small indie team with a good idea, but console games generally have to be bigger.

Shovel Knight started out on Kickstarter, raising money for the initial development through crowdfunding. Kickstarter and similar platforms are a popular way for smaller indie games to generate some initial funds and market an early idea. The initial money helps, but the initial fan base is as or more important to making a small game with a small (or zero) marketing budget a success.

Since its release, *Shovel Knight* has shipped multiple downloadable content (DLC) packs, which have later been released as separate games. *Shovel Knight* has become a series with explorations in multiple genres and different playstyles.

Selling as a single purchase drives *Shovel Knight* to focus on providing a complete package. Deeper progression and varied content make the single purchase feel worth it, generating good word-of-mouth to keep the game selling.

Narrative

Story and gameplay are friends. They work together to bring joy and happiness to players. Different games make more or less use of this friendship. *Shovel Knight* is a great example of the most common use of story in games.

In *Shovel Knight*, the main use of story is to provide emotional context for the player's progression and emotional punctuation at key points. The game establishes early on that Shovel Knight is trying to rescue their friend Shield Knight. A classic rescue mission, which is a great way to make a player want to reach the end. My friend needs help!

Most of the time, this is just a small piece of background motivation. During gameplay, the game doesn't make reference to Shield Knight or anything else about the characters. Bosses get a quick intro to establish their character, during which the player has no input. The game stops to tell the story. Then after a big level, there is a short dream sequence that reminds the player of this long-term goal and provides some interactive rewards as well. Some of the NPCs provide additional narration and backstory, but it's all contained in a few sentences so it never gets too involved or deep.

This is great. This is exactly what most games want. Story is there. Emotions are triggered. The player knows why they're doing all this, and if the player puts the game down for too long, they feel a little guilty. Poor Shield Knight. The story is fun and interesting, and the game is stronger because of it.

Some games use story in deeper and more complicated ways. And I love those games, too. But I've made some of them so I know how complicated and difficult it can be to interweave story and gameplay in ways that actually matter. More on that later.

Emotions

Story is one source of emotions, but games can evoke many emotions.

For action games, the most common emotion is frustration, which might sound like a problem, but it really isn't. Talking about games for the last few decades, I've noticed that there are many flavors of frustration. Some are good, and some are bad. The main difference is how and where the player has agency in the frustration.

- **Outside Frustration:** If the player has no agency, then it's outside frustration. It can be annoying, but it's less personal so thus less impactful. I can get frustrated watching a communication problem unfold in an episode of a sitcom, but I don't feel it personally.

- **Uncontrolled Frustration:** Once the player has control of the action, the potential for emotional involvement is higher. Give me buttons to press and now any failure is my fault. So, the worst case here is when the player has input but no real control. If the player expects to have control but loses due to reasons outside of their control, that can be very frustrating. The game made a promise and then failed to deliver. This is often the worst form of frustration and game designer should be careful to avoid situations like this. If the player needs to fail regardless of their actions, make it very clear that the game knows it's not the player's fault.

- **Confused Frustration:** If the player has agency that actually matters, that's going to reduce the negative impact of the frustration. But this is only true if the player understands all that. If the player doesn't understand how their actions influence the outcome, they might as well not have agency. This is where many games fall apart, especially for more casual audiences. It's very frustrating to press buttons and not understand why they matter. And that understanding is entirely the responsibility of the game designer. Remember, the player only knows what comes through that tiny funnel of information they see on the pixels on the screen. If they aren't able to construct a full mental model of the logic going on inside the computer, to expect, they're going to have some negative frustration. In many cases, the hard part of being a game designer isn't coming up with good ideas; it's getting the player to understand those good ideas.

- **Difficult Frustration:** Agency that matters and makes sense is not enough. The challenges also have to be fair. Banging your head against an impossible challenge can be a positive type of frustration (cough Elden Ring cough), but not for all players. Some players want more manageable challenges and find extreme difficulty to be bad frustration. But the inverse is also true – a player who enjoys mastering a skill may consider a sequence of easy challenges to be frustrating in a very different way. Finding the right balance for the audience of your game can be difficult – more on that later.

- **Fun Frustration:** Finally, in some cases, players have agency, understand the consequences of their actions, and still fail. This is called gameplay. If the player understands why they failed, the frustration from the failure is much less. In the best cases, frustration is a fuel that drives the player to come back and try again. Games are built on iteration, both as a development practice and as a player strategy. A good game will create positive feelings of frustration that guide the player to an emotional response along the lines of "I can do better". Which is a great lesson to learn for life, even outside of the magic circle.

Meaning

I think it's important to understand what games mean. Since games are a relatively new form of art, we don't always think of them as having an impact on the world. But they do. The person who starts playing a game is different from the person after the game is done. Games make people think about things. Games change the world.

For many games, this is not the primary goal of the game. It might be money. It might be providing a simple fun time. But meaning happens whether the creator intends it or not. I understand programming better because I played *Robo-Rally*. Some of my love of creativity and creative problem-solving comes from early Infocom text adventures. *Minecraft* has made a generation of kids think differently about creation and resources and exploration and problem-solving.

I don't think any game has one discrete meaning. Even games with a clear intended meaning will be interpreted differently by each player who encounters it. So, when I talk about meaning in the games in this book, I don't intend to exclude other meanings. When we talk about this in class, every semester has different answers and they're all right.

For me, *Shovel Knight* is about persistence. It's not the only game where the main character is beaten down constantly and has to constantly get up, but it's a clear example of that style of play. I'm not the most skilled player, so I tend to die a lot. But the only time I feel like I'm losing is when I put the game away and give up on saving poor Shield Knight.

Candy Crush Saga / Goals

CANDY CRUSH SAGA

Candy Crush Saga is a great game.

 Candy Crush Saga (Figure 3.1) is a mobile game released by King (now part of Microsoft) in 2012. Since launch, it has consistently been one of the

FIGURE 3.1 *Candy Crush Saga* screen.

DOI: 10.1201/9781003346586-3

most popular games on mobile, with hundreds of thousands of monthly users Curry, D. (2024).

I've never worked on *Candy Crush Saga*, but I did work on a competitor. When I was at a studio called Zindagi, we designed a match-3 called *Crazy Cake Swap* based on a similar puzzle game called *Crazy Kitchen*. The studio got bought by Zynga and didn't stay around for long after that, but I know this genre better than I know most genres.

CANDY CRUSH SAGA – GAMEPLAY DISSECTION

Verbs

To understand *Candy Crush Saga*, let's start where we always do: verbs. What can the player do in *Candy Crush Saga*?

In this case, it's a simple answer: swap. The player can touch a candy in the grid and then slide it to an adjacent candy. When the player does this, the two candies swap positions. That is the entirety of the player's active contribution to the core loop (Figure 3.2). There are some interesting less active things the player does while swapping, such as "Scan" and "Predict", but these aren't the simple button actions, so we'll save discussion of those for later in this chapter.

The core loop continues from there, though (Figure 3.3). After the player makes a swap, the game rules check to see if either candy creates a line of three or more. If it doesn't, the swap is canceled. If it does, the game removes those candies, possibly with an extra effect if the line is four or more candies. Then the remaining candies fall to fill the empty space, which can possibly create new matches and cause a chain reaction as each match creates new matches.

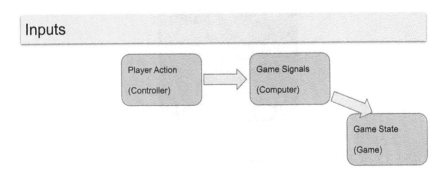

FIGURE 3.2 Inputs.

Outputs

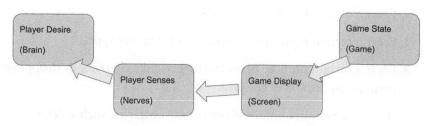

FIGURE 3.3 Outputs.

The player performs a simple action, and the game rules result in complex outcomes. This is one of the strengths of video games – the processing burden of the game can be placed on the computer's shoulders. The rules of *Candy Crush* would be much less fun as a board game where the players have to move each candy by hand and figure out the outcome of each new position.

Swapping and the reactions to that swap is the heart of *Candy Crush Saga*, and the core loop of any match-3 game.

And for completeness, *Candy Crush Saga* also has a few special case verbs:

1. Players can use powerups such as the lollipop to remove specific candies or otherwise affect the grid outside of swap actions. Outside of the tutorials that teach these interactions, they are never required to complete a level, but they are always there for the player to use. But they are a limited resource that can only be acquired as an occasional reward or for money.

2. Late in the game, there are new board elements that include an interactive choice by the player. For example, Candy Frogs let players choose where to place them when they go off.

3. Secondary modes like events provide a choice of what to play and sometimes have some basic decision-making in the event itself.

So outside of these caveats, the verb of *Candy Crush Saga* is "swap".

Goals

The gameplay goal of *Candy Crush Saga* varies based on the level. All goals revolve around clearing things off the board, but the nuances of exactly what you're trying to do can change:

1. Clear a certain number of candies.

2. Clear a certain number of candies of a particular type.

3. Clear a certain number of special objects, like cherries, by dropping them to the bottom of the grid.

4. Remove a certain number of non-candy obstacles, such as jellies.

5. Etc.

More on this in a moment.

Challenge

The real variety in *Candy Crush Saga* (and most match-3 games) comes from the randomness of the falling pieces and the variety of obstacles that make reaching the goal difficult. Most levels have more than just candies on the board – a large variety of different objects create additional challenges and opportunities for the player. These range from simple inert objects that are removed when matches are made near them (Frosting), to inert objects that expand across the grid over time (Chocolate), to snakes that charge into baskets after enough matches are made next to them (Candy Cobra). These aren't all dangerous – there are also advanced board elements that can be useful, such as conveyor belts, or are almost purely beneficial, such as the UFO that drops special candies.

These obstacles are key to *Candy Crush Saga*'s success. The basic concepts of the match-3 genre existed before *Candy Crush Saga*. Specifically, the concepts of the genre were solidified in *Bejeweled* (2001) and *Bejeweled Blitz* (2009). Many of the core ideas were present in earlier games like *Shariki* (1994). The core gameplay is very directly based on previous games like *Bejeweled*. But those previous games used only a single level – there were no obstacles and just one board. *Candy Crush Saga* innovated by adding a variety of levels with different obstacles and a different grid layout for each level. This gave the existing fun core gameplay more variety

and long-term appeal. *Bejeweled* was successful, but *Candy Crush Saga* took that success to vast new heights by adding varied challenges and a stronger sense of progression.

The sense of progression comes from the "Saga" in the title. One of the big innovations of *Candy Crush Saga* was the Saga Map. It's not just that the player was given a variety of levels with different obstacles, it's also important that these levels were set up as a line – a path to a destination. Once the player completes a level, they move on to the next one, heading toward the end. The Saga Map organizes this progression in a simple line, showing the player the next levels they'll be playing. This came out when social gaming was king, so the line also shows you where your friends are, creating some social pressure to advance. But the key concept here is that the player is always doing something new, and has a sense of progression that makes them want to come back tomorrow and try again. Progression is a great driver for players, in any form.

The basic flow of the game is simple – the player swaps to clear the level, with various obstacles in the way. But the obstacles and goals change in each level, as shown in Figure 3.4, making the simple flow work for a long time.

CANDY CRUSH SAGA – NON-GAMEPLAY DISSECTION
Technology
Candy Crush is a fairly simple game that relies on a vast network of advanced technologies to work. This is one of the fun daily realities of the world we live in. The rules of the game and the interactions the player

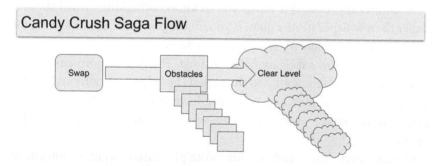

FIGURE 3.4 *Candy Crush Saga* flow: Simple diagram showing Actions, Challenges, and Goals, with lots of variation on the Obstacles and Goals.

experiences are built on easy-to-understand combinations of simple shapes. This is good game design and keeps the player engaged. But the rest of the experience is built on touch screens and constant online communication and vast behind-the-scenes databases that are way more powerful than the technology that brought humans to the moon.

One thing that is important to think about as a game designer is how these vast changes in the world of technology affect your game. New technology comes along all the time, and some of it is a great fit for new types of games. Sometimes there is a direct linkage between a new technology and a new style of game, such as GPS-enabling *Pokémon Go* (2016). Sometimes the changes are more subtle and need time and thought to understand. It's not obvious (except in retrospect) that improvements in computer miniaturization and wireless communication would lead to everyone having a powerful connected computer in their pocket at all times. And even then, it's less obvious that it would lead to people looking for games that they can pick up and play at any time for very short play sessions. Technology doesn't only change what people can do with games, it changes what they want to do and when they want to do it and for how long. The changes to the rules of technology create changes to the dynamics of how people interact with technology, but more on the word "dynamics" in Chapter 4. These changes can be harder to predict but provide great value for your game designs once you notice them.

Senses

Candy Crush Saga looks cartoony and childish. Everything is in bold, bright colors. The candies are simple and iconic. The game is not subtle in its communication; if it wants you to know something, it will shout it rather than whisper it. At a glance, you might guess that this is a game for children. But the majority of players are adults.

Clearly, this works for *Candy Crush Saga*. The game is immensely successful, and there's no reason to think that the bright cartoony style holds it back. Various clones and imitators have tried to re-theme match-3 gameplay in darker, more adult styles and failed. Childish works for adults.

On one level, this could be pure nostalgia. Adults want a moment to relax and escape from their everyday world, so something that evokes pleasant childhood memories could be just the thing. The reason childish works might be because adults want to feel like children.

On another level, childish might work because childish is good design. Kids are not the only ones who like bold, bright colors. Iconic shapes are easy to distinguish and help make gameplay easy to understand. Direct clear communication is good for everyone, including adults who are trying to just relax. The design principles that work for children also work for adults. It's not childish design, it's just good design.

This is not to say that *Candy Crush Saga* is constructed in a childish way. There is a lot of attention to detail and polish in *Candy Crush Saga*. When I started working on match-3 games, one of the first things I did was spend a week analyzing some of the top games, and some of the worst games. I recorded a few levels of *Candy Crush Saga* and then literally watched the recording frame by frame to see exactly how everything moved and all the little tricks of presentation. It's a very useful exercise if you're trying to understand polish and presentation. Make sure you do the same with some less successful games to really see the differences.

FREEZE FRAME

Things I saw by watching every frame of *Candy Crush Saga*:

- Be really careful with motion. Humans know how falling looks and expect things to accelerate and decelerate in certain ways. Falling at a constant speed is easier to code but looks weird.
- You can cover up lots of things with explosions. Don't bother with expensive transformations if an explosion will feel just as good or better.
- Squash and stretch. This is an animation term for changing the shape of an object to emphasize an impact. It really works.
- Anticipation. Building up to a reward is as important as paying off the reward. Adding a few frames of buildup makes almost everything better.
- Sequencing. Know the order of events and keep that holy. It'll help players understand what's happening and it'll keep your game logic and code understandable.
- Compression. When you have lots of things that need to happen at once, you can break the Sequencing rule and have things overlap a bit. But do it in a logical and constrained way. Think through what the player needs to focus on, and do some hand-waving in other places.

Emotion and Narrative

Candy Crush Saga is not a deeply emotional game. There is no complex storyline to follow with deeply realized characters following narrative arcs who the player grows to care about. There is a simple story that presents a problem to solve, and then a few levels later congratulates you for solving it. This is enough story to give you a reason to continue, but *Candy Crush Saga* is not a game where the majority of players are advancing to find out what happens next.

Candy Crush Saga does hit emotional notes through the gameplay. *Candy Crush Saga* is a game of constant rewards. Whenever you do anything in the game, something explodes and the game tells you how great you are. This is maybe not the most emotionally deep reward system, and I wouldn't trust the game's praise to evaluate my self-worth, but sometimes it's just nice to hear praise. Constant rewards can be emotionally soothing. A working mom who is having a hard day and just wants to catch their breath and relax doesn't need a game that constantly tells them they've died and need to start everything over. *Candy Crush Saga* does have fail states, and it does apply a little bit of emotional pressure in those moments (mostly to encourage the player to spend money), but that's the exception, not the rule. Most of the time, playing *Candy Crush Saga* is soaking in a warm bed of reward and praise. Some games are here to give people what they want.

Money

How does *Candy Crush Saga* make money?

The other big innovation *Candy Crush Saga* added to the match-3 genre, other than the level variety demonstrated in the "Saga" part of the title, is the monetization model. *Candy Crush Saga* is free to download and to play. All ten thousand plus levels are free to access. But the game constantly asks you to spend money on other things. Powerups. Unlimited lives. Extra turns. Special modes.

Free-to-play business models drive most of the sales in the games industry these days. And they work. Most of the players in these games pay nothing. A small percentage pay something. And an even smaller percentage pay a lot. These are the "whales" – the large spenders who keep everyone else afloat.

The morality of the free-to-play model is a hotly debated topic. There are certainly companies trying to suck every penny out of their players, and using some questionable approaches to do that. No one should be exploiting gambling addictions or tricking children into spending their parent's money or promising things to players that will never materialize.

But most free-to-play games, such as *Candy Crush Saga*, are not that bad. Every monetization model – arcade cabinets, CDs in boxes, hypercasual ad-driven games – is trying to use human psychology to get people to buy things. At some level, all marketing is manipulation. But that doesn't mean it has to be an entirely bad thing. Good marketing is manipulating people to notice things that they want and will enjoy. And I believe that most free-to-play games are actually providing a valuable service to people. People need entertainment and games are generally a good deal in the entertainment world. Free-to-play allows most people to get their entertainment for free, with some advertisements as the cost. And the people who want to spend more and can afford it fund the rest of the players.

I've done interviews with whales. Most of them are very happy with their purchases and would spend the money the same way again. They have disposable income, and this is how they choose to use it. Rich people spend money on much sillier things than mobile games. You can find people who overspend or otherwise have a negative spending experience, but even among whales most of the transactions are mutually beneficial.

Candy Crush Saga is a quality game. Spending some money to make the experience better is not unreasonable. I'm personally a free-to-play player (most of the time – I'll spend a little money to support games I particularly enjoy), but I understand why people would spend without being coerced. The free-to-play model isn't perfect, and if I could wave a magic wand and let everyone play and make games and all be rich I would, but I believe that free-to-play is only problematic when abused.

History

Mobile games are the core of the games industry these days. Console games and PC games are still going strong, but in terms of dollars spent, mobile games are bigger than everything else combined.

Mobile games took a while to get there, though. In the early days of the mobile game market, there was a lot of experimentation and uncertainty. No one knew what would succeed.

- Some companies tried releasing console-quality games (*Infinity Blade* (2010)) or literal ports of PC or console games (*Return to Monkey Island* (2022, mobile 2023), *Grand Theft Auto: San Andreas* (2002, mobile 2013), *XCOM: Enemy Within* (2013, mobile 2014)). Neither of these approaches became dominant, but there were a few notable successes, such as a little title called *Minecraft* (2009, mobile 2011). Although even *Minecraft* dropped its price significantly compared to other platforms.

- Some games experimented with the novelty of touch screen inputs. Games like *Flight Control* (2009) or *Where's My Water?* (2011) discovered new styles of game that wouldn't work with a controller. These generally did well and you can see new innovations come out and succeed regularly. A lot of the modern innovation in this area is in the hypercasual genre where innovative ideas are needed to grab people's attention (and then throw a lot of ads at them).

- This was also the early days of the shift to digital distribution across the industry. Games could now be services with new content flowing to players as quickly as it could be approved by Apple. *Pocket God* (2009) was an interesting experiment in this space, updating as quickly as possible with big new features changing the very nature of the game regularly. Games that play like *Pocket God* aren't common these days, but the model of constant meaningful updates has become very common and remains successful, even on other platforms like Roblox or for other games like *Fortnite* (2017).

- Along with other changes, monetization was also uncertain. At first, companies thought that mobile gamers would pay something close to console price, or at least similar to the downloadable markets that were developing on consoles and on Steam. But as companies experimented with pricing, they found that lower prices worked. The increase in sales offset the drop in price, so soon *Angry Birds* (2009) was the top of the Grossing chart at the lowest possible price – 99 cents. Then Apple added the option to sell things inside the game,

and in-app purchases were born. Immediately, games like *Smurf Village* (2010) discovered that free was even more appealing to people than 99 cents. The modern free-to-play model was born.

In this era, mobile games were also learning a lot from social games. Facebook was a huge platform for games for a few years, before changes to the advertising structure and success of mobile killed it. Social games pioneered many of the free-to-play principles that later dominated the mobile market.

Candy Crush Saga was originally a Facebook game. And before that, it was originally a web game. King, the company that makes *Candy Crush Saga*, has used an interesting method for testing out new titles. They generally release lots of new games first on their web browser and see how they perform there. The best-performing titles are considered for conversion to other platforms. At the time, Facebook was considered the first step and mobile was a new and experimental platform. So, *Candy Crush Saga* first appeared as *Candy Crush*, a web game without the level variety that made *Candy Crush Saga* so successful. The Saga idea first appeared in *Bubble Witch Saga* and proved successful. When King brought their score attack match-3 *Candy Crush* over to Facebook, they added similar Saga elements. *Candy Crush Saga* did great on Facebook, so within a few months it was brought over to mobile as well.

By the time *Candy Crush Saga* came to mobile (2012), the battle over pricing was mostly done. The free-to-play models that had been pioneered in Facebook were dominating on mobile. So, *Candy Crush Saga* launched for free, with strong social elements. Many of those social elements have faded to the background over the years as the industry has continued to evolve and updates have changed *Candy Crush Saga*. Competing for high scores against your friends, or for progress along the Saga, used to be prominently displayed but now is more of an afterthought.

So, *Candy Crush Saga* came into the market at the right time with an innovative take on both the gameplay of match-3 and the free-to-play monetization model. The game was a hit from day one. King already knew that it had a good chance, based on its success on other platforms, but nothing is certain in this industry. In this case, it worked. *Candy Crush Saga* was so successful it spawned multiple sequels, a line of merchandizing, and even a short-lived network television game show. And it became my wife's favorite video game.

Meaning

What is *Candy Crush Saga* about? What does *Candy Crush Saga* say about the world? How does playing *Candy Crush Saga* change how you see the world?

To me, *Candy Crush Saga* is about the joy of unintended consequences. The player makes a seemingly simple innocuous action, and suddenly the screen is filled with colorful explosions and some guy with a deep voice is calling out compliments. The player didn't plan that out. The player didn't know exactly what was going to happen. But like many things in life, taking that first step leads to all sorts of unknown things.

Candy Crush Saga is the type of game that doesn't really challenge the player. Sure, some levels are nearly impossible, but those levels generally require luck to complete along with skill. Mostly *Candy Crush Saga* is a warm bath of compliments and pleasant explosions. And I believe these types of games make the world a better place. People need comfort. People need more praise in their lives. If a game can help people be happy and get through their lives, I support that. Since the dawn of time, humans have sought escapism. That need is deep in the human psyche. Games are the latest delivery method. I'm not going to fight against the human psyche. Let people enjoy simple fun.

GOALS

Verbs tend to work together. In *Shovel Knight*, I can move, and I can attack. I'm generally more successful in the game when I combine these verbs. I don't move, pause, wait, then attack. I attack while I'm moving. I look around while I'm moving. I don't stop and pause; I'm constantly performing all the actions at one time and that's part of what makes these games challenging and interesting. Not all players can manage the feats of dexterity and rapid stimulus processing required to be successful at move-shovel when they all have to be done together.

The player's goals can also work this way. When I'm moving to line up a shot, I'm also considering how to best avoid the line of fire of another enemy at the same time. Goals can be combined just like actions can be combined (Figure 3.5). But goals are even more likely to be layered rather than combined.

Look at *Candy Crush Saga*. If you chose a random second of a player's session in *Candy Crush Saga*, the verb is likely to be "swap". Maybe "look"

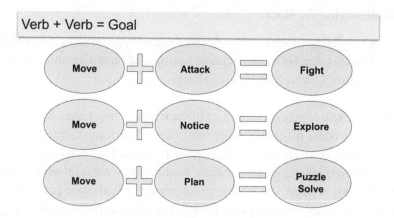

FIGURE 3.5 Two Verbs merging into a bigger verb.

if you accept that as a valid verb. But the player's goals are going to hit many different layers of analysis:

1. Making a match

2. Having this match lead to a chain reaction or create a power gem

3. Having this match lead to a better board state when it's done

4. Removing lots of gems

5. Making progress toward the goal of this level

6. Scoring points

7. Beating this level

8. Beating this level with three stars

9. Completing an event or challenge goal

10. Getting to the end of the level progression

11. Getting a better score than my friends

12. Relaxing

13. Helping the cute little puppet creature to complete its goal

14. Clearing the chocolate

15. Removing the blockers

16. A very large number of level-specific goal types that I could list but then this chapter would become boring and repetitive and as a game designer I try to avoid boring things

This is normal. In games as well as life, a single action rarely has a single goal. Goals come in herds. Some with subtle nuanced distinctions, and some coming from completely different directions. *I want to beat the level. I want to beat the level with three stars. I want to beat the level with a higher score than my brother.* These are expressions of the same base goal but with different nuances. From a game design standpoint, these can be merged into a larger goal: success in the level (Figure 3.6).

The bigger differences between goals are often based on scale. I want this action to clear lots of gems. I want to beat the whole level. I want to get to the end of the game progression. I want the action I'm performing now to make me successful now, soon, and in the future. This sort of layering of goals is very important to game design. Game designers like to talk about goals as onions – one goal is contained within the other goal (Figure 3.7). Progress toward one smaller goal also progresses you toward a larger goal.

So, both goals progress based on the same player action, but the second goal is bigger so it takes longer. Completing the first goal is a step toward completing the second goal. When you complete the first goal, you still

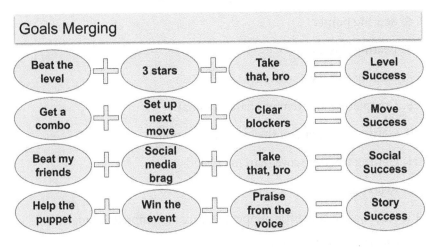

FIGURE 3.6 Two goals merging into a bigger goal.

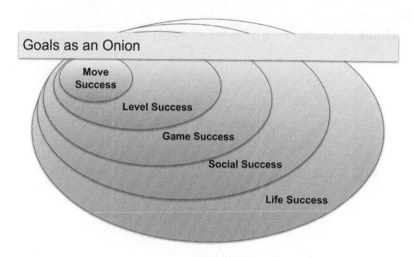

FIGURE 3.7 One goal inside another goal.

have the second goal to keep you driving forward. At no point does the player complete one goal and have nothing left to do. For a game designer, a player with "nothing left to do" is a problem – they're likely to leave the game and go do something else. Layered goals fix this by keeping the player motivated at all times.

In *Candy Crush Saga*, a player may say that their goal is to beat this level. But to do that, they need to find and make matches. Once they complete the small goal and make that match, they are (hopefully) closer to their big goal of completing the level. But now they have to start another loop of activity to find another match and complete that small goal again. Only after a few dozen small goals is the large goal reached.

And once the large goal is reached, the player is taken back to the Saga Map where they remember that the large goal is just a small step toward the ultimate long-term goal of progressing to the next story bit or to beat a friend or to reach "the end".

So maybe goals aren't onions. Maybe goals are garlic. One head of garlic seems like a single unified thing but when you break into it, you find many smaller versions inside (Figure 3.8).

This is good psychology. Humans like to group things and draw lines around them. Part of the fun of goals is getting to define a task and then check it off your to-do list. Completing a goal is fun.

And to be clear, this isn't a monetization trick. This is what makes the game fun. "Engagement" is a key goal of free-to-play games, and it

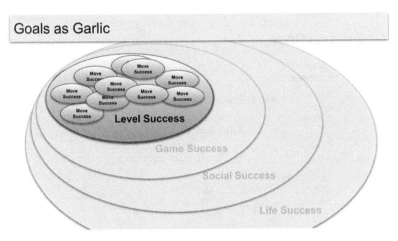

FIGURE 3.8 Many goals inside another goal.

does drive monetization. But it's also a sign that players are having fun. In my opinion, the best way to drive monetization is to make sure the player is having fun and engagement is one way to identify when that's happening.

This is why layers are great. If there is always something more to do, the player is never looking at an empty checklist. When they complete one check box and get that hit of serotonin, there are still more checkboxes to do. Not just the next one, but one that's halfway finished. Or even better, one that's just about to be finished. If you're at 4% progress toward a goal, there's no pressure to stay in the game and complete it. But if you're at 96%, then you might as well play one more level to finish it off. And then when you do, there will be another goal at 97% waiting for you.

This is present in many games:

- *Civilization* and other 4x strategy games are well-known for promoting "one more turn" gameplay where there are many different layers of goals that overlap in complex ways, ensuring there is always one more thing to do.

- Boss levels are another way to promote players' desire to check off boxes. The boss is the hardest part of the level, but it always shows up when you're already past 90% complete. The temptation to check off that box is part of why boss levels are so motivating.

- Role-playing games (RPGs) offer multiple forms of progression – story quests, side quests, character stats, faction relationships, skill points, equipment, etc. This ensures that whenever a player completes a goal, there are more things to do.

You can see this in the evolution of *Candy Crush Saga*.

Match-3 games such as *Bejeweled* existed before *Candy Crush Saga*, with very similar core gameplay loops, even down to the specific power gem abilities. But when *Candy Crush Saga* came out, its sales and engagement blew them all away. *Candy Crush Saga* succeeded in large part because of the Saga goal structure. The Saga structure takes a fun core gameplay loop that had been mastered in previous match-3 games (Figure 3.9) and adds another layer of goals on top of it. You still want to make good matches and get a good score, but now there are two new layers.

In the time-battle-based style of games like *Bejeweled*, there's no way to "beat" a level. You can get a good score, but you can never check off a box that says the level is done.

The Saga map gives a clearer sense of progress on an individual level. You can "beat" that level, even if there's always room to go back and improve your score (Figure 3.10).

And once you beat a level, you're taken back to that map and shown the true goal – long-term progression. In *Bejeweled*, the end of a level may or may not check a personal goal box depending on your final score. In *Candy Crush Saga*, you're usually checking at least one box and maybe more (Figure 3.11). And you're reminded of all the remaining boxes you can check in the future. That's much more emotionally compelling and drives long-term retention in a great way.

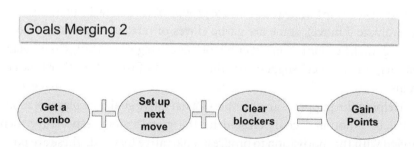

FIGURE 3.9 Goals merge: Make match, Create combos, Gain points.

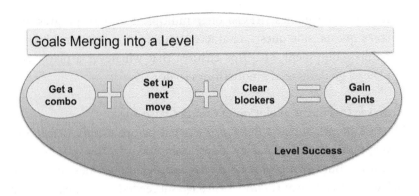

FIGURE 3.10 Same, but with a bigger circle around it: Beat level.

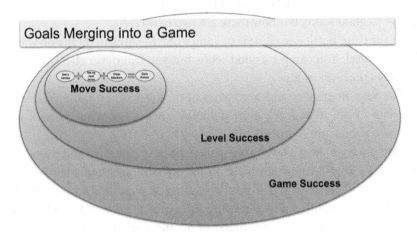

FIGURE 3.11 Same, but with a bigger circle around it: Complete game.

Other Goals

Looking at the list of goals, some are groups of related tasks (various ways to evaluate a move), some are garlic cloves of related progression (move, level, game), but some don't fit either of these categories. Things like "relax" or "help the puppet" suggest that there is a lot of room for other types of goals.

Helping the puppet is an example of a narrative goal. The player is motivated by emotional goals created by the game's story, especially when mixed with the motivation to progress a narrative forward. These are powerful goals for humans, as storytelling and completion are deeply woven

into humanity. For many games, just this goal motivation is enough to invest time and effort into a full story with (expensive) cinematics. Core gameplay drives players forward, and progression keeps them wanting more, but deep engagement requires some emotional investment.

Other goals like "relax" suggest that the player may have goals for playing the game that are outside the structure of the game. The game doesn't directly have a relax button, and none of the explosions that occur when candies match are directly designed to ensure player relaxation. Relaxation is the reason the player comes to the game, not something the game directly produces. When all the parts of the game are working correctly, this goal will be the result. These sorts of goals are important to look for and understand in your games. Just because they're not entirely driven by game features doesn't mean that you as a game designer can't influence them. Understanding what your players want inside and outside the game is critical.

Player-Generated Goals

One type of goal that doesn't show up in the goal list is player-generated goals. The list focuses on goals that the game creates and enforces, but humans love to generate and track goals on their own. Every time you generate a to-do list and mentally check off items as they're completed, you're acting as your own game designer to structure and motivate daily life. Players do this during games, too. In *Candy Crush*, players might strive to clear a certain area or create a certain combo even if the game doesn't ask them to. This is good.

As a game designer, you can't force players to make their own goals. But you can create an environment where goals are easy to make and track and enjoy. The more freedom the game gives the player to try divergent actions, the more players are going to find them and enjoy them. Players like interacting with everything in the game world, which is something most game designs should encourage. Finding ways to give strong feedback during these actions helps the player know that their actions matter and that the game recognizes what they did. When I was working on *Paperboy 64* (1999) (my first full game design), we made sure that almost everything reacted when being hit by a newspaper. The player was only meant to target a few specific things, but the world is much more fun and engaging if everything reacts. And if a player wants to focus on throwing papers at dogs to keep them away from cats, they can do that.

They don't earn points for it, but the game still creates these little scenarios with emotional potential and shows the player that their actions have consequences.

Player-generated goals are also an important driver for gameplay goals. During early playtests, keep an eye out for things players try to do. Ask players what their goal is. If players want to do something, the game should recognize and reward it. In some cases, take those personal goals and make them into gameplay goals. But if that's not appropriate, take those personal goals and acknowledge that they matter. Keep track of them in the design to make sure they remain fun as the game changes and iterates. If possible, track them and give the player a small thumbs up in-game when they complete that goal, even if it's unrelated to the main goal. Players like a pat on the back, so give them as much feedback as you can to make that happen.

Events

Since launch, *Candy Crush Saga* has been finding ways to push the player's ability to complete goals even further. One of the most successful features in many free-to-play games is the event. For example, in *Candy Crush Saga*, they might have a special race where the player is rewarded for completing a certain number of levels before other players do. In the current builds of *Candy Crush Saga*, some of these "events" have become important enough to bake back into the main game progression cycle. They started as special events that only appeared occasionally but now are just something that happens naturally during play.

There are a lot of good psychological hooks built into limited-time events.

- Players love getting more things "for free".

- They encourage coming back soon, so you can complete the goal before the event ends.

- They feel special and often emphasize the unique never-before-seen qualities of this event.

- If the goals are set up right, they scratch competitive urges in a way that doesn't automatically advantage expert players.

In *Candy Crush Saga*, events are a great way to add an intermediate layer of goals. *Candy Crush Saga* does a great job of providing immediate goals, and the Saga Map provides a great long-term goal. But the long-term of the Saga Map can be pretty far off, especially now that there are thousands and thousands of levels. The motivation to reach the end of the map now takes multiple years to complete. So, there's a need for more checkboxes between the "complete a level" box and the "beat the game" box.

Events provide a goal that is bigger than a single level but is still realistic to actually complete. A player may never reach level 20,000, but they can earn the free powerup by collecting a few more levels to win the race. It doesn't even matter if they want a free powerup – it will still motivate them to push forward just to check the box. Humans are weird that way.

Being able to see this in retrospect is a sign of a reasonably skilled designer. But the real trick is identifying this before the feature is implemented. A really talented game designer would be able to look at *Candy Crush Saga* at launch and identify the goal layers. A really really talented game designer would be able to do that, and then notice that the goal layers are fairly far apart. Even with only 80 levels, the motivation to complete a level and the motivation to complete the game have a big gap. And it takes a really really really talented game designer to do all that, and then design the right solution to fix that problem while also fixing a few other problems along the way. I never worked at King, so I don't know who came up with the idea to add the events. But they deserve a raise.

(I'd be willing to guess it wasn't a single person sitting down doing this analysis and going "Aha!". It was almost certainly a joint effort by many people who fed each other small good ideas and then tested and iterated on those ideas to find the best ones. Someone along the way probably noticed the goal structures and might have advocated strongly for certain ideas based on it, but in games good things rarely happen because of one moment. Games are made by teams, and good games are made by iteration.)

Secret Verbs

So good goals are garlic, with lots of goals and lots of layers in each goal.

Good goals also support good verbs.

When you just think about the verbs of *Candy Crush Saga*, it can make the game sound a little boring. You're always doing the same thing? Just

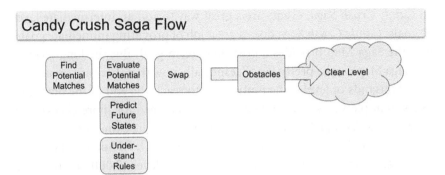

FIGURE 3.12 Flow diagram from before, with expanded player actions to account for scanning and evaluating.

swapping over and over? But the experience of playing the game is different. The game feels engaging and fresh even after playing for a long time. How does that happen?

One reason for this is that *Candy Crush Saga* actually has another important verb, but it's not one that is obvious. It's not even an action the player takes. So, it's a little bit harder to notice.

Before making a swap, the player spends a good amount of time scanning the board, looking for good matches. The player isn't actively touching anything, but the act of searching is an important part of the gameplay process. Searching is generally more engaging than swapping – swapping is just the mechanical outcome of searching.

Searching involves multiple types of mental processes (Figure 3.12).

- The player has to scan the board to identify what matches are possible.

 - As a game designer, it's important to build levels that support interesting board states.

- For each match, the player has to evaluate the value of that match.

 - This can involve lots of possible factors, including stepping ahead multiple turns to see how this action affects future actions. This is the hard part of a Match-3 game.

 - But for most players in most situations, this analysis isn't very deep. If you are more interested in relaxation than victory, a quick scan without a lot of second-order analysis is enough. The ability

to choose how deep to go is a great quality in a game design, as it allows different players to approach the game in their own way, and also results in varying skill levels with different outcomes, which is also good for your game.

- Once matches are identified, the player has to compare the matches to determine which to do.

 - There are many possible ways to evaluate – there's no one right answer for most board states.

 - This can include predicting a few steps ahead. The player can predict how the candies will fall, allowing them to set up future matches. This can't be done too far into the future since the player doesn't know what random candies will fall from the top of the screen.

Scanning is fun where there is an interesting board state. What makes a good board state? I'd argue there are two main qualities that make a match-3 board a quality board.

First, the board needs the right number of possibilities. When a player is scanning, they only have so much mental capacity. This is actually a real thing in psychology – human brains hold about seven things at a time (Miller, 1956). So as a game designer, you want to give the player about seven things to think about. Probably a bit less so you're not quite at the limit. And maybe even less than that for a casual game where the player's not signing up for advanced memory feats. In *Candy Crush Saga*, the number of things the player needs to worry about at any one time is easy to count – just go through the current board state and count the number of possible swaps. If you do this, you'll see that most board states on most levels have three to five options. Many levels start in a constrained space where there are only one to three options. It's very rare to have seven or more choices. This makes sense, given our understanding of the human brain.

And in many cases, the choice in *Candy Crush Saga* is even easier than that. When we're tracking player's mental capacity, we don't need to include every possible option. The only ones that matter are the ones that take up mental space in the player's brain. If the player sees a swap but immediately dismisses it as a bad idea, it's not causing them any stress. So really, only potential swaps that have a real possibility to be the current

best move are worth counting. In that case, the number is much lower – in most boards, there are only one or maybe two moves that are fully worth considering. Note that this varies a lot by players. Players who think ahead and track future moves may notice options that other players quickly discard. And to a new player, every option takes a lot of mental capacity to evaluate. So, while only meaningful options matter, "meaningful" is in the eye of the beholder. Game designers need to keep all options in mind when considering all possible players.

The second quality of a good board state is uniqueness. Level 462 should feel different from level 463. And from level 4 and level 4,621. If the player starts to notice that the evaluation that they're doing in this level is the same thing they've done countless times before, they might start to get bored. As with meaningfulness, this varies greatly from player to player. Some players would say that every level of *Candy Crush Saga* feels the same to them. They may need a different type of game to find true happiness. But for many players, small differences are enough. And some players seek familiarity and repetition and wouldn't mind if there were only tiny differences between levels. As a game designer, you want to make as many people happy as possible but you also need to acknowledge and accept that not everyone wants the same thing. Create the right level of variety for your game and your audience and your personal sensibility.

Searching makes *Candy Crush Saga* more interesting and compelling than a game that is just about swapping. Searching is where interesting mental processes happen.

COUNTING OPTIONS

Counting the number of meaningful options the player has in other games can be more challenging than it is in *Candy Crush Saga*, but it can be done.

- Most card games give the player five to seven cards in their hand at a time. Even then, many of the cards are situational so they can be ignored most of the time. A starting hand of *Magic: The Gathering* (1993) is seven cards, but usually two to three of those are lands and only one to two of the spells are available based on mana costs. So, the player only has a small set of choices for each decision in a turn.

- Big strategy games and big open world games are called "big" because there are lots of options. But once the player selects a goal, the number of options that effectively move the player toward that goal drops considerably. That's the number to keep track of.
- Understanding what makes an option "meaningful" is often the difference between a novice player and a skilled player. Looking at a random turn in a game of chess, a novice might count all the ways each piece could move and consider their set of options. But a skilled player knows there are only a few moves that make sense at that time.

Verbs and Goals

The other reason that *Candy Crush Saga* is compelling with only one (now two) simple verbs is that the verbs aren't really all that simple.

Verbs don't exist in a vacuum. Verbs only matter in the context of a goal. The actions available to the player don't matter except in how the player can use them to reach goals. The goals are what make the verbs interesting.

In *Shovel Knight*, we talked about how the player might use the same verb in different ways to accomplish different goals.

In *Candy Crush Saga*, the action the player takes can't change much. When described mechanically, one swap is basically the same as all others. But each swap includes a multitude of different goals.

Every time the player finds a possible match, the player has to balance a range of possible goals that might be affected by that swap:

- Does this help me complete the unique goal of this level?

- Does this create a power gem?

- Does this set up another match as part of the cascade that falls after this match?

- Does this remove a blocker that is in the way of my future progress?

- Does this move a gem closer to a key position for a future turn? Can I get a bigger match on a future turn? Can I clear something related to the unique goal on a future turn?

- Is the random fall of candies after this match likely to do something good?

Within each possible match, a large number of different goals overlap and come together, forcing the player to understand and evaluate all these goals to make a decision. Evaluation is a big part of the skill required in *Candy Crush Saga*, and many other strategic games. Chess is a game of evaluation and thinking ahead. Poker skill depends on multiple types of evaluation all merging together into a mechanically simple action. Good game design finds ways to unite many different systems of evaluation into each decision, so players are always finding new interesting moves that are rewarded in the game, even within well-known rule sets. This is one way that game designers build interesting decisions.

Goal Design

As a game designer, you want to make sure this happens in your game. This means thinking about what goals might motivate the player, both short-term and long-term. If there aren't enough different layers, consider adding new features to make the player think short, long, and medium terms. Garlic doesn't just happen; it's something that game designers must actively generate to ensure that the player stays motivated.

If your game has lots of goals, look at how they relate to your actions. When the player engages with the core loop of the game, are they also engaging with all the varied goals? If not, you might need to rethink your core loop or restructure your goals. The core actions in the game should directly tie into the core goals and most if not all of the secondary goals. Goals that aren't connected to your core loop are ones you might want to consider cutting. This can be a helpful way to evaluate early game design concepts – how well do the actions and goals align? How can that alignment be improved?

This is not to say that everything the player does needs to touch on all goals at all times. Secondary actions outside the core loop can have their own side goals. Sometimes the point of non-core gameplay is to give the player a break from their big oppressive goals and let the player enjoy something else for a while. In an RPG, every quest doesn't need to advance the story. In an action game, every area doesn't need to provide big rewards. Having these alternate goals can provide important variety to keep players engaged.

A game is only as good as its goals. Designing goals that excite players and keep them engaged over time is key to making a great game. If a game isn't fun, it's often the verbs that are at fault. But if a game isn't engaging for a long time, it's usually time to tweak the goals.

CHAPTER 4

Centipede / Dynamics

CENTIPEDE

Centipede is a great game.

In *Centipede*, the player controls a "Bug Blaster", which is a weird spaceship thing that exists alongside giant bugs for some reason. The player's Bug Blaster shoots at attacking centipedes and other insects and creepy crawly things, who also plant mushrooms that block your way. Mushrooms in reality aren't actually planted by falling insects, but in the context of the game, it works.

Centipede (Figure 4.1) is a classic of the arcade era. It was not the first or the biggest arcade game, but it was a key player when video games were just getting started. All video games that exist today owe a debt to our arcade ancestors who were the first to figure out this crazy business.

CENTIPEDE – GAMEPLAY DISSECTION

Verbs

What does the player *do* in *Centipede*?

This is actually pretty easy to determine in old arcade games. Most old arcade games had semi-unique inputs. So, looking at the buttons and other things the player manipulates gives you a good sense of the verbs. Ignore the coin input and "Player One Start" buttons for this purpose – they're basically the wrapper User Interface (UI), not gameplay. In this case, there are two verbs:

1. **Move.** The player can use a trackball input to move their ship around on the screen. The ship is limited to certain portions of the screen,

DOI: 10.1201/9781003346586-4

FIGURE 4.1 *Centipede* – screenshot of the game. Note: The image used is licensed under the Creative Commons Attribution 2.0 Generic license. The author is Rob Boudon. The image was cropped to focus on the screen.

but this isn't visually communicated to the player. The trackball was a great control for this game as it allowed for quick zipping around with constant changes in direction and speed, leading to very precise character placement for skilled players. Later ports to home consoles and computers suffered a bit due to less precise inputs.

2. **Shoot** (aka Attack). There is one button and it fires the ship's weapon. The shots follow a rule used by a number of classic arcade games: the player can only have one shot on the screen at a time, so shooting at things close to you allows you to shoot very rapidly, but if a shot misses and flies across the whole screen, the player has to wait for it to finish before firing again. This is partially due to the limitations of early computers, making it hard to display lots of shots at once, but it led to good gameplay. Just because something started as a technical limitation doesn't make it bad game design.

You may notice that the two main verbs of *Centipede* are similar to the two main verbs of *Shovel Knight* (and first-person shooters and many other games). Moving and attacking are key verbs in many different games, many of which are very different games. This is a little bit weird and

demonstrates that while verbs are a great place to start, they aren't going to answer all your questions.

Just from verbs alone, we can see some key differences in how *Shovel Knight* and *Centipede* work:

	Move	Attack
Shovel Knight	2D gravity-based motion scrolling to the right in a vast 3D world, constantly moving to new areas with new maps.	Jump on enemy heads, or swing a shovel in a fixed forward animation. Used against a wide variety of enemies with different behaviors.
Centipede	2D point-to-point movement on the bottom section of a fixed screen.	Create a particle that travels up. Used against a wide variety of enemies with different behaviors.

So, the games have some similarities, including lots of diverse enemies. But they are clearly different in many ways – different motions, different attacks, different worlds. So, while the similar verbs do indicate a similar popular starting point – traversing a space in order to be victorious in battle – the games take this starting impulse to very different places. Why is that?

Goals

Centipede and *Shovel Knight* are also similar but different in what they ask the player to do. What are the goals of these games?

1. Don't Die

In both games, the player reaches "Game Over" if their avatar character dies. *Centipede* has a simpler health system – any contact with the enemy kills the ship – but the player can have multiple lives before Game Over appears. This is more of a negative anti-goal but definitely fundamental to play in this case.

2. Collect Points/Gold

Points are used in *Centipede* to measure success and encourage players to do things, similar to how gold motivates and rewards many player actions in *Shovel Knight*. "Score Points" is almost always a meta-goal more than a goal itself. You can't score points unless you understand the actions that score points, so the point-scoring actions are the real goal, and points/gold is just the way of recording your progress.

Lots of different game actions tie into the point system, but in *Centipede* points generally come from destroying enemies. Contrast this against the *Shovel Knight* point system (expressed in Gold), which rewards players for combat but also for reaching interesting, hard-to-reach, or hidden areas in the level. *Shovel Knight* wants players to complete combat, but it also wants the player to explore the space in a way that doesn't happen in a single-screen game like *Centipede*.

While the *Centipede* score system is very focused on vanquishing, it still has a number of nice flourishes. The player earns more points for destroying spiders based on the distance between the spider and the ship when the spider is eliminated. This incentivizes the player to move into risky positions with spiders to try for that 1,000-point kill.

3. Destroy Enemies

Winning combat is the main goal of *Centipede*. The player spends most of their time destroying enemies and working out how to better destroy enemies. Destroying enemies is a goal in itself, separate from points, as players want to remove threats and enemies are set up as the antagonists. Not surprisingly, this ties into our two previous goals. The best way to stay alive is to remove the enemies before they can touch you. And the best way to score points is to destroy a bunch of enemies.

4. Gardening

There is a subtler goal going on in *Centipede* that isn't as obvious or directly stated. Optimizing for combat requires dealing with pesky mushrooms. They not only get in the player's way; they also speed up the centipedes. And when the centipedes are in the bottom half of the screen alongside the player, they become another threat the player has to dodge. So, the logical next step as a player is to remove mushrooms to clear out the space, especially in ways that sculpt the mushrooms to send bugs flying down the screen to you. This becomes a goal that isn't as important as directly destroying enemies but fills the space between enemy-destroying moments and encourages players to adjust their behavior a bit while destroying.

Centipede is a clever game, and the ways that mushrooms interact with centipedes is a good example of that. When a centipede hits a mushroom, it moves down one level and turns around (Figure 4.2).

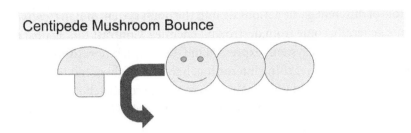
Centipede Mushroom Bounce

FIGURE 4.2 *Centipede* gardening dynamics – The Mushroom Bounce.

This makes sense, and in a normal mushroom arrangement means that centipedes work their way down the screen to eventually collide with the player. But certain arrangements – one mushroom offset and below another – cause the centipede to move down, turn around, and immediately hit another mushroom (Figure 4.3).

This can send a centipede straight down very quickly. Which is generally bad for the player. But since this sends the centipede *straight* down, it can also create opportunities. As previously mentioned, the player gets one shot at a time but can fire rapidly upward when the shot hits something. So when the centipedes are traveling slowly enough, creating a tunnel like this can give the player a chance to quickly eliminate a complete centipede before it becomes a threat. Especially in the early to mid-game, creating and maintaining these arrangements is a good thing. And by the time the centipedes are too fast to track, the player usually has no time to garden anyways.

And to make it even more interesting, when a centipede head is destroyed, it becomes a mushroom. So, when players are shooting centipedes in tunnels, the tunnels quickly become clogged with new mushrooms. Tunnels that are bad for the player result in no dead heads, so they stay around naturally forever. Tunnels the player is using to their advantage require maintenance by the player to keep around. This is good game design – players only get advantages if they're paying attention and putting in the effort to earn that reward.

There are more secondary goals than just these. There are more gardening patterns, especially for advanced expert players. Players may have longer-term goals like getting on a high-score list or advancing a certain number of waves. As discussed in the last chapters, there are lots of types of goals, and players are always coming up with new ones. But when doing a general gameplay dissection, the core focus is on the goals presented by the game and how those drive the core gameplay. For this purpose, the four goals above are the key.

Centipede Mushroom Tunnel

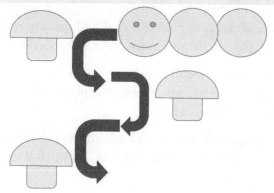

FIGURE 4.3 *Centipede* gardening dynamics – The Mushroom Tunnel.

Action Goals

Applying these goals back to the verbs, we start to see how the goals shape the player's actions.

"Score Points" is a general meta-goal that drives the other goals, so it's more a motivation behind the scenes rather than a direct motivator.

"Destroy Enemies" is the main goal, and most of the player's moments are guided by this goal. Both verbs are used extensively when approaching this goal – the player needs to position themselves just right and then shoot at the enemies. This is clearly emphasized with the fleas, who come down fast in a specific column, requiring precise positioning to destroy, which is also a great subtle tutorial to encourage the player to try that with rapidly descending centipedes, as discussed above. But even with the trackball, it's easy to misjudge by a pixel or two and call up the anti-goal of "Don't Die".

Different enemies engage the destroy goal and the player inputs in different ways.

- Slow centipedes give players targets to shoot at from a safe distance.

- Later centipedes encourage the player to develop advanced techniques such as gardening.

- Spiders force the player to learn how to dodge. Since spiders come from the side and the player can only shoot up, the player often has to avoid the spider before they can take the shot.

- Learning to dodge is important because once the centipedes get low, the player has to dodge them, too.

- Fleas are more about lining up the shot and quickly responding. These reward rapid precise movement and a single decisive shot.

- Gardening mushrooms requires some positioning. But each mushroom takes multiple shots, which helps the player learn about how shots work and how to rapid fire.

- Mushrooms also provide a constant backdrop, which means players who fire indiscriminately or miss their shot can still feel like they hit something.

The anti-goal of "Don't Die" is mostly a modifier on the moments where the player is trying to destroy enemies. Dying is something that happens along the way while the player is trying to destroy enemies, so "Don't Die" is a factor in the player's decisions more than a separate decision on its own. "Don't Die" only becomes a focus when things have gone horribly, horribly wrong – when there are a lot of enemies in the lower part of the screen.

"Gardening" can sometimes be a modifier on "Destroy Enemies". Sometimes the player will adjust their path or fire off a few extra shots while crossing the screen to destroy a few errant mushrooms. But "Gardening" can also be a primary goal. When the threat level from the enemies is low, the player may decide to focus their attention on mushroom removal for a few seconds. This is encouraged by the firing behavior mentioned earlier – the most dangerous mushrooms are the ones inside the player's movement area, but the ability to fire rapidly at nearby targets makes them the easiest mushrooms to remove. Park the ship right below a mushroom and hold down the button and the mushroom will be gone in an instant.

Allowing the player to sometimes focus on "Gardening" even has some nice subtle nuances. The decision to garden versus attacking gives the player an interesting meta layer to consider when not panicking. But even within the gardening approach, it's not always the best strategy to remove all mushrooms. When the lower section is mostly clear, fleas are much more likely. Which can be dangerous, but can also be profitable for players who can spare a moment to rack up some points. It's a judgment call that individual players can make.

Challenge

So there really are two types of moments in *Centipede*.

Enemy Moments where you focus on efficiently removing enemies.

Gardening Moments where you focus on modifying the terrain to make the other moments easier.

What makes these moments challenging?

The vast majority of the challenge in *Centipede* comes from the enemies. The exact count of enemies depends on whether you consider centipede heads and centipede bodies to be the same thing, but there are always at least a few and they're all unique and different.

- Each level includes a main centipede that is working its way down the screen. This is the most constant and explicit enemy in each level. It's so constant it's even the name of the game. The player has to learn various techniques to deal with centipedes, and the strategies change based on how many there are, where they are, and how many segments they have remaining. Having a regular enemy makes for regular patterns that the player can learn and keeps the feel of every level consistent. An all-spider level would be an interesting variant bonus level but would clearly not be the basic gameplay.

- The spider is very different than the centipede. It wiggles around semi-randomly in the player's space. The spider is not the primary goal but instead serves to make movement more interesting. The player can't freely move around their space because they have to constantly dodge or destroy this erratic threat. And new spiders can appear from anywhere, adding another layer of threat. Be careful around the edges!

- Fleas are another different layer of threat. Fleas are an immediate physical threat, as they fall fast. But the real problem with fleas is how they affect the environment. This can change the nature of a level quickly, and provide new behaviors for the centipedes that are coming down. Fleas alter everything else the player is doing and also feed into the Gardening mode discussed above.

- Scorpions are a meta-threat. They appear in the top section of the board and convert mushrooms into poison mushrooms. When a centipede touches a poison mushroom, it zips down the screen quickly,

becoming an immediate problem. So, scorpions are not a direct threat to the player, but they create a situation that can quickly get out of hand. Since scorpions appear at the top of the screen, they might be hard to shoot if you haven't been gardening to keep some clear shots available.

The different enemies provide different challenges that focus on different goals and verbs. This is really good enemy design. The enemies also interact with the mushrooms and with each other in interesting ways that force the player to think about everything together.

During Gardening Moments, there is not an explicit danger that the player faces. It can still be challenging, but it's a different flavor of challenge. The player still has to manipulate the controls carefully to quickly get to the right place and shoot the right thing. But in the Gardening case, the other thing isn't moving or trying to kill the player. So, it's a lower level of challenge.

There is a second layer of challenge to Gardening. Just because you're positioning and shooting well doesn't mean you're gardening well. Selecting targets and selecting the right goal are just as important. There are decisions the player has to make based on their understanding of how the game systems work and their assessment of the current state of the board. These are a bit lower pressure than combat decisions but still require rapid processing since the game never lets up and enemies are always about to reappear. Quick thinking and fast reactions are required, even when taking it easy.

Flow

Putting the Actions, Challenges, and Goals together creates a simple flow diagram for *Centipede*, as seen in Figure 4.4.

But while clearing the board is always the player's main goal, that goal can be broken down into multiple smaller goals that direct the player's actions at any given time (Figure 4.5).

In this case, these three goals can be clearly prioritized (Figure 4.6). There's no benefit to focusing on the centipede if you're in immediate danger. And if there's an opportunity to take down the centipede, it's not best to be focusing on mushroom maintenance.

So, while gardening is the least important of these to the player's survival, it's also the one that has the most options (Figure 4.7). Surviving a

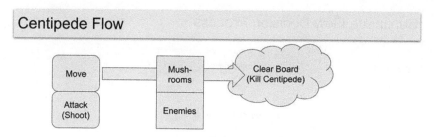

Figure 4.4 *Centipede* flow from Verbs through Challenges to Goals.

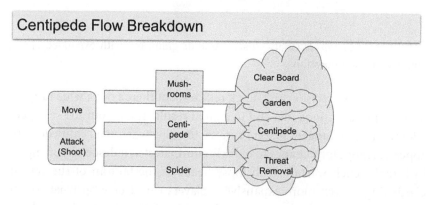

FIGURE 4.5 *Centipede* flow from Verbs through Challenges to Goals, broken down into more lines.

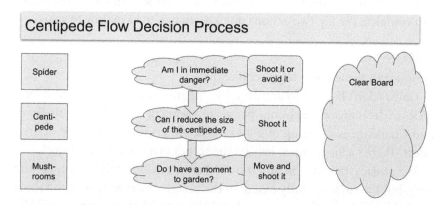

FIGURE 4.6 *Centipede* flow from Verbs through Challenges to Goals, as questions.

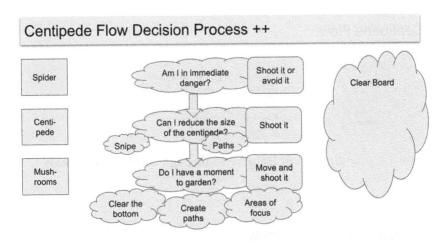

FIGURE 4.7 *Centipede* Goaly Goals: Same diagram, but with expanded choice options on lower questions.

spider requires precision and quick reflexes, but there's not a wide range of possible player actions that end in a good result. Taking out the centipede allows for more range – players can try to snipe when the centipedes first appear, arrange for a chance to quickly eliminate it as it descends, or engage in brutal trench warfare with loose heads at the bottom of the screen. Gardening is even more expansive – players can decide on what sort of board they want and take steps to achieve that future. Some of these long-term goals are natural outcomes of the game dynamics – clear out open space in the bottom to move around, and create pathways for centipedes. But players can choose what to focus on and what specific board layouts work for their play style. There are many possibilities, but only if the player can complete the top two actions quickly enough to have time to spare.

Rules

How does a game come together like this?

Games don't happen by accident. Every game has been crafted by a long series of decisions, either by one person or a team of many. Each Verb, Goal, and Challenge is made up of a lot of little things that lead to the desired effect. There's a lot going on behind the scenes to make each part work.

We already talked a bit about how shots work. We call "shooting" the verb, but the game is really based on the nuances of exactly how the shots work. If you change even a small detail about the shot, the game would be very different.

When we think about a board game, we're used to seeing the rules written out and directly stated to the player. But in a video game, it's not so obvious. You have to watch and pay attention to catch the details of how the rules work. Let's try to list out some of the rules for how shots work:

1. There can only be one shot on the screen at one time.

2. Shots move quickly.

3. Shots move straight up.

4. A shot is created when the player presses the shoot button.

5. When a shot is created, it appears at the top of the ship.

6. The player can't shoot while there is a shot already on the screen.

7. If the player is holding down the shoot button, a new shot is created when the old one ends.

8. A shot is destroyed when it hits anything.

9. When the shot collides with an enemy, the enemy is destroyed.

10. Centipedes create mushrooms when destroyed.

11. Centipedes split when a body segment is destroyed, creating a new head.

12. When the shot collides with a mushroom, 1/4 of the mushroom is destroyed.

13. When the shot reaches the edge of the screen, the shot is removed.

I think these rules are a fairly complete description of how the shot behaves for most cases. If I wanted to add more precision, I could add some pixel lengths and exact times. When you're describing a game that already exists, that can be useful. When you're writing out a design document for a new idea, it's not really worth detailing everything since those values are likely to change during iteration. Sometimes when I'm writing those early docs, I'll make note of the desired variables so they get into the code, especially variables I know I'm going to want to manipulate regularly during iteration. Having all of those in a text file (or even better in an in-game editor) saves lots of iteration time.

If you wrote out a list like this for every feature in the game, you'd have the Game Design Document, or at least a solid start on the features part. Sometimes people do that as a starting point for designing a game, but usually it's more iterative than that. The game designer might write out a few of the key points and key features, but not define everything in this level of detail. Or in some cases, every feature will get a document like this but some of them won't be written until halfway through production. As with all documents, use lists like this when it helps you think things through or helps you communicate with others, and don't use lists like this when they're not useful.

BREAK IT DOWN

How do you generate a list like that? Breaking down a feature requires looking at the feature from lots of perspectives.

- **Time**. What are the steps that have to happen? In this case, creating a shot, the shot moving, then the shot hitting something.
- **Visual**. What does the thing look like? Can you break it apart spatially? Shots have a clear visual, but not a lot of supporting visuals. There's no visual effect when a shot hits an enemy, but the consequence is pretty clear.
- **Goals**. What does the player want out of this? In this case, the moment of destruction is key. That's how the player achieves their goal.
- **Physics**. What are the operational qualities of the motion and reactions?
- **Interactions**. What happens when X interacts with Y? What happens when a shot hits an enemy? A non-enemy object?
- **Information**. What does the player need to know about this? How is that shown? In this case, the position of the shot is key and that is clear from the shot's visuals.

Using Rules to Identify Changes

Breaking out the rules like this shows how dissection can be helpful when making new games. Each rule suggests different changes that could be made to the game with interesting possible effects. If you're trying to determine how to make your game interesting and new, a great place to start is to look closely at similar games and see where you can change a few things. The 2021 release *"Centipede Recharged"* includes a few of these proposed features, which demonstrates the utility of this sort of exercise.

But since our dissection is limited to the original arcade game, let's focus on that for our *Centipede* feature ideas:

1. There can only be one shot on the screen at one time.

 a. Allowing more than one shot, possibly as a powerup, would be powerful. The bullet hell genre provides examples of how this can be fun but was only possible when technology got better at displaying lots of things on screen at once.

2. Shots move quickly.

 a. Altering the speed of the shot would have a big effect on play. I wouldn't want to slow things down permanently, but a temporary effect based on enemies or certain level types could be interesting. Frustrating, but interesting. I especially like that (if handled correctly) this would call the player's attention to the "one shot at a time" rule in a way that would aid understanding without needing a text explanation.

3. Shots move straight up.

 a. Having shots wiggle around a little could be a way to make the game less skill-intensive if you're trying to make this appeal to a broader audience. Giving shots a zig-zag path would make them more likely to hit something but also less precise and predictable.

 b. Currently, the shots only move straight up. If these were real projectiles, they would follow physics and have some momentum based on the movement of the ship. This could be interesting to experiment with, but I suspect it would be terrible in a world where you want to shoot exactly straight up to hit fleas. When designing a game, it's more important that your idea is fun than it is that your idea is accurate to reality. Not every idea has to be a winner; even the ideas that don't end up changing the game help you understand things better.

 c. Physics could also slow the shots down over time to simulate gravity. But this also doesn't sound very fun. Often, realism is less fun than simplicity.

d. Shots could project in different directions. Some similar games have powerups that add additional shots that fire in diagonals. But if you only have one shot, straight up is a lot easier to understand than diagonals.

4. A shot is created when the player presses the shoot button.

a. A powerup that creates multiple shots per press could be fun.

b. A powerup that creates different types of shots could be fun.

c. A version of *Centipede* where the Bug Blaster constantly fires without player input would be interesting. Removing or automating a control can make a game simpler, but in this case at the cost of reducing precision. In this case, it would give the player much less control over the (interesting) shot economy, which doesn't seem worth it.

5. When a shot is created, it appears at the top of the ship.

a. Shots could appear from different locations on the ship, but center top is the simplest and easiest to understand so this doesn't seem like a great place to change, at least for the first shot.

b. An upgrade that allows multiple shots at once would need to modify this rule, so shots appear in different positions.

6. The player can't shoot while there is a shot on the screen.

a. This is the rule that limits the player's ability to fill the screen with shots.

b. While this is a key technical limitation, the rules allow rapid fire under the correct circumstances.

c. This could also be controlled by a timer – the ship needs to wait a second between shots. This would still limit the number on screen, but it wouldn't allow the rapid-fire fun that makes quickly eliminating a full centipede possible. So, I'd argue it would be less fun.

d. The number of shots on the screen could also be controlled by having the shots have a limited distance. But then you lose the ability to handle centipedes when they first appear.

e. This rule is at least partially predicted by the technical limits of the original arcade game. That is no longer a concern – modern machines can manage more shots than the player could recognize at once. Features like this that have outlived their technical constraints are often worth examining and possibly changing. But not always – this one has a lot of important effects on the rest of the game so shouldn't be changed lightly.

7. If the player is holding down the shoot button, a new shot is created when the old one is removed.

 a. Some games use this input to create a charged shot. As the player holds down the shoot button, the shot projectile object gets bigger and more powerful. When the player releases the button, the shot is fired. This is getting pretty far from traditional *Centipede* gameplay but could be an interesting way to diverge. The question I would have is which is more fun – charging up a shot, or rapid fire? That's often the best lens to evaluate potential new features.

8. The shot is destroyed when it hits anything.

 a. There could be some targets that go away when hit without removing the shot. The shot goes right through them and keeps moving, allowing the player to hit multiple things with one shot.

 b. There could be things that destroy the shot when it travels near them. If the player misses, the shot is removed when it gets near the enemy. This might make certain areas of the screen more challenging – the player would need to take out these enemies before dealing with other threats behind them. This might be hard to visually explain – maybe a beetle with wings that pop out but aren't damaged by attacks but is destroyed when its head is hit?

9. When the shot collides with an enemy, the enemy is destroyed.

 a. For this rule, each part of the centipede is considered a separate enemy.

 b. *Centipede* doesn't have any enemies that require multiple hits (other than mushrooms, but they're more scenery than an enemy). If I were creating a boss level for *Centipede*, I'd probably

start with something like how mushrooms are destroyed. Or just a multi-object entity where each part is destroyed separately, like centipedes are.

10. *Centipede*s create mushrooms when destroyed.

 a. The semi-sequel to *Centipede* (*Millipede*) adds bombs that create a dangerous cloud when shot. So, the enemy is destroyed but replaced with something new. This could be used for lots of interesting effects. Replace the enemy with other threats, or beneficial things, or things that alter the behavior or traits of other enemies. Lots of potential design space there.

11. *Centipede*s split when a body segment is destroyed, creating a new head.

 a. This is an important feature that sets the tone for the rest of the game, so I wouldn't remove it entirely.

 b. Having some segments that treat this rule differently would be interesting. Maybe hitting certain body parts increases or reduces the size of the resulting centipede, encouraging players to attack certain areas. Centipedes could vary based on the components that make up their body.

 c. Or hitting certain parts of the centipede causes different behaviors for the new centipedes. Destroy an abdomen and the new centipede is stunned for a second. Destroy the nervous system and the new centipede head moves straight down.

12. When the shot collides with a mushroom, 1/4 of the mushroom is destroyed.

 a. I'm confident that when setting up the original *Centipede*, they tried out different numbers here and settled on four hits being the right pacing. This is the sort of thing that prototypes are good at determining and setting this is important because it determines the feel of the rest of the game.

 b. Enemy design has a lot of great variety, but there are only two types of mushrooms in the game, and from a Gardening perspective they behave the same. It'd be interesting to have some

objects that clutter the space but behave differently. Bubbles that take one shot to destroy and don't remove the shot when hit. Rocks that can't be removed. Boulders that roll when hit. This has a lot of potential to add variety.

13. When the shot reaches the edge of the screen, the shot is removed.

 a. This is pretty important, given that the player only gets one shot.

 b. The shot could bounce instead of just stopping immediately. There would need to be some limits so it doesn't just keep going forever, but games like *Arkanoid* play in this space to good effect.

As a game designer, the rules of your game are up to you. As you can see, some of these rules are critical and dangerous to adjust. Some are only loosely held together and easy to poke at to get different effects. This is one of the key roles of the game designer – to identify which rules can and should change during development of a game.

Even a simple game like *Centipede* has lots of choices for a game designer. Which of these changes are the right changes? It really depends on what you're trying to do. Identifying places where things can change is easy. The hard part is identifying the right changes. And to do that, you need to know what your goals are. Not the player goals like we've been talking about, but rather the development goals. What type of game do you want to make? What is the feel and mood you're looking for? Or if you're looking at a more specific change, what problem in the game are you trying to fix?

Once you've gotten out of the initial brainstorming phase of a game, you shouldn't make any change without a specific goal in mind. Change is scary. As we'll talk about, changing anything in the game can have lots of unintended consequences. Change for change's sake is a common mistake that makes game development harder and makes games take forever to finish. Don't be afraid to make changes, but understand that every change has a cost, and the benefit needs to outweigh that cost.

While any change matters, the cost gets higher the later you are in development. Early in a game's lifecycle, trying out new ideas just because they sound cool can be a good idea. But once the game is halfway done and all the content is designed, making a change to the core game loop is going to be costly and likely requires reworking large chunks of the game. Only do that if absolutely necessary.

Progression

Centipede has a simple progression system. Each level starts when one or more centipedes appear at the top of the screen and ends when there are no centipedes on the board. The board is not cleared between levels, which means that as mushrooms start to fill the board, they can become a long-term problem. *Centipede*s appear in a repeating pattern, with increasing difficulty coming from the arrangement of starting centipedes, increases in the speed of the game, the presence of more advanced enemies, and the tendency for the board to fill up with mushrooms.

CENTIPEDE – NON-GAMEPLAY DISSECTION

Senses

Centipede has a lot going on for only one screen. This is common in old arcade games. In order to compete in a crowded arcade, games were forced to be loud and garish. If you don't get noticed, you don't get quarters.

Centipede has a distinct visual style for the era, with more greens and pastels in its color palette than the stark neon primary colors of *Pac-Man* (1980) or the even starker whites of *Asteroids* (1979). This still fits the need to stand out and be noticed but demonstrates how the arcade market was starting to mature and expand a bit. If everyone is loud and garish, you need to do more than just that to get those quarters.

The black screen and clear lines of early arcade games were mostly a technical restriction, but one that led to very clear visual communication. It's easy to tell what is important when the restrictions mean only the important things are drawn. And it's easy to see boundaries and collisions when everything is drawn with clear lines against a black background.

Even with the technical limitations of the times, *Centipede* still uses sound and visual effects to emphasize when an enemy is defeated. A little particle explosion persists in that location for a few frames. Similar to *Shovel Knight*, it's important for players to know the consequences of their actions.

History

Centipede is a clear example of the golden age of arcade games. *Centipede* came out in 1981. Arcade games started in 1972 with Pong but really took off with Space Invaders in 1978. If you weren't around in those days, it's hard to overstate how big arcade games were. This was the first time many people

around the world saw computers controlling games. Video game arcades were huge successes and the media noticed. This boom only lasted a few years – by the early 1980s home consoles started to take some of the edge off the arcade, especially dedicated arcades with dozens or hundreds of games.

Centipede was not the first big arcade game and not the last. But it was big.

An interesting note about *Centipede* is that it is one of the few classic arcade games coded by a woman. Dona Bailey was the only female programmer at Atari and was a key member of the four-person team that made *Centipede*. In interviews, Bailey and others describe an intent to make *Centipede* more appealing to women, focusing on natural themes and less human on human violence. It worked – *Centipede* had a large female audience, especially compared to other games of the time (Guide, C., & Gary, K. M. (1982)).

Money

Centipede made money through quarters. Technically the game developer made money by selling arcade machines, but the demand for those machines was entirely driven by how many quarters went into each, so it's fair to say that quarters are what matter. And you can see the importance of quarters throughout the arcade era. Monetization isn't a new thing that changes how games are made; every game has to consider how it makes money in the core design.

- Arcade games need to attract attention quickly in a crowded market, so they are loud and bright.

- The player spends money at the start of the game, and no new quarters go in until the player's session ends. So, sessions try to be short – maybe a couple of minutes. After a minute or so, the game is actively trying to get rid of the player, overwhelming them with increasingly deadly waves of enemies. Arcade games are aggressive and difficult, and once they become difficult, they don't give you a break. *Centipede*'s progression system is built around this rapid difficulty rise. It's possible to stick around for a while, but only players with a lot of talent and a lot of time investment can last more than a few minutes.

- Arcade games are highly skill based. If you're good, you can last much longer than an unskilled player. This might seem to violate

principle #1, but the only way to get good is to play for a long time, so rewarding skilled players creates a longer-term motivation for the player to keep spending quarters. If the game is really hard but I have no sense that I can master it, why play? If there's another player who shows me what greatness looks like, I am driven to emulate them (by spending quarters).

- High Score lists are a great example of a game feature that was added to support monetization. Watching a great player makes me want to get better. Typing in my name codifies that goal into something real.

- Story doesn't really matter. Players are only around for a few minutes each, so it's more about the thrill than guiding players through a deep narrative.

Narrative and Emotion

Centipede is not a game that oozes with story. It's not even very clear what the player's avatar is meant to represent. Official marketing materials refer to it as a "Bug Blaster", but even then, I'm not sure if it's a bug or a spaceship or what. The original version of the game contained no explanatory text or cut scenes. Removing bugs is a fairly intuitive action that resonates well for many people, so no additional context was provided. Later games have added some narrative layers, but when the original arcade cabinet came out there was none. Which was pretty common for the time.

Emotionally the game generally has the strong visceral emotions of most action games. The game can be frustrating, both in a positive way when the player reaches their skill limit and in a negative way when a spider spawns in a position that doesn't give the player time to react. The game is one of the first to start to explore feelings of nurturing or shaping and building, but it's a bit overwhelmed by the rapid action going on and hard to really dig into for most players. And calling this a nurturing game is a bit of a stretch. So, there's more emotional potential here than some competing games, but it's mostly untapped.

Meaning

What is *Centipede* about? What does it say about the world? How is a player changed by the experience?

A player could see this game as saying that the natural world is the enemy and must be controlled. Bugs are threats. Mushrooms get in the way.

A player could see this game as a metaphor for the frantic nature of the time it was created. Many arcade games require constant motion and constant work to delay an inevitable decline. The 1980s were a time when people were struggling with the demands of work and the drive for corporate success. Not that those pressures don't exist today, but they were discussed in many types of media and art at the time, and video games are one expression of that drive in society.

To me, *Centipede* is really about the power of systems and dynamics. The game has rules, but like a natural system the overall experience is much greater than those rules by themselves. Mushrooms and centipedes and spiders combine to create a unique and compelling experience that is more than the sum of its parts. I think it's not surprising that a game about nature is one that expresses these system ideas very clearly. I have a degree in Biology, and only later realized that my love of games and love of biology are both expressions of my love of systems.

DYNAMICS

There's a new word I want to introduce that is very useful when dissecting games. When two or more rules combine to create an outcome not directly stated by those rules, that is a dynamic.

We've already been talking about the dynamics of *Centipede*. The idea that a player might want to remove mushrooms is not directly stated in the rules of the game of *Centipede*. But it's a logical outcome of a series of other rules:

- RULE: *Centipedes* move down and turn around when they collide with a mushroom.
 - DYNAMIC: This means that mushrooms can accelerate the centipede's descent.
- RULE: The ship can only move around the bottom of the screen.
- RULE: The only way centipedes harm the ship is by colliding with it.
 - DYNAMIC: These two together mean that the centipede is only a threat when it's near the bottom of the screen.

- DYNAMIC: Since the centipede is only a threat near the bottom, and mushrooms make the centipede reach the bottom faster, it makes sense that the player would want to remove them.
- This dynamic is complicated by other rules:
 - RULE: Fleas drop more mushrooms on the screen.
 - RULE: Centipede segments turn into mushrooms when they die.
 - RULE: Fleas spawn more often if there are fewer mushrooms.
- And further complicated by other dynamics:
 - Fleas cause rapid descent of centipedes through a set of dynamics:
 - DYNAMIC: There are certain patterns of mushrooms that cause very rapid descent just due to the previously stated rules. For example, if you have two columns of mushrooms near each other, the centipede will bounce back and forth quickly.
 - DYNAMIC: Fleas tend to make mushrooms in columns, which encourages this pattern.
 - DYNAMIC: This encourages players to shoot fleas as quickly as possible so they don't make a long column of mushrooms.

These examples show how individual rules can lead to more complex results. Many of the example dynamics above are strategies – sets of actions that the player is encouraged to take based on a combination of rules. And these are very important to understand when you're designing games – you want to make sure that the strategies you're encouraging the player to use are fun and create the type of gameplay that you're looking for. But strategies are not the only type of dynamics. Any combination of rules that leads to a new result counts.

- When a game is described as "elegant", that usually means that it takes a relatively small set of rules and builds a lot of interesting dynamics around those rules. The rules of *Go* are (basically) "On your turn, place a stone of your color on a 19x19 grid. If a group of stones is surrounded, it is removed. Whoever has the most stones wins". But this foundation leads to a lot of other dynamics.

- You can build enemy AI out of very simple rules that result in a behavior that feels complex. For example, if you want a group of AI-controlled characters to move as a group, you can get very compelling flocking behavior out of a few simple pointers that each entity interprets on its own. Flocking is a dynamic.

- The combat in *Halo* has a certain feel. It's fast-paced but with an interesting back and forth based on weapon types and distances. These are not written in the rules or the code but are a consequence of the code. The "feel" of the game is another important type of dynamic.

Talking about dynamics is a way to understand how different rules fit together to make something bigger. It's a way to read between the lines and see the underlying systems that are built out of the individual rules.

Dynamics are important because the dynamic is often the target that the game designer is trying to hit. Game designers don't strive to make a game with 0.7 seconds between sniper rifle shots (see the 2010 GDC talk by Jaime Griesemer "Design in Detail: Changing the Time Between Shots for the Sniper Rifle from 0.5 to 0.7 seconds for Halo 3"), they strive to make combat feel fast-paced with an interesting back and forth, combat that feels different every time because of different abilities that combine to create new effects or to make a game that evokes a sense of wonder and exploration. The game designer's goal (separate from the player's goal) is to make those specific dynamics happen. But the game designer can't just code in "make the combat fast-paced" or "wonder". They have to work with individual rules and content values that combine to create the desired effect. Understanding dynamics in games is a key step toward understanding games.

SIMPLE AI RULES

I worked on a game called *Hunter: the Reckoning* (2002), where the player fights zombies. Early on, we built a robust state-based AI system with lots of controls and inputs to determine how the zombies move and attack. Once we started testing it and playing with it, we ended up only using a few of those commands in the final game.

In a game about killing hordes of zombies, the enemies don't need to do much other than "move toward the player's character" and "attack when you're close enough". Since the enemies are only supposed to be

on the screen for a few seconds each, anything else was not just unnecessary but often just confusing. Zombies turning around because another goal caught their eye didn't make sense to the player. Our zombies did not need robust internal narratives; they needed to attack once or twice and then die.

The complex AI system was used in a few places. Some of the later enemies had more complex behaviors, but they were still very simple things like "use this second attack every 3 seconds" or "the first time you move toward the player, do this special charge attack". Bosses were the only encounters that used the full AI, with multiple stages and ranges of attack. But even the bosses were simpler than we had initially anticipated.

Dynamics in *Centipede*

So this gives us another important tool when we're trying to understand a game like *Centipede*. Understanding individual rules is important, but it's also important to understand when rules combine to become greater together.

We already discussed mushroom gardening.

And we discussed how the "one shot on screen at a time" rule leads to some interesting consequences: players can rapid-fire on close-up targets such as mushrooms, which makes mushroom removal more viable and fun. If mushrooms behaved differently, or if shots behaved differently, this would be different both in its strategic consequences and also in the visceral feel of the game.

You can combine rules to create interesting, unexpected dynamics. I can logically prove "The spider is your friend":

1. RULE: The player can only move in a certain area at the bottom of the screen.

2. RULE: The spider only moves in that same space.

3. RULE: The spider destroys mushrooms when it touches one.

4. RULE: Mushrooms block the player's movement. (Which spawns a DYNAMIC: "Mushrooms can be annoying and make you die when they get in your way".)

Thus,

5. DYNAMIC: Sometimes you might want to let the spider live for a while before you destroy it.

Or "Rapidly descending centipedes are your friend":

1. DYNAMIC: A combination of mushroom patterns and centipede logic means the centipede can get into a state where it rapidly descends directly down. This is usually a problem as the player doesn't want the centipede down low.

2. RULE: The player can only shoot directly up.

3. DYNAMIC: The player can fire rapidly in some cases due to the rules around how shots are generated.

4. DYNAMIC: When the centipede is descending downward, if the player is in the right position, the player can rapid fire and destroy an entire centipede while it descends.

Thus,

5. DYNAMIC: Sometimes it's good to have columns of mushrooms that send the centipede rapidly down.

A good game will have many dynamics, and some may be surprisingly counter-intuitive.

Dynamics: Phases

Many games have "phases" where the player needs to adapt to changes in the game world. In some games, this is direct and obvious – *Mario Party* (1998) tells you when you're starting a new mini-game. But even games without big signposts have different phases that players recognize without being told. These are dynamics that come about as a result of all the rules and content in the game. For example, in *Centipede* there are two main phases:

1. Descent: The centipede has appeared and is working its way down the board. The player is encouraged to destroy the centipede quickly from a distance to avoid entering the more dangerous other mode.

2. Crowded: The centipede or centipedes are in the player's movement space, making it crowded and thus endangering the player.

Then there are meta-phases between those two:

1. Between: There is a short pause between killing the last centipede and the appearance of another. This gives the player a moment to do some quick Gardening.

2. Top Heavy: Eventually after many stages, the top of the screen will usually be very densely packed with mushrooms. This will cause new centipedes to immediately race down to the bottom. There is still a Descent phase, which still gives the player a viable opportunity to destroy the *Centipede*, due to the "rapidly descending centipedes are your friend" dynamic discussed above. But the window to shoot them down gets shorter and shorter as the centipede speeds up.

These stages aren't built into the rules or hard-coded, but they're natural progressions from the rules and code. That's another example of dynamics.

SYSTEMS

Dynamics are an example of how games are built as systems.

A system is any set of things where the relationships between the things are as important as the things themselves.

- The world economy is a big system where the products made in one area affect the products and prices in other areas.

- The natural world is a system where species get food in various ways and the populations of one species affect the populations of other species nearby.

- Humans (and all living beings) are made up of many organs which have clear functions but depend on the functioning of other organs.

- A family is a system where the actions and moods of one family member can have a huge effect on the actions and moods of the others.

Systems are everywhere, and understanding systems is key to understanding everything.

The study of systems is a fairly new and growing field. All systems have certain qualities and relationships that are shared, and understanding

these meta-rules for how systems work can help in understanding any system. I recommend books like "Thinking in Systems" (Donella H Meadows, 2008) for any game designer interested in better understanding how games work.

Centipede Systems

So, if games are systems, what are the systems of *Centipede*?

This can be a difficult question to answer, and it really depends on what you're looking for. The needs of your dissection determine where you want to look for systems and how detailed you want to look. If you're just trying to understand the overall game, a high-level systems analysis will do. If your game draws inspiration from one particular feature of another game, your analysis might have a different focus. You can take any of the high-level systems and break them down into multiple sub-systems and do an analysis at that level. It works better with bigger games where there is more going on in each system, but the principle applies in either case. Systems are not a universal truth, they're a lens you can use to look at the things that matter to you.

High-Level Systems

At the top level, you can break down most games into a few high-level systems. These usually correspond to the things we've been talking about already:

1. Actions

 a. Movement Systems

 i. How does the player's avatar move?

 ii. What are the controls the player uses to influence movement?

 iii. Once the avatar has moved based on player input, how does the physics engine move the avatar? If you want to call physics a separate system, you can. Usually not worth it on a simple game like *Centipede*, but it can be done.

 b. Attack System

 i. See the detailed bullet list rules above. That's the majority of the attack system.

102 ■ Anatomy of Game Design

2. Goals

 a. Score System

 i. How does the player earn points?

 ii. How are points displayed?

 b. Combat System

 i. For a big game like *Halo* or *God of War*, I would consider the attack system to be how the player creates attacks and how they're presented up until the moment that the attack scores a hit, and the combat system to be all the other things about what happens when something is hit, and also how enemies behave in combat.

 ii. In the case of *Centipede*, the combat system and the attack system are simple enough that they could be considered to be just one system. The attack rules list above already includes a number of combat rules that aren't technically about how the player attacks.

3. Challenge

 a. Enemies

 i. Each enemy has different rules and AI behaviors.

 ii. This includes how they appear, how they move, how they interact with things they touch when they move, how they die, and so on.

 iii. As discussed, these relatively simple rules lead to interesting dynamics, especially when enemies interact with other qualities of the game such as mushrooms.

 iv. Some qualities of enemy are better described as content rather than part of the system, but we'll talk about that in a later chapter. For now, we're just grouping everything here.

 b. Mushrooms

 i. Mushrooms have their own rules for how they work. If you want to call that a system, you can. If you want to consider

that part of the level, you can. It just depends on the level of
fidelity you need for the dissection you're currently doing.

 c. Levels

 i. There are rules for the generation of levels and the progression of levels as time goes on.

Note that some of the lines between things are fuzzy. This is fine. If you
want to say enemy behavior is entirely contained in the AI System, great.
If you'd rather group Enemy movement and Enemy attacks as part of the
Enemy AI System, great. If you want to throw in all the other qualities
and rules about enemies and just do one big Enemy System, that works,
too. It just depends on what's important to you and your analysis. The
underlying rules don't change. Systems are just ways to group those rules
together to make them easier to talk about and compare. Which is why
it's hard to get people to agree on what the systems of any particular game
actually are.

System Dynamics

We can describe pretty much everything happening in *Centipede* with
five to seven high-level systems. If we wrote this out, we could describe
the entire game in maybe ten pages – all the rules for how things appear,
move, combine, and end. Most modern games are bigger and more complicated than this, especially once you include all the content, but the principles are the same.

 The fun thing about systems is that those ten pages would be just the
start to a true understanding of the game. The real depth of the game
comes from how those rules – and those systems – interact. Combining
two or more rules together will often lead to one or more dynamics, each
of which creates new gameplay. Each system has complexity within it, but
the true complexity comes when they are combined.

- (Mushroom System + itself) The rules for how mushrooms come and
 go create the gardening goal that we discussed above.

- (Mushroom System + Attack System) The way shots work combines
 nicely with the way mushrooms work, encouraging players to blast
 nearby ones but making far-away ones a challenge.

- (Movement System + Enemy System) The trackball-based movement combines nicely with the spiders to keep players moving around at all times, creating an interesting frantic mood to the game.

- (Point System + Enemy System) Spiders giving you more points when you're close to them encourages risk-taking.

Understanding the game requires an understanding of all of these intersections and consequences. A full and complete understanding of every possible (rule + rule) combination would be huge. Even for a simple game like *Centipede*, that would be impossible to fully map out and document. That's why it's important to prioritize. A good game designer can play a game for a bit and map out the key dynamics and systems that are important to understand. They're not going to map out every little thing, just the top priorities for their needs.

- One possible need is Industry Analysis: If you're just trying to understand the game and why it's a success, identify the top five to ten systems and any unique dynamics that have a big effect on how this game feels.

- One possible need is System Analysis: If you're looking at a game because it has a system similar to one you want to make, then you need to dig deeper into that particular system and map out more of those dynamics. Other systems only matter in the way they relate to this system.

- One possible need is Genre Analysis: If you're looking at a game to better understand how a genre works, then focus on how this game interacts with standards of the genre. For most genres, the systems are going to be the same game to game, but there may be an added one in some games, and each game will have its own twists on specific dynamics to create a different feel.

System Visualization

It can be useful to create a visual map of the systems of a game.

Honestly, I don't normally do this very often. I map things in my head way more than I do on paper. But partially that's because I've been doing this for a long time. Early in my career, I did draw things out and draw

lines to connect them and think things through in that way. These sorts of diagrams can be useful to communicate a game design to others, but personally I find that doesn't often work. As discussed, a dissection or system outline is very personal to the perspective of its creator. Other people aren't necessarily going to have the same interests or goals in their dissections, so diagrams may fall flat. Where they are very useful is in thinking these things through. Visualizing the system can help you as a game designer identifies systems and how they work in ways that text or mental imagery cannot. Find the diagram that works for you and use it when you really need to deeply understand.

Venn diagrams can be a nice way to think about how systems interact, as seen in Figure 4.8.

The first, and maybe hardest part, is coming up with your boxes. Identifying the systems that matter for your current analysis requires you to go through the whole process described in this chapter to tease out that information.

Once you have your boxes, start to think about the most important connections. Put those boxes near each other and start to overlap them to show where they touch. Label those intersections to clarify what happens there. Keep doing this until you get to some interactions you might not have considered already. What happens when mushrooms touch

Centipede as a Venn Diagram

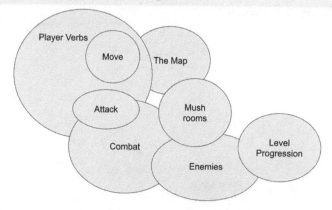

FIGURE 4.8 *Centipede* represented as a Venn diagram.

fleas? I bet we could add something interesting there. This was a key part of the design process for *Where's My Water?* We knew that every new feature had to have an interesting interaction with every other feature, so we would brainstorm different ways each intersection could play out in the game.

One weakness of a standard Venn diagram is that representing one on paper only allows for two dimensions. Once you've placed two boxes near each other, it's hard to squeeze in too many more near that intersection. A true deep analysis would consider how every box touches every other box (and combinations of more than two). But with only two dimensions, this becomes challenging once you get past three boxes. Make sure you're paying attention to this in your diagram. Shuffle things up and try multiple diagrams with multiple perspectives. Or use the diagram to spark ideas, the document every combo somewhere else.

Flowcharts give you another way to think about the relationship between systems, as seen in Figure 4.9. Instead of intersections, here we have arrows showing things flowing from one system to another. If you do use flowcharts like this, make sure you apply your standards consistently. If bubbles are nouns and lines are verbs, stick with that throughout.

This is a great way to map out certain types of systems, such as your economy. Use multiple arrows, where each arrow represents one type of resource. Show where resources convert into other resources. Throw in some numbers if you're comfortable doing that.

Centipede as a Flowchart

FIGURE 4.9 *Centipede* represented as a Flowchart.

Flowcharts can also be used to map other types of directional relationships. Show where players are putting their time or attention. Show the flow of difficulty and comprehension over time. Systems are about relationships, and these relationships can come in many different forms. Make the diagram adapt to your needs. Just be careful to be consistent in how you use each element in the diagram. In the *Centipede* flowchart above, circles represent objects in the game world and arrows represent actions they can take on each other. That's just one way to turn *Centipede* into a flowchart.

It can be helpful to think about your video game as if it was a board game, as seen in Figure 4.10. If you had to write out the rules as text, how would you phrase them? How would you describe this system to a new player? What diagrams and examples would help people see how this is meant to work?

Writing out rules as text is a useful first step toward creating the design documentation for your video game. But the diagram part is often even more useful. A good board game rulebook isn't just text – there are a lot of diagrams and images and examples to show how things should work, and handle some of the more confusing cases. This gets you thinking about your systems from more of a player perspective, which is key. Systems can get very abstract and conceptual, so bringing them back home to a practical experience can really help. Understanding the system doesn't matter if you don't understand how it's going to influence actual players.

Centipede as a Rulebook

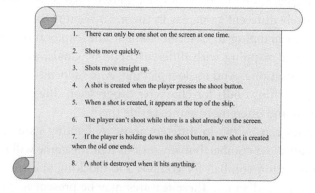

1. There can only be one shot on the screen at one time.

2. Shots move quickly.

3. Shots move straight up.

4. A shot is created when the player presses the shoot button.

5. When a shot is created, it appears at the top of the ship.

6. The player can't shoot while there is a shot already on the screen.

7. If the player is holding down the shoot button, a new shot is created when the old one ends.

8. A shot is destroyed when it hits anything.

FIGURE 4.10 *Centipede* represented as a Rulebook.

Dissecting Systems

How do you turn a game into a set of rules, dynamics, and systems?

First, play the game. There's no substitute for experiencing the game on your own in your own head. Watching other people play or reading other people's analysis can provide insights, but all dissection is predicated on you having a mental model of the game that includes the player experience – what draws the player's attention, what strategies seem useful, and how it all feels. That's hard to replicate without actually playing the game yourself first. Ideally, you should play in the same circumstances as your players will, but that's usually impossible. You're never going to be a suburban mom who finally got the kid to sleep and is sitting down for the first time all day, or whatever your target audience is. Unless you actually are a suburban mom who finally got the kid to sleep. In which case, you're a hero and I have so much respect for you. Getting kids to sleep is hard.

Once you've played the game, start to break out what you noticed. What features or game design decisions stood out to you? What made this game interesting and different compared to others you've played? As you start to break out those key features, you can start to identify which are rules, which are dynamics, and which are systems (and which are content, which we'll discuss in a future chapter).

If you're familiar with the genre and previous similar games, you probably have at least a vague idea of what the key systems are. If not, start to generate that high-level overview. As shown above, this can normally flow from our definition – Actions, Goals, and Challenges. When you identify what those are, that's also where your systems are going to be.

Bigger games will take a little more work to do even a high-level analysis. Many big games will have multiple different phases or states that can include entirely different gameplay in them. So, a game like *Oblivion* will have a system mapping to describe combat and exploration, but also a whole different mapping with different Actions, Goals, and Challenges just for conversations. And for lockpicking. And (depending on how you want to break things out) for character progression. Bigger games have more systems and often more games inside them.

And games can be big in different ways. A fighting game like *Street Fighter 2* is all about combat, but any serious fighting game will have many sub-systems within combat, for combos and blocking and hit boxes and move chaining, and so on. These features may be present in games with simpler combat, but in a fighting game they are a key part of the experience

and are more likely to matter. As mentioned, any dissection depends on the perspective of the dissector.

Mapping Non-Existent Systems

So, you've read the past few pages and now you're an expert at dissecting system. So, you go to start working on a new game idea, and the first step is to play the game. Wait a minute! The game doesn't exist yet, so how can you build a dissection off of playing it? That's crazy talk.

Dissecting games that don't exist is a critical skill for a game designer. And it can be hard.

The best way to do this is to play the theoretical game in your head. When you're thinking about a new game concept, there's something that draws you to it. There's something that you can picture that makes it compelling. Take that picture and expand on it. Close your eyes and think of that amazing new moment, then keep playing past that. Add on the rest of the rules and systems and features that are needed to make the game a complete experience. Map that like you would a real game.

Once you've got something to start with, you can reverse engineer the systems of the game.

- If your picture of the game is a single moment, you probably know something about the actions of the game, and the moment-to-moment goals and challenges. Think about how those moments can be expanded into a full level, and many levels, and a full story, and a full game. Shamelessly steal progression systems from other games. The moment is what makes this game shine, so it's fine if the long-term systems are ones people have seen before.

- If your picture is a story or character or mood, think about how that can be expressed through player actions. Build a core game loop that strengthens the thing that inspires you. If the thing that inspires you isn't a player interaction, maybe consider if it would be better to turn it into a book or movie or something else. The inspiration for a game can come from anywhere, but if interaction isn't at the heart, it might be better served elsewhere.

- If your picture is something outside of the core game loop – a progression system or deep strategy or new play pattern – then map out that feature but quickly get back to the core loop. Everything

depends on the actions and goals and challenges the player experiences over and over. If your idea for a great new progression system doesn't have fun core gameplay, you're in trouble. But in a case like this, you might look for a popular genre where your core loop is similar to previous games, and then add your exciting new twist. The first games to let the player manipulate time didn't also come up with completely new gameplay to surround it – they were first-person shooters or side-scrolling adventure games or other classic core loops with time twisting as the exciting new part.

This is part of why playing a lot of games is important for game designers. You need to be able to identify the systems and rules and dynamics of other games so you can identify them in yours. And then fill in the rest of your game with things that are proven to work. If you understand how rules combine into dynamics and systems, you'll be able to start to predict how your exciting new bits will combine with the classic old bits. This is a big part of the work of a game designer. Predicting how rules will interact is the value that game designers provide to game teams. No designer can do that perfectly. But a good designer can anticipate problems and design optimal solutions to reduce the workload on the rest of the team. Knowing how to design enemies and levels to fit your game's mix of new and old reduces the amount of trial-and-error iteration and puts the team on a fast track to success, or at least improves the odds by skipping a few of the early rough iterations.

Systems: To Be Continued

Systems are very important, and I want to keep talking about them. But I also want to dissect a lot of games in this book. So, we'll come back to systems and talk about them in more detail in a later chapter.

Settlers of Catan / Uncertainty

CATAN – GAMEPLAY DISSECTION

Settlers of Catan (also known as just *Catan*) is a great game.

Catan is a board game based on building settlements and managing resources on a randomly generated island (Figure 5.1). *Catan* is one of the best-selling board games of all times, selling over 25 million copies since its release in 1995. Some credit *Catan* with inspiring the golden age of board games that we are currently experiencing – many of the successful games that followed it have similar qualities. I worked at Mayfair Games in 1995 and 1996 and helped Jay Tummelson (and many others) bring *Catan* to America, and I wrote the first US rule book.

Verbs

This is the first board game we're discussing, but the fundamentals of dissection are the same. All games are about interactivity, including board games, so we start with the verbs that define that interactivity.

The key verb in *Catan* is "Build". The player builds settlements and roads that provide resources and score victory points. "Upgrade" is a closely related verb, as upgrading a settlement to a city is just building with some restrictions and costs. And buying cards is just building with variable outcomes. The heart of *Catan* is turning resource cards into stuff that gets the player more resource cards.

DOI: 10.1201/9781003346586-5

FIGURE 5.1 *Catan* photo, by the author.

"Trade" is another key verb in *Catan*. Players aren't ever required to trade, but success in the game comes largely from identifying the correct resources and trading with other players (and the ports) to acquire those resources. This could also be framed as "Negotiate" or "Beg" or some other phrasing, but it's still about trading intelligently.

"Gather" is almost a verb in *Catan*, but it's not exactly what we're looking for here. The player has no action that they can regularly take to directly gain resources. Building settlements and cities increases the player's gathering power, but the actual production of resources is determined by the roll of the dice, not the player's choices. "Gather" is definitely something players do, and it's certainly a goal players have, but it's not a player-directed action like the Verbs we talk about. A first pass verb list will often include a number of goal verbs along with the action verbs.

There are a few verbs centered around the Robber. Triggering the robber is not a player action unless they're using a card. But once the robber starts, the player has to "Place the Robber" and "Steal" with relevant choices as part of that. And some players may have to "Discard" if they have too many cards. These are all legitimate meaningful verbs because the player has to make a decision with consequences. But for the purposes of most types of dissection, these can be grouped as "Robber" verbs. They only happen occasionally during a game, so they're not the core gameplay loop.

Similarly, "Play Card" is a verb with lots of different specific sub-verbs, but we can group them together for most analyses.

Things that are not verbs in *Catan*:

- "Roll" – This is the interface for gathering, not the action itself. In *Centipede*, we don't call "Press Button" a verb, so this doesn't count either.

- "Settle" – There's no actual settling occurring, other than how "Build" is related to this word. If you want to play a game with its action verbs in the title, try *Minecraft*.

Things that are verbs in *Catan* but aren't active parts of the core gameplay loop:

- "Assess" – Knowing what spots matter and will provide the best return is key to success in *Catan*. Many games are decided by thoughtful initial placement of villages.

- "Compute" – Knowing the probabilities and how the math works out helps with assessment, but it isn't an action the player does, it's contained within Assess.

- "Defeat" and "Win" and "Score Points" – All verbs that players may do, but they're tied to achieving goals rather than specific actions players take, so they're a different category of verbs.

- "Gather", as mentioned, is a goal verb but not an action verb.

Goals

The goal in *Catan* is technically to acquire victory points.

But in order to do this, the player needs to build an empire. Gaining victory points is done by building. And building is done by gathering resources.

The gameplay goals of *Catan* align nicely with what the player naturally wants to do, which is important in any game. Building little empires is fun. Gaining more resources is fun. When the action and the goal don't flow naturally together, you can get players who think they're doing well, but then realize too late that they're not actually doing the right thing. But in *Catan*, everyone wants to build more things, so rewarding that impulse is good.

Building has multiple goals within that create a nice set of garlic layers (Figure 5.2). Each turn, even other players' turns, provides an opportunity to gather resources. Which is a clever trick to get people to pay attention throughout the game, also seen in games like *Monopoly*. Getting the right resources leads to the opportunity to build. Depending on what the player wants to build, they may need to build other things first. Can't have a city without a village, and (usually) can't have a village without new roads. There's always something new the player wants to build or gather to reach the long-term goal of points.

The pressure between player impulse and game goals can be seen with the Longest Road card. Players like building the biggest and best of things, and this card is a nice way to reward that. But I've been in plenty of game sessions where one or more players focus on the Longest Road card to the detriment of their overall victory (I'd like to say hi to my kids here). This is especially true when players get competitive, trying to top each other

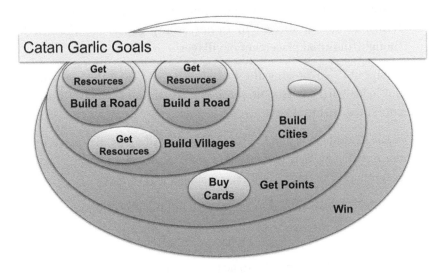

FIGURE 5.2 *Catan* goals as garlic layers.

with increasingly convoluted roads. While there's a reasonable argument that the game is asking you to exercise your strategic judgment to avoid this problem, it can lead to feel-bad situations where players who focus on roads are disappointed at the end of the game, which is not desirable for a game designer. If the player thinks their actions are going to lead to victory, the game should find a way to make that happen.

Challenges

So, the player is trying to build an empire to gain victory points.

What makes this challenging?

There are no enemies. There are no pits to jump over or bugs attacking you. There's barely any conflict between players. So, challenge and uncertainty in *Catan* (and many board games) come from a different place.

The primary barrier to success is the economy. The player can't build whatever they want – they have to build based on various restrictions, including the resources needed for each build. The rules tell the player that they can only do the fun thing in certain ways – you can only build here, not there; you can't build until you have enough of this; you need this before you can build that. These rules tell the player when resources are created, and this production is highly variable based on die rolls. The player has to be creative to find ways to get the most production possible out of these limited resources and apply their resources to the best methods to gain more in the future. Limited resources and restricted building rules are the true enemy in a game like *Catan*.

There are other subtler limitations on the resources in the game. There are only so many places to build on the island, and many of them are terrible for resource production. You can't build close to other villages. You have a limited number of each building object. Most of the rules in the game are restrictions put on the player's ability to build whatever they want whenever they want. Limits come in different forms.

The other major barrier to success is the true enemy in many games – other people. Navigating resources only gets you so far. The player needs to manage other players both in the standard ways – long-term strategy, planning around future actions, etc. – and in personal and persuasive ways. Convincing everyone else that you're not a threat and it's OK to trade with you (again, I'd like to emphasize how much I love my kids) can be as important to victory as careful resource planning.

Core Loop

This creates a simple diagram to understand how the core verbs and the non-verb gathering action create the core loop of the game. The player gains resources that they can spend to increase their ability to gain resources in the future. These actions also increase the player's victory points, and eventually that value reaches a critical mass and that player wins.

This is a common and successful loop for lots of resource- and economy-based games (Figure 5.3). It's essentially a variant of the power fantasy seen in the character progression systems of many video games, but in economic terms. The player keeps getting bigger and exerting more control over the world around them and then invests that power to gain more power in the future. In a combat-driven game like *Shovel Knight*, the player battles enemies to get gold, then invests gold in RPG stat upgrades so they can get more gold in the future. In *Catan*, players gather resources to build villages to gather more resources in the future.

Note that all of the uncertainty is on the gathering side. As with many economic games (*SimCity* (1989), *Agricola* (2007), *Civilization* (1991), *Pet Simulator* (2018), *The Game of Life* (1960), *Roller Coaster Tycoon* (1999)), the challenge for the player is coming up with the resources. A player with resources has clear verbs with clear focus. There is intellectual challenge in picking the right building choices, but no uncertainty in knowing what will happen when a choice is made. If the player who wanted to build had to spend their resource cards and then had to roll to see if the village was successfully built, that would be a very frustrating failure. It's better to provide variable rewards than variable outcomes.

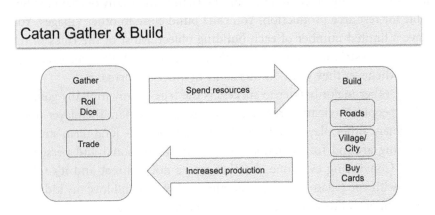

FIGURE 5.3 *Catan* Gather and Build flow.

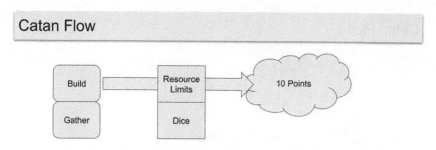

FIGURE 5.4 *Catan* flow: Simple diagram of Actions, Challenges, and Goals for *Catan*.

Every game can be mapped to verbs leading to a goal with challenges in the way (Figure 5.4). This simple flow diagram can be expanded (Figure 5.5) to show how a *Catan* player turns that core economic engine into victory. The player has to Gather in order to Build, so there's a simple dependency there. And within Build, there are specific player actions that also have dependencies. The player can't build cities without villages to upgrade and can't build villages near each other, requiring roads. This mandates a standard flow that makes building interesting.

And from there, most build actions feed back into both the gathering system and the point system (Figure 5.6). Villages and Cities are worth points, moving the player directly toward victory. But they also give the player new ways to generate resources or to generate more resources. Similarly, cards have a random chance of either providing direct victory points or providing economic benefits. Roads are the only building action

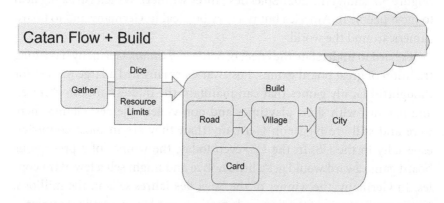

FIGURE 5.5 *Catan* expanded: Same diagram with Gather before Build and more options inside Build.

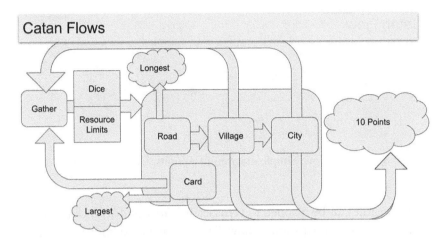

FIGURE 5.6 *Catan* ConnectedPlus: Same diagram, showing links between build actions, Gather, and Points.

that doesn't directly provide either victory points or other resources, unless the player manages to build the longest road.

CATAN – NON-GAMEPLAY DISSECTION

History

Settlers of Catan came out in 1995 in Germany, and 1996 in the US. It was an immediate success, winning the prestigious Spiel des Jahres for 1995 (Figure 5.7. shows the 2021 Spiel des Jahres winner). Which isn't a big deal to most people in America but is a very big deal in Germany and to board gamers around the world.

It's hard to understate the effect of *Settlers of Catan*. Germany has a long tradition of great board games. Post-war Germany had a large market for thoughtful family games that can maintain the interest of both children and parents, with short playtimes and non-violent themes. Games there were and still are bigger in Germany than they are in most countries, especially in the US. In the US, even today, the winner of a prestigious board game award would get a little notice and might sell a few extra copies. In Germany, the winner of the Spiel des Jahres sells in the millions. *Catan* was just one of the first such games to see big success in America.

America had a board game industry before *Catan*, but it was smaller and less inviting. There were the traditional games that were sold in toy

FIGURE 5.7 Spiel des Jahres. Note: The image is licensed under the Creative Commons Attribution-Share Alike 4.0 International license. The author is Thomas Ecke für Spiel des Jahres e.V. No changes were made.

stores and department stores – games like *Monopoly* or *The Game of Life*. And there were the hardcore gamers who played war games and *Dungeons and Dragons* (1974) and small quirky games from Steve Jackson Games or Cheapass Games. When *Catan* came out, the hobbyist game industry was going through a growth period due to the explosion of *Magic: The Gathering* a few years earlier (e.g., that's how I got a job in the games industry). There was a revitalized hardcore audience, so when *Settlers of Catan* came out and offered them a game they could play with their non-hardcore friends, everything came together. From there, *Catan* spread across the world and became a huge influence on games to come.

 Catan heralded a golden age of board games that continues today. I think it's reasonable to assume that even if *Catan* never existed, the world would still have discovered the beauty of German board games and this renaissance would have happened, but in a different form. In this fictional scenario, my money would be on Carcassone (2000), but *El Grande* (1995) or even *Manhattan* (1994) could have done it. Or just about anything by Reiner Knizia – *Tigris and Euphrates* (1997)? *Medici* (1995)? "What if" is fun. But the unique qualities of *Catan* have helped shape a board game culture that respects randomness, respects non-violent play, and has strong system game design principles at its core. Gamers owe a lot to *Catan*.

Monetization

Catan sells in a box. A rather expensive box, compared with many other games, especially the mass market toy store games of 1996. In some ways, this becomes a selling point. The game is high quality. The pieces are high quality – sturdy wood instead of flimsy plastic. The box is heavy. If you invest in this quality product, you can play it over and over again, so while it's a higher initial investment, it's a great deal in the long run. That's not to say that a higher price point makes it sell MORE copies, but at least there's a legitimate reason for the customer to consider it.

Catan also sells things beyond the box. There are expansions and video game adaptations and merchandise. You can buy T-shirts with sheep jokes on them. I take great pleasure in seeing *Catan* jokes. I made sure to include a few simple jokes in the original American rulebook to set the right mood and get people to see this as something light and fun, even if the game requires thought. I like to think it worked, and that it helped at least a little in the game's success. But the core of the business is that box.

In some ways, *Catan* set the standard for monetization in the modern board game industry. Appeal to a broad audience. Keep the game short – under an hour. Invest in production quality to make the game feel valuable. There are plenty of successful games that cater well to smaller audiences, but *Catan* showed that a broadly appealing game can make a significant amount of money over multiple decades.

Senses

Graphics mean something different for a board game compared to a video game. In a board game, it's about the look of the game and the components and the box. Board games even get an extra sense – touch. The feel of the components is a big part of the sensory experience of a board game, and people like something that feels hefty and solid and real. A good game has a good feel and mood, and the senses set the tone for that.

Visuals also help explain how to play the game – a good game should guide the player to understand everything without even touching the rulebook. One of my greatest regrets as a board game designer/developer is not pushing for better visual clarity on the first US edition of *Settlers of Catan*. I was young. I was fresh out of school. I didn't know any better. But as the gameplay developer on that edition, it was my responsibility to guide the talented artists at Mayfair and I didn't do a great job. Compare the first US edition with the later editions and you can see the difference – the colors

and images on the hexes and cards in my version were too similar and it became hard to tell the difference in some cases. That's a problem. Not a big enough problem to prevent the game from succeeding, but looking back I know I could do better with what I know now.

Narrative

In *Settlers of Catan*, the player is settling on an unexplored island, competing with other players who are also building on the same island at the same time. The story is not deep and not specific, but evokes historical periods of growth and construction, using generally European resources and society.

In recent years, the board game world has been wrestling with some difficult questions. Many of the most popular board games are based on themes of expansion and exploration and discovery. These make for great gameplay and inspirational goals, but when combined with historical themes, they raise some questions. Historical exploration and colonization were usually based on exploitation and destruction. In reality, Europeans settling on a "new world" had consequences for the people who lived on that "new world" before them. Games that build on historic and economic models based on the positives of never-ending growth are increasingly being called into question.

Games are systems. Games boil concepts down into understandable bits that players can work with. Games that try to recreate reality inherently need to simplify reality to make that work, and it's worth considering the biases and assumptions inherent in that simplification. All human endeavors include bias and assumptions, so that's not a flaw. But it's similarly not a flaw to question this and poke at it with a stick.

> Understanding why we use such settings, and why they can be unsettling, is necessary, but I don't intend to condemn it and I don't think we, game designers, should stop making boardgames that caricature the Orient or Ancient Greece, no more than we should stop making games that caricature barnyard or jungle.
>
> – BRUNO FAIDUTTI

Catan presents an island for the player to settle. There's no mention of previous inhabitants or a historical location. This lack of specificity allows the player to set these sorts of questions aside and not worry about them.

Klaus Teuber, the designer of the game, says he was inspired by Vikings reaching uninhabited Iceland (Raphel, A (2017)). *Catan* is meant as a fun moment of escapism, not a deep rumination on history. Not every piece of fiction needs to bring up and resolve every possible complication implied by its premise. Superhero comics don't need to explain why building suits of armor with vast military power doesn't change the geopolitics of the world. Illumination's Minions franchise never needs to tell me what they were doing in the mid-1900s. Part of the joy of games, and movies, and books, is the escapism, and it's not every game's responsibility to address every social issue.

But I do love games that do confront social issues head-on. The lack of colonial specificity in *Catan* is as an opportunity for future games to dig deeper rather than a problem with *Catan* itself. Simplified models of the world that allow escapism are great and are never going to go away. But I would love to see more games that wrestle with the tough problems of history to make players think. History is messy, but it's also a great source of inspiration.

Meaning
Catan is about expansion and growth.

How do you take an irregular flow of various resources and turn that into the things you want?

Can you build an empire out of a dribble of scraps?

When life gives you sheep, make sheep-ade. Or on second thought, don't.

There's also an interesting discussion of cooperation and competition. Most games of *Catan* involve a lot of trading, but at some point, a player starts to take the lead and other players become reluctant to trade with them. Players work together collaboratively, up to a point. Having a strictly defined zero-sum goal encourages this behavior, even if that's not how reality works. I like to think that the early game of *Catan* says nice things about humanity, and the end game is more about the artificial systems of the game. But I'm an optimist.

UNCERTAINTY

We've talked a lot about verbs and a bit about goals. Now let's talk about the middle section of the game moments: challenge.

Challenge is really where the fun lies in a game. Toys are pure interactivity with no goal, and that can be fun. But the difference between a toy

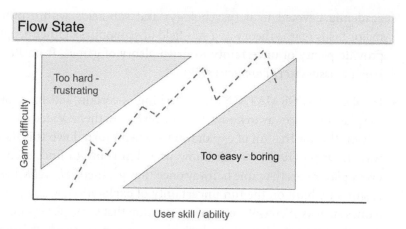

FIGURE 5.8 Adapted from *Flow* by Mihaly Csikszentmihalyi.

and a game is a goal. A game points you in a direction and makes it diffi-
cult but not impossible to get there. The fun of a game is the struggle. If
you know you're going to get to the goal, it's too easy and thus no fun. If
you know you're not going to get to the goal, then it's also no fun. Fun is a
balancing act.

This is where games resemble the flow state from psychology (Figure 5.8).
For something to achieve a flow state, it needs to be difficult but not impos-
sible. Humans want to push themselves against difficult but no impossible
odds. We play games because they provide artificial challenges that let us
practice and play with difficult things but with low stakes. Remember our
definition of games – goals and interactivity but inherently separate from
the real world. Without some uncertainty, this artificial challenge isn't
challenging.

Types of Uncertainty

Maintaining the balance of fun requires uncertainty. If the player knows
the outcome, the game collapses into either too hard or too easy and breaks
down. Not knowing the outcome is what makes the outcome interesting.

Different games create uncertainty in different ways.

- PEOPLE: Multiplayer games, including most board games, have
 it easy. Other humans create a lot of uncertainty. Understanding
 the actions of other humans is so difficult we have whole fields of

academia devoted to it (psychology) and sub-fields within other major fields (game theory as a sub-field of economics). Other people provide plenty of uncertainty to drive plenty of games, from Rock Paper Scissors to *Diplomacy* (1959).

- HIDDEN INFORMATION: If something is certain and fixed but the player has no way to know it, it's uncertain to them. Video games rely on this for the fun of exploration – when I turn down this hallway in *Doom* (1993), I don't know what I'm going to find, even if every player sees the same hallway once they get there. *Shovel Knight* is similarly built on the fun uncertainty of exploration. Many party games such as Werewolf rely on information that some players know but others do not. Managing which players get access to which information at what time is an important way for game designers to balance the flow of fun, especially in multiplayer games.

- PHYSICAL SKILL: Most action games create uncertainty from physical actions that are hard to perform precisely. For example, most sports require difficult physical actions such as throwing or kicking or running where it's hard to predict if a specific person can perform that action correctly or not. Basketball is fun to play or to watch because you never know if that shot is going to go in.

 - Some physical actions are more predictable than others, making them less about uncertainty and more about pure skill. If you know that you're playing a tug of war against a body builder, it's not very uncertain. But some physical actions are harder to predict, like balancing a wooden block on other wooden blocks, bringing uncertainty back to the forefront.

- MENTAL SKILL: Some games create uncertainty by giving the player so much to think about or process, making it effectively impossible to look too far ahead. This is actually quite similar to the physical challenges that action games provide, but less obvious – in either case, the uncertainty stems from the player's ability (physical or mental) to complete the challenge, which is up to the player to provide. You could argue that all people-based uncertainty is just a variant of mental skill uncertainty, with the ability to predict people being the skill.

- RANDOMNESS: Many games create uncertainty by using randomness. Dice, decks of cards, or just random number generators give you a certifiably random result. More on that in a moment.

Randomness is the purest form of uncertainty. Other uncertainties stem from things that have patterns or predictability but are hard to know – other people, individual skill, or just things you haven't seen yet. But if randomness is done correctly, there is literally no way to know the result ahead of time. All games need uncertainty, but randomness is the king of uncertainty.

Uncertainty in *Catan*

You can see many of these types of uncertainty playing out in *Settlers of Catan*. The balance of different types of challenges based on different types of uncertainty is part of what makes *Catan* a great game.

- PEOPLE: Understanding your opponents and adjusting your strategies to account for other players' actions is a critical skill in *Catan*. This is true when competing for the top production spots but is even more clear in trading. Trading is a highly social activity where persuasion and pleading can advance your cause in the game. And on the other side, knowing when to give in to someone else's pleas and when to stand firm often decides the fate of a game.

- HIDDEN INFORMATION: *Catan* has multiple types of hidden information. Any deck of cards relies on hidden information, both the order of cards in the deck and also the cards in other player's hands. The Victory Point cards are specifically designed to play off this, as they can be revealed at the last minute to create a sudden win. There are often signs that another player is holding onto a Victory Point card, but there's always some uncertainty that makes victory totals more interesting.

- PHYSICAL SKILL: Physical skill is absent from *Catan*, other than being able to balance the city tokens on top of the road tokens to amuse yourself when someone else is doing a long trade negotiation during their turn. Games based on physical skill are usually grouped into the genre of games we call "Sports", with a few exceptions like

Marbles or making a goal post with your fingers for someone to flick a paper triangle into.

- MENTAL SKILL: *Catan* is very much a game of mental skill. A good player will have a higher winning percentage than a bad player. They won't win 90% of the time like they would in a game like chess, but they'll win 65–75% of the time against less skilled players. There are lots of individual decisions that have a significant impact on the final victor. The starting layout is the largest and most obvious of these. A bad starting placement can be very difficult to recover from, making it a key way to distinguish mental skill.

- RANDOMNESS: *Catan* has lots of randomness, but the randomness is used in the right ways. See below for a detailed breakdown.

How Uncertainty Works

To understand the role of uncertainty, let's go back to a previous diagram, modified for *Catan* (Figure 5.9).

This diagram is beautiful and perfect but does not include everything. Inside the Player Action box, there is more going on. When the player chooses an action, there is normally more than one verb available to choose. And even a simple verb may have multiple different options on how to use it.

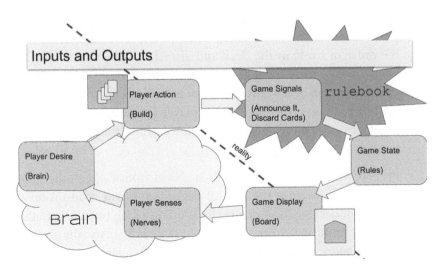

FIGURE 5.9 Input—Output diagram, *Catan* version.

For example, in a game of *Catan*, many turns have a core decision the player has to make. After the player rolls the dice and (maybe) gathers some resources, what other action or actions do they want to do? They can always pass, but with the right resources they could build or buy various things. And there's always the option to try to trade with other players. Most turns in *Catan* end in a pass, but the other options are always on the player's mind (Figure 5.10).

Each of these choices has the player choosing a verb that is allowed by the game of *Catan* – the verbs we start our dissections with. But the other parts of the dissection are also present.

When the player is making a choice, they're doing so because they have a goal in mind. There is something the player wants, and the action is their attempt to achieve it. So, a player who passes their turn in a game of *Catan* may not have any resources to build with, or they may be doing it because they want to save up their resources to build something bigger in a later turn. Similarly, a player who builds something is usually doing so because the game gives them rewards for doing so – victory points, more resources on future rolls, or blocking off other players. Different players may be motivated by different goals even when they're taking the same action.

And between the player's action and the eventual goal, there are various challenges, either direct barrier like enemies in *Shovel Knight* or indirect barriers like the economic system of dice rolls in *Catan*. These challenges are what make the connection between the action and the goal uncertain and interesting.

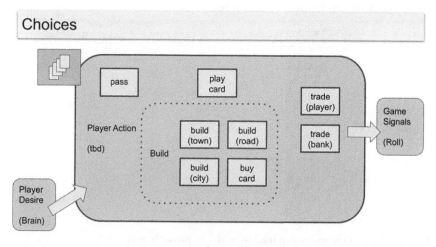

FIGURE 5.10 Choices in a turn during a game of *Catan*.

This is all happening inside the Player Choice box in our diagram. The player can choose an action, and the game result follows directly from that action. If I discard four cards to build a village, the outcome is always that I build that village. There are lots of possible player actions, but each player action ends with only one response from the game rules. Even if the player passes, the outcome is always certain – the play passes to the next player. For the sake of simplicity, the next few diagrams will focus on two options – pass or build.

A player's choice between pass and build can be represented by adding a branch to the input/output diagram we've used before, as seen in Figure 5.11.

Adding a branch changes the diagram. The player may go down one path with one game state as the result (build a village and now the board layout is different) or down another path that results in a different game state (pass the turn and have more resources in hand). Every game of *Catan* is the result of an endless series of branches like this, with an endless possibility space of different game states from every choice.

Other events in the game work differently. At the start of each player's turn, they are required to roll the dice. There are no options there, no variation for the player to choose. But the outcome of this action is variable based on a randomizer – the dice. So, one input produces many possible outcomes (Figure 5.12).

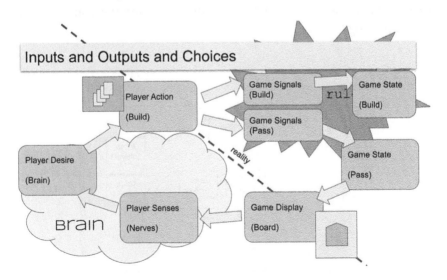

FIGURE 5.11 One input can lead to multiple possible outputs.

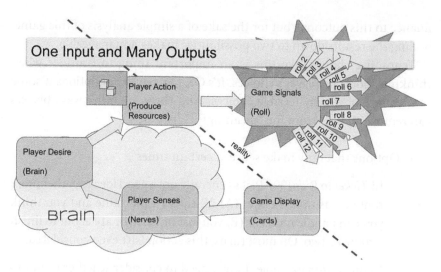

FIGURE 5.12 One input can lead to many outputs.

As you can see, this can lead to explosive possibility spaces. Even just 11 outcomes make it hard to manage all the possibilities (Figure 5.13). Thankfully, our brains are good at managing this sort of possibility space. In most cases in *Catan*, the results can be boiled down to a binary good or bad. Did the player produce resources or not? There is definitely more

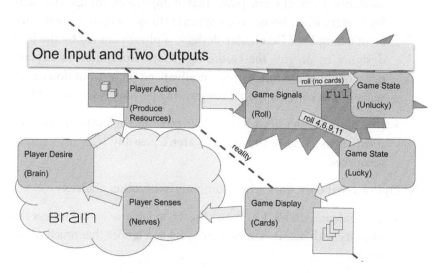

FIGURE 5.13 Many outputs can seem like only two based on how the brain processes it.

nuance to this outcome, but for the sake of a simple analysis of this game, boiling the results down to two possibilities makes it manageable.

Trimming choices like this is an important thing to consider when thinking about the player's choices. It's OK to have lots of options if some of them are obviously terrible choices. And there are other ways players can remove choices from the "meaningful" list:

- Options that only make sense at certain times

 - In *Ticket to Ride* (2004), it's generally not a good idea to gather more route cards unless either (A) it's early in the game and you think you can handle more, or (B) you just finished or are about to finish a route or two. On most turns, this action isn't even considered.

 - In our *Catan* example, I don't need to consider whether or not to play my Knight if the robber is currently in a place I like, especially if I just put the Robber there recently.

- Options that only work when you have the right resources

 - In a game of *Magic: The Gathering* or *Marvel Snap* (2022), you can ignore cards that cost more than the resources you have that turn. But an expert player will consider how those options might influence their current play. That complicates things, but only for players who choose to complicate things, which is great. This is an example of "lenticular design", a phrase coined by the lead designer of *Magic: The Gathering*, Mark Rosewater, to explain decisions that are interesting for advanced players but don't even register as a complication for beginning players (Rosewater, 2014).

 - In *Catan*, I don't need to consider most of the build options for most turns because they simply aren't possibly with my current resources.

- Options that only work when combined with other choices

 - In *Pandemic* (2008), I can't use the Treat Disease action unless I'm in a city with disease cubes there. So, I can ignore that much of the time.

 - In *Catan*, I might have made a deal with another player so I don't consider placing the Robber on that space. This can also go the

other way and add complexity to my decision, if there isn't a clear deal and I want to make one in the future, or if there is a deal but I might betray them.

Game State

Once the player has condensed their choices down to a manageable number, they pick an action and change the state of the game. These changes add up. Each time the player makes a choice, they change the state of the game as a result of their choice. And each time the dice are rolled, they change the state of the game as a result of randomness.

In a game with clear winners and losers such as *Catan*, one way to consider the state of the game is who is winning. Each action and result that changes the game state in any way can be tracked based on whether it increases or decreases the player's chance of winning. Actions that add victory points move the players closer to a win, as do actions that gain them resources either now or in the future. The same can be said for each random result (Figure 5.14). The player's goal is to get to the win, and change in state is designed to move in that direction.

Eventually, the entire game boils down to a series of choices and random events, each moving the state of the game one way or the other (Figure 5.15). Until eventually one player wins and the other players lose.

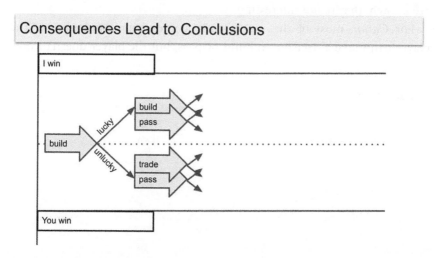

FIGURE 5.14 Consequences lead to conclusions.

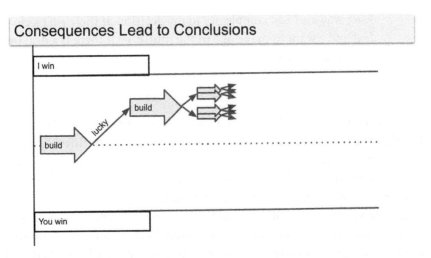

FIGURE 5.15 Consequences lead to more conclusions.

This is how the actions, goals, and challenges of a game add up to a full experience (Figure 5.16). These are the core of the game and result in the final outcome.

If the player knew the full results of each of their actions ahead of time, the choice between two actions would always be trivial. A game where every outcome is certain is not really a game at all. Every game does something to ensure that players can't just breeze through every decision. As Sid Meier said, a game is a series of interesting decisions. If the decisions are known, they're not interesting.

For *Catan*, most of that uncertainty comes from randomness. The player can make a decision to build or pass, but the player doesn't know

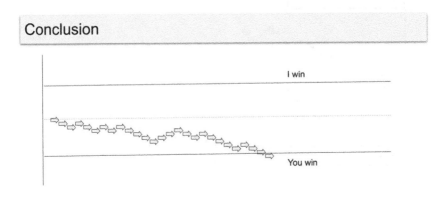

FIGURE 5.16 Choices lead to conclusion.

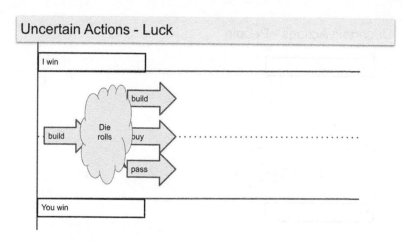

FIGURE 5.17 Uncertain actions – luck.

what rolls are going to occur in the future, so the outcome of the player's action is unclear, and thus interesting. Uncertainty creates a cloud of uncertainty that prevents players from perfectly predicting the outcome of each game action (Figure 5.17). That uncertainty keeps the game unpredictable and thus fun. A good game has many of these clouds to ensure that players don't worry about perfect optimization. Knowing who's going to win is not fun. Waiting for 45 minutes for the other player to compute who is going to win is even less fun. Clouds of uncertainty remove the incentive to over-optimize.

Trading is similar. Trading is an uncertain action that may or may not benefit the player. But in this case, the uncertainty comes from something other than randomness – it comes from other players (Figure 5.18). The player knows how the trade will benefit them, but does not know what the other player has in mind. Good players know to not only consider the benefit of a trade but to also consider the cost – the benefit to the other player. If the other player gets more out of the trade than the first player, the first player may want to reconsider. This gets even more complicated when we consider the effects of all the players. In *Catan*, a trade that is better for the other player may be a good idea if the other player is nowhere near winning and all the first player needs is a small benefit on their own side to secure a win. This is the type of uncertainty that makes games like chess fun. Chess has no randomness, but every player action results in an interesting array of possible responses from the other player.

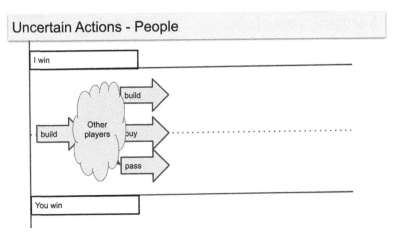

FIGURE 5.18 Uncertain actions – people.

The final type of uncertainty seen in many games is skill. *Catan* doesn't have any player actions where the result depends on the player's ability to move a mouse precisely, or run quickly between bases, or wiggle a joystick at just the right time, or physically overpower another person. But plenty of other games are filled with actions where the results are uncertain due to strength or dexterity or other demonstrations of physical or mental skill (Figure 5.19). These actions are uncertain because the player doesn't know if their skill is enough to pass the challenge.

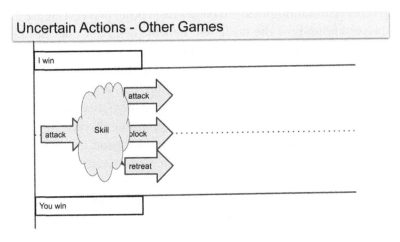

FIGURE 5.19 Uncertain actions – other games.

Clouds of uncertainty come in many flavors, but all of them have the same effects – keeping players focused on the moment and ensuring the game retains the necessary uncertainty.

Benefits of Uncertainty

Uncertainty Tends to Avoid Analysis Paralysis

Analysis paralysis is a term originated by H. Igor Ansoff in 1965 for corporate strategy, but used by gamers to describe cognitive overload. When a player has too many options, or too many factors to consider for each option, that player can get overwhelmed. They may take a long time trying to analyze each option, or they may just shut down and give up. Neither is a good result. As a game designer, your goal is to create decisions that are interesting for the player. That means each choice needs a certain level of challenge, but not so much that it becomes overwhelming.

At any point in a game, the player has a certain number of options on what to do next. A simple choice might only have two options. You can build a whole game around this level of decision-making. *Love Letter* (2012) is a successful and fun game where the player never has more than two options (ignoring targeting and a few other secondary decisions). But most games have more. If you dissect a bunch of games, you'll find that most of the successful games for average gamers try to avoid giving the player more than about five options to consider at any one time.

- Most card games give each player a hand of about five cards

 - *Magic: The Gathering*: seven cards at most, but on most turns it's actually five or less

 - *Robo Rally* (1994) gives the player up to nine cards, but each is very simple

 - *Dominion* (2008) gives the player five cards each turn, but with ways to draw more

- Some games give a player a list of things they can do each turn, usually three to four actions with three to five choices for each

 - *Pandemic* gives the player four actions per turn with eight options (but many of these are similar or rarely used)

 - *Ticket to Ride* gives player one action with three options (but one is rarely used)

This aligns nicely with psychology. Memory research generally shows that people can store about seven things in memory at one time (Miller, 1956). There are ways to get around this, and there is newer research that questions the details of this. The actual number might be smaller. But the general concept that people can only store a finite number of things in their head at one time is still generally accepted.

So, if the human limit is seven (or maybe a little less), it makes sense for most games to err on the side of caution and go with about five things to consider at one time.

In a game like chess, the number of possible game states is more than seven. Even if the player can manage to trim down the number of possible options as discussed before, the possibility space still gets very big very fast (Figure 5.20). For many people, thinking this far ahead is no fun. Chess is a popular game, but for many people playing at a high level is more headache-inducing than fun. Most people play games for a light good time, not for grueling intellectual intensity. And there's nothing wrong with either preference.

And even for players who enjoy grueling intellectual intensity, the process of doing so can create analysis paralysis. There's a reason high-level chess uses timers to keep players from spending days on each turn. If you want to reduce analysis paralysis, you need to stop the player from analyzing too far in advance. Ideally, you want to discourage the player from worrying about more options than they can keep in their head.

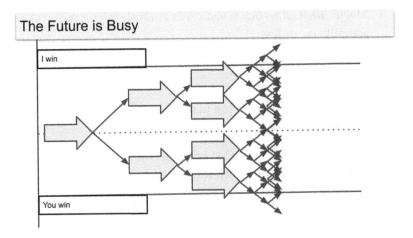

FIGURE 5.20 The future is busy.

Randomness is great for this. If you put out a branch that the player literally cannot predict, with more possibilities than it would ever be reasonable to compute through, the player is strongly discouraged from thinking too hard about the future.

It's like you put up a barrier in the diagram and prevent the player from seeing past that (Figure 5.21).

The dice have too many outcomes to reasonably predict. And when the player draws from the development deck, the possibilities are even harder to track. This effectively puts a limit to how far the player can predict. This can also be true for other types of uncertainties, if there are enough possibilities. In a game of pool, there are enough skill-based nuances to where each ball moves that it's impossible to predict specific turns far in advance. *Pool* is not a game of long-term strategy.

You can see this clearly in highly random games like *Munchkin* (2001) or *Fluxx* (1997). There's no reason to plan out a long-term strategy in these games because there is no way to predict the state of the game even one turn in advance. And even if you could, the game doesn't give the player verbs that will affect that future state – actions are all about the current state, so the player stays focused on that.

Catan strikes a nice balance here. There isn't value in predicting the moment-by-moment play out too far. The player can't know exactly what they'll do on their next turn, but they can plan where they want to build next. Building is a flexible enough goal structure that it can handle some

FIGURE 5.21 The future is blurry.

randomness and still feel good to complete. Players can predict how general trends are likely to play out over multiple turns. And over multiple turns, the dice are more likely to conform to predictable mathematical patterns. Players know enough to know that if a player tends to produce a lot of wheat, a wheat port is a good idea, even if they don't know exactly when it will pay off.

Uncertainty Makes Games More Varied

Good games have lots of variety. Players enjoy it when they can play a game many times and/or for many hours and still find something new and interesting each time. Replayability is a key metric for measuring the quality of games. For linear games, it's less about replay and more about filling hours of fun. But it's still the same principle. Variety makes games good.

All of the forms of uncertainty we have discussed are also source of varied outcomes. A variant of *Catan* where each tile produced resources on a fixed schedule could replicate the same probabilities and frequencies of the current game. But part of the fun of *Catan* is that crazy things can happen. In most games of *Catan*, the dice are rolled often enough that the probability curve starts to take shape, but not often enough that it always collapses down to the ideal form. If every game of *Catan* involved hundreds of resource rolls, then things would average out over the course of a game and players could depend on probability to work out by the end. But with the current game, odd things can happen. I still remember the game of *Catan* where we literally never rolled a six. That game was memorable and fun and interesting and while predictability might sound nice, I'd rather occasionally lose like that and come out with a good story.

You can see this in games like *Dungeons & Dragons*. Tabletop role-playing games would be pretty boring if attacks were always the same. Rolling dice to determine success makes things a little different every time. When a critical hit is rolled, it's a big moment that players can celebrate. This gives players different things to react to each session.

Mixing things up doesn't absolve the game designer of responsibility for making things interesting. Randomly generating boring enemies is still boring. Maybe a little less boring, but still boring. The range of possible results needs to have enough meaningful variation so the randomization matters. But mixing them up through randomness lets the game stretch those elements out longer. To make the best variety, you need quality parts and the right amount of mixing.

Benefits of Randomness

All forms of uncertainty provide a way around analysis paralysis. And they all provide good variety. But to further understand the pros and cons, we need to break uncertainty into two main camps. Not all uncertainty is due to true randomness.

Skill is the type of uncertainty where the root underlying the uncertainty is something solid. There's an actual difference between the players that is hard to see but is actually there.

Randomness is a type of uncertainty where the root underlying the uncertainty is not based on anything. It's just uncertainty for uncertainty's sake. Which sounds terrible, but is actually better than skill in many cases.

Randomness Tends to Make a Game Easier

The more decisions the player has to make, the harder the game is for new players. As mentioned above, new players can easily be overwhelmed by too many decisions, especially if they haven't learned the coping mechanisms to simplify those decisions. One way to improve this as a game designer is to take some of those decisions out of the player's hands. Replacing a choice with a random event makes the game simpler and easier for a wider range of players.

Imagine *Catan* where you could pick what resources to buy each turn from a budget with no randomness. It would give players more control but would also add a big decision to each turn and thus slow the game down. And it would make games more predictable – players would tend to buy exactly what they need and nothing else, so they'd do that every time. But mostly it would make the game harder. You'd need to make better purchasing decisions than the other players if you want to win. The real *Catan* is easier and thus more fun for more players.

This is where understanding your game and your audience are important. Maybe you want to attract players who like complicated decisions. Maybe your vision for your game is based on players learning to manage decisions like this one. But if neither of those are true, and you're hoping to get as many people as possible to play your game, you may want to consider streamlining any choices except the most important ones. If it's not your core game loop, maybe it should be a die roll instead of more things players need to think about.

Randomness Allows Mixed Groups to Have Fun Together
Casual players prefer randomness over skill. If you don't have the skill, randomness is your best chance to win. This may sound terrible, but it's important. Most people in the world use games for entertainment and don't invest enough time to master every game they play. But they still want to play games with a variety of different friends and family and have a good time. Playing a skill-based game with people of varying skill levels is not a great experience for either side. The best player gets bored and the worst players get frustrated. This is why I don't play a lot of multiplayer first-person shooters these days – I'm terrible at them and just die over and over again. Dice fix this. For a mixed group of varied skill levels or mastery levels, a little randomness provides a way for all players to engage with the game, even if the skilled players win a little more often.

Randomness Tends to Make a Game More Widely Appealing to a Large Audience
There are more people out there who enjoy a quick game every now and then than there are experts who master the skills of a game. If you want your game to have a large audience, rather than small but passionate audience, it's generally easier to succeed with a game where everyone feels like they have a chance to win.

The sweet spot is when you make a game that everyone feels they can win, but the skilled players feel they're more likely to win. This is where *Catan* shines. It feels both random and strategic at the same time. This is a big part of why *Catan* was incredibly successful as a gateway game, bringing hardcore gamers together with casual gamers around the same table. The casual players feel like they understand what's going on and have a chance, and the hardcore players feel like they are more likely to win because they understand even more. And that provides a way to bring new players into the board game community, which is a wonderful thing.

Randomness Provides a Catch-Up Mechanic
Randomness provides a way for players who are behind to realistically expect that they might catch up. Whether they're behind due to some bad choices early on, the superior skill of the opponent, or just bad luck, there's always hope that the next die roll or the next card draw or the next random loot item will turn that all around.

This has a larger impact on the success of a game than you might think. Giving players psychological armor to make them feel good and enjoy the game at every moment is a huge benefit. Part of the reason many people find *Monopoly* to be an imperfect gameplay experience is that despite the heavy use of random probability, *Monopoly* does not have a good catch-up mechanic. If you're behind in a game of *Monopoly*, it feels like you're just going through the motions until you lose. That's not a positive play experience. Compare the feeling of being behind in *Monopoly* to the feeling of being behind in *Catan*. In *Catan*, it always feels like you're just a few die rolls away from doing something big. Maybe not winning immediately, but at least building another town. Building creates good goal structures. And with the right combination of the robber and a few bad die rolls, the player in the lead can be toppled. I don't know the statistics for how many come-from-behind wins occur in *Monopoly* versus *Catan*, but when we're talking about emotional feel, it doesn't really matter. The important thing is that the player feels better about the bad result in *Catan*, whether they actually come back or not.

Downsides of Randomness

Uncertainty is part of what makes a challenge interesting. Adding randomness randomly to a bad core loop isn't going to improve things, but finding the right places to add a little bit of uncertainty can help most games. This depends on your audience. Uncertainty and especially randomness work for certain types of games for certain types of audiences, and not for others.

All games want some flavor of uncertainty, but skill-based uncertainty and random-based uncertainty attract very different sorts of players, especially for competitive games. Competitive gamers want outcomes decided by skill and skill alone. This is true for mental skill games like chess and games that include physical skill, either shooters like *Call of Duty* (2003) or a professional sport. Removing all traces of probability from your game is a strong statement that you want it to be decided purely by skill.

Punishes the Best Players

The highly skilled players who spend a lot of time developing and mastering a skill tend to get annoyed when someone else wins based on random events. Expert players tend to frown on luck. High-level *Super Smash Bros* (1999) tournaments usually turn off items, which are a feature that adds

random powerful items to the map at certain times, creating a lot of chaos that might make a less skilled player win. Without items, the game is more skill-based and allows experts to pit skill against skill. The more complicated a board game gets, the less chance affects the outcomes.

Takes Away Earned Rewards

This actually demonstrates what I consider to be the worst use of randomness in *Catan*. When anyone rolls a seven, all players with more than seven resource cards have to discard half of those cards. This doesn't feel great. The player worked hard for those cards, and they are taken away with no recourse. There is no way for the player to react to this event and salvage their hard-earned resources.

This is generally a psychological problem with uncertainty. When there is something that the player can't know, and it does something negative to the player, that feels unfair. Especially when the penalty is immediate and there's no way for the player to mitigate the negative impact.

Players get especially angry when the penalty takes away something that they consider "theirs" either by right or by earned effort. Humans tend to use a very broad definition of "mine" and get very touchy when this sense of ownership is violated.

In defense of this rule, it's right there in the rulebook and everyone knows it can happen at any time. Players can take steps to avoid this penalty. If you have more than seven cards, or are close to it, this rule puts a lot of pressure on you to do whatever you can to build on your turn. Which is the point of this rule. But there are still plenty of times when you take every possible step but end up with a good income right before a seven, or when no good builds are possible and you have to hold only six cards and hope. It's a necessary and useful rule but leads to less-than-perfect moments.

Can Overwhelm Choices

Games are about choices between the actions the player can take. Random events are not verbs, because they're not actions the player takes (unless the game is set up so a player initiates the random event, which is a whole different thing). If a game has too much randomness, it can take away from the core of the game. If there's so much randomness that my actions don't really matter, then why even play a game? Games like *Munchkin* and *Fluxx* are not popular with some players for this very reason. Games are only fun if the player's actions are meaningful, in the context of the game.

Downsides of Uncertainty

The cloud of uncertainty that we talked about as a positive before can also be a negative if not handled correctly. If you use uncertainty to prevent long-term prediction, but you cover up too much of the game with uncertainty, players might feel like nothing is ever knowable and strategy is not worth it. If the game's catch-up mechanic is too strong, it can feel like there's no benefit to getting into the lead. This can be another problem with *Munchkin* – players who do well early are severely punished, so some players will pace themselves and not move to win until one or two other players have tried. Which some players consider to be an interesting political strategy, but feels wrong to some players.

Building Randomness in *Catan*

Catan is a master class in how to use randomness to make a great game. Let's look at each place where the game introduces random elements and discuss the principles that make the randomness work.

Initial Board Setup

Each game of *Catan* starts by setting up a randomly generated board. This includes both randomly arranging the tiles and also semi-randomly arranging the numbers on the tiles and the ports around the island.

A different board each time is a big part of the appeal of this game. Each board offers a new puzzle for players to analyze and react to. As discussed, uncertainty provides variety.

One reason randomizing the starting layout of the game works so well is that it's done before the player makes any decisions. Randomness can't take away earned rewards if the players haven't started the game yet. And this randomness is fair – everyone is on the same footing and reacts to the same information.

Resource Production

Every time a player rolls the dice to produce resources, there's no way to know what's going to happen. But over the course of a whole game, you can say what is likely to happen. One important factor when setting up a random event in your game is to have an idea of how often that event occurs.

Things that only happen once across the whole game make the random nature very obvious and hard to manage. If you get a weird result in something that only happens once, it's really going to stand out. If you get a

weird result once and it determines the outcome of the game, that's a problem. These things should only be randomized if they meet the other criteria for good randomness – for example, the random board in *Catan*.

Things that happen many times over the course of a game are going to spread that randomness around and display the full range of random outcomes to the players. This gives players the tools to understand and manage the randomness long-term. The resources in *Catan* are a good example of this. Resources are rolled many dozens of times every game. The number of different outcomes the players see makes it likely that they'll see a good range of outcomes. *Catan*'s resource production is very nicely balanced where the probabilities tend to even out over the course of a game, but not always perfectly. There is enough variation from game to game to keep things fresh, but there is enough consistency within a game that players who understand probabilities will have an appropriate advantage.

That said, the probability doesn't always work. The most frustrating games of *Catan* that I've played are the games where a player makes an intelligent informed choice early in the game, but the dice decide to not behave that day. There are feel-bad moments when a player does everything right but the probability doesn't align appropriately. Most players are able to weather this psychological trauma, and probability makes that easier to manage since there's something else to blame. In an entirely skill-based game, players have nothing to blame but themselves. In a game with random elements, the dice (or cards, or RNG) becomes a convenient scapegoat. This sort of mental crutch may sound silly but it's a very useful tool as a game designer. The more you can do to make the player feel good after a loss, the better overall experience your audience will have. A game where the winner walks out happy but the loser walks out sad is a net zero fun. But a game where the winner walks out happy and the loser walks out feeling fine is a net positive. Make the world a happier place – let players blame chance.

Development Deck
The development deck is a classic randomizer. Decks are so ubiquitous as a randomizer that people sometimes forget that they're random. Losing a card game because you didn't draw the right cards feels different than losing a card game because a card did something that randomly picks targets (yes, I'm looking at you, *Hearthstone* (2014)).

The development deck is also a strong example of some of the nuances of randomness. The deck is mostly soldiers, which have a useful but not huge effect. The rest of the deck is either victory point cards, which make you win, or cards with varied but powerful effects. So, players who draw cards are expecting to draw a soldier, but sometimes get something better. If the non-soldier cards were weaker than soldiers, that could be a very negative moment. Paying resources to draw something but getting something worse doesn't feel great. With the deck as constructed, even when you don't get what you expect, you get something you're happy with.

Rolling a Seven

One result of the resource roll is special. When a seven is rolled, that player gets to move the Robber. This does a few varied things: the hex the Robber is on doesn't produce, the player gets to steal a resource card from someone near there, and all players with more than seven cards in hand have to discard half of them.

Now, I worked briefly on *Catan* but I never met Klaus Teuber, the designer of the game. I don't know any details of his process or how the game changed during iteration. But I have strong theories about why the Robber works the way it does.

First, there is a common complaint about *Catan* (any many board games) that the game is not very interactive. In this context, this isn't looking at the player's interactions with the game – there are clearly lots of meaningful choices in a game of *Catan* – but instead at the players' interactions with each other. Trading is very interactive, but it's always mutually beneficial. There aren't a lot of ways to slow down the progress of another player in a game of *Catan*. I suspect that Mr. Teuber had an early version of the game with no robber, and he quite wisely noticed that there was not enough interaction. So, he found a way to add some in. Both the production halt and the card theft are good ways to weaken the top player.

The third effect – players with lots of cards have to discard some – also feels like something that would crop up during iteration. I can picture Mr. Teuber hosting a few playtests where one player has a good run and ends up with a hand of dozens of cards, then doesn't do anything with them for a long time. This doesn't feel great for anyone, so it makes sense to add a way to encourage players to build with cards instead of hoarding them. Based solely on my thorough analysis of circumstantial evidence, I believe that the Robber came about as a game design solution for two problems in

early versions of *Catan*. The fact that this doesn't seem obvious when first playing the game is a testament to the elegance of these solutions.

CERTAINTY ABOUT UNCERTAINTY

Catan provides a great model on how to use uncertainty and specifically randomness. Dissecting the verbs and goals helps us see how uncertainty works here, and why the randomness of *Catan* feels better to many players than randomness in other games.

- Uncertainty helps avoid analysis paralysis by preventing players from analyzing too far in the future. But the build goals still allow players to look ahead and think long-term.

- Uncertainty keeps the game interesting for the largest number of players by providing a balance for players with greater skill at analyzing resources.

- Uncertainty is used in places where it's either not disrupting players or providing players with ways to understand and analyze the randomness and change their actions accordingly. Randomness doesn't destroy player agency.

Understanding how randomness is used in *Catan* can help many games improve their play experience and appeal to more people.

Spelunky / Systems

SPELUNKY

Spelunky is a great game.

Spelunky (Figure 6.1) was first released as a web game in 2008, then attained larger success on Xbox and other platforms with a 2012 update/ remake. *Spelunky* is part of the first wave of indie games, which have spawned a thriving market.

SPELUNKY – GAMEPLAY DISSECTION

Verbs

What do you do in *Spelunky*?

You run, you jump, you attack, and you use items that act as powerups. Yes, there are more verbs here. But as discussed, the depth of dissection depends on your goals for the dissections. And this meets my goals for this chapter.

Run? Jump? Sound familiar?

Spelunky is an indie 2D side-scrolling platformer. *Shovel Knight* is an indie 2D side-scrolling platformer. These games have many similarities, but also many differences. More on that in a moment.

DOI: 10.1201/9781003346586-6

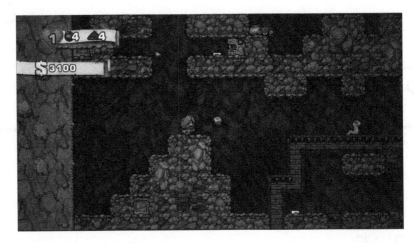

FIGURE 6.1 *Spelunky* screenshot.

Goals

As a platformer, the goal of *Spelunky* has a fairly typical set of layers:

1. Explore the lost temple or whatever it is that you're exploring (narrative framework).

2. Get to the end of the game (long-term gameplay goal).

3. Get to the end of the level (medium-term gameplay goal).

4. Get lots of treasure (gameplay goal that ranges from short-term to long-term).

5. Rescue your friend (medium-term gameplay goal, with gameplay rewards but no strong connection to the story; rescuing people is such a popular trope in games like this that it needs no introduction).

6. Don't die (short-term gameplay goal).

Again, these mirror the goals of *Shovel Knight*. Games in the same genre tend to have a lot of similarities.

Challenges

Levels in *Spelunky* are challenging because of difficult jumps, varied enemies, and lots of different hazards. The exact set of dangers and their powers is different in the two games, but the concept is the same – every level is a sprinkling of varied challenges that keep the player on their toes at all times (Figure 6.2).

FIGURE 6.2 Simple diagram showing Actions, Challenges, and Goals for *Spelunky*.

Progression

This is where things start to change a bit.

In *Shovel Knight*, the player plays through a sequence of levels that are pre-defined and never change. The player might need to re-play a section of a level after the player dies, but that section will always be the same and the section after it, too. Every player sees the same content.

In *Spelunky*, the levels are procedurally generated each time the player plays. If the player dies, they have to face an entirely new level with new hazards arranged in new ways. There is no level progression in a traditional sense – the player plays as many random levels as they can until they die, and then they start over again. Until you get far enough to get to an ending, but I don't want to spoil it all. This leads to a number of different dynamics that affect the overall feel of the game. More on that in the systems discussion, below.

This style of play, with random levels that reset on death, is called "rogue-like". More on that in the history discussion, below.

SPELUNKY – NON-GAMEPLAY DISSECTION

Senses

Spelunky is a sprite-based retro-styled game. Simple graphics are important, as procedural generation puts lots of extra requirements on the content of the game. Everything has to be flexible enough to be placed anywhere, and still perform its intended function. Platformers are notorious for requiring precise placement of items and platforms to get the desired difficulty – the length of a jump has a huge impact on how it plays. So, making a wide range of content that all fits those requirements and still looks great is no easy task.

Spelunky content creation is extra double challenging because not only does everything have to work in the generation system, but it also has to

clearly communicate how it works. The game is built on the player's understanding of how every hazard and enemy behaves. In a normal game, that understanding would be built partially on carefully designed introduction scenes where the player learns the dangers of a new item and how the character is meant to interact with it. Because the player's first encounter with a new hazard in *Spelunky* is randomly generated, the object itself needs to communicate everything about how it works based solely on itself. An enemy that shoots projectiles might be firing short-range, might be firing at a walking character or a falling character, and might be the first thing the player sees or the end of a long sequence of threats. Communicating how gameplay elements work is always hard. Communicating like this is like doing trapeze acts without a net.

Given these constraints and requirements, it's kind of amazing that *Spelunky* works at all. It's especially amazing that it's cute and compelling and has a strong style of its own.

History

Spelunky is an indie game. As discussed with *Shovel Knight*, indie games are generally PC games that generally have a strong artistic view and generally are smaller and more personal than big console or mobile games. Talking about "indie" is usually a contrast to differentiate a game from the big AAA studios.

Spelunky is a rogue-like. This sub-genre gets its name from an old computer game called *Rogue* (1980) that used ASCII graphics to build dungeon levels out of letters and keyboard symbols. Players would explore a random ASCII floor of a randomly generated dungeon, fighting monsters and acquiring treasure in a simple *Dungeons and Dragon* style adventure. Despite the simple graphics, *Rogue* inspired a number of similar games (Figure 6.3) and became a moderately popular sub-genre of computer role-playing games. Rogue inspired the *Mystery Dungeon* (1993) series in Japan, which drew inspiration from *Rogue* but added real pixel graphics instead of the simpler ASCII approach. *Diablo* (1997) also explored these ideas to great commercial success.

Spelunky was a conscious attempt to infuse the rogue-like structure into a genre that is not normally created with procedural generation. Previous explorations into the rogue-like structure had generally kept the dungeon setting and *Dungeons & Dragon* styling with magic and monsters and so on. *Spelunky* went a different route, with platformer gameplay based on running and jumping more than character progression and

FIGURE 6.3 *NetHack*, my favorite early rogue-like.

stats-based battle. *Spelunky*'s success led to a revival of rogue-likes, especially in the indie scene. Games like *Slay the Spire* (2017) and *Hades* (2018) and *FTL: Faster than Light* (2012) took that progression structure and applied it to all sorts of different core loops, leading to a wide range of interesting games. Some people call rogue-likes that play with the core loop "rogue-lites". I call them fun.

Money

How does *Spelunky* make money?

The primary financial structure of *Spelunky* is the download. *Spelunky* initially launched as PC freeware, without huge commercial aspirations. When this version proved successful, the developer reworked the game for Xbox Arcade. While most indie games are thought of as PC games, console download services were a key factor in popularizing many early indie titles, including *Spelunky, Castle Crashers* (2008), and *World of Goo* (2008). This provided a stronger revenue stream than early PC download platforms could offer. Since then, Steam and other PC downloads have boomed, so console downloads remain important but are less necessary.

Emotions

The emotional pang of losing all your progress and having to start over from the start is part of the appeal of rogue-likes. In my opinion, it's also a limiting factor in the appeal of rogue-likes. Many players (myself included)

love that extra emotional kick in the pants, especially when it's clear that the game is built around that and repeated playthroughs are expected. I suspect that not everyone agrees with that. Losing everything can feel terrible, even if you know it's just a temporary setback. Which is why roguelikes and rogue-lites are critical darlings but can struggle to find huge commercial success. The ones that have the greatest commercial success (*Diablo, Mystery Dungeon*) are the ones that take the edge off that loss by maintaining a good chunk of the player's assets and not doing a full reset.

Spelunky also hits another emotion common in games – feeling clever. There's a certain joy in realizing something that you hadn't noticed before and using that understanding to reach new heights. This is the driving factor in most puzzle games, which *Spelunky* shares.

Meaning

What is *Spelunky* about? What does *Spelunky* say about the world? How does *Spelunky* change you?

There's something special about defeating a level in *Spelunky* and realizing that no one has ever beaten that level before. No one has seen the exact combination of things that you just defeated. There's power in uniqueness. It feels good to discover and defeat something new.

Spelunky is also a great example of something I firmly believe. Learning is fun. Not in an elementary school book fair kind of way (although I also believe in those), but in the act of learning itself. For many people, play is the best way to learn. Experimenting with an idea in a safe, structured space gives learners a sense of ownership and accomplishment, especially if the space includes positive feedback on key actions. Games have always taught through play, and humans have been learning through play for tens of thousands of years. Our modern education system works very hard to remove this impulse from most students, but for the few who manage to maintain that perspective, there is a lot to enjoy and savor in a game like *Spelunky*. Your battles feel more rewarding when you know that you discovered your solutions yourself.

SYSTEMS

So how does a game like *Spelunky* do it?

In the *Centipede* chapter, we talked about dynamics and systems. Now let's talk about them in more detail and look at how game designers can use systems to make better games.

Building a level in *Spelunky* takes a lot of clever ideas. It's not just randomly generating a bunch of hazards. Randomness would result in lots of dead ends and impossible levels and unfun layouts. Incorporating randomness into a process like level generation takes some careful crafting and balancing. It requires a thoughtful approach on where to include randomness and where to ensure good game design. If you're dissecting how to do this for a game like *Spelunky*, you're in luck. Derek Yu, the creator, has done a great job explaining his process in the book *Spelunky* (Yu, D. (2016)). It's interesting and clever and will help anyone planning on making a procedural generation system. I recommend you read it.

For this book, I'm interested in talking about how a game like *Spelunky* works from more of a player perspective. How do players figure out a big complex level? How is that still fun?

Understanding Fun

To start off, the player needs to understand how a single element of the game works. This is true in every game – we already broke down some of the rules for games like *Centipede*. Let's do this again for *Spelunky*. *Spelunky* has lots of different hazards, but one of the early ones is the dart gun, also known as an arrow trap.

Here's a basic set of rules for an arrow trap:

1. When the player moves in front of the arrow trap, it shoots an arrow.

2. The arrow moves in a straight line for a short distance, or until it hits something.

3. The arrow damages the player if it hits him.

4. Each arrow trap only has one arrow, after which it doesn't do anything.

That's the basic idea. As a casual reader, this works fine. But whoever codes this functionally needs to dig deeper into details to actually make it work – What is "something"? What is "in front of"? How much damage does an arrow do?

All these only work if the player knows what's going on. If the player thinks that arrows will track their position and aim at them, then that player will not be able to devise the correct strategies to survive. The game

needs to make sure that everything in the sentences above is very easy to learn and understand and notice. The arrow trap is intended as a "trap", so it doesn't need to clearly communicate everything to the player when it's first encountered, but once the player has seen it happen, they should be able to predict what will happen in future encounters. There are various ways that the presentation of the arrow trap helps the player understand the rules up above:

1. An arrow trap is a different color than the ground, so it stands out.

2. An arrow trap has a face on it that indicates the direction it's facing.

3. The mouth on the face shows where the arrow comes out.

4. When an arrow fires, there are visual and audio effects to make it clear what's happening.

5. The arrow is an object that follows the rules of the world and persists after it is launched.

(As a game designer, I'm actually a little surprised that there is not a clear visual distinction between "arrow trap ready to fire" and "arrow trap has no arrow". Even a small texture change or slight color swap would be a nice way to emphasize this distinction, which is critical to understanding how to manage the arrow trap as a player. Maybe that would be too obvious, and it's meant to be one more thing for the player to keep in mind.)

Following on the dynamics concept that we discussed back in the *Centipede* chapter, we can start to see some dynamics that are logical consequences of these rules:

1. The player can make the arrow trap fire to make it not a threat.

2. Since the arrow follows the rules of physics, if the player is falling fast enough when the arrow is triggered, the arrow will miss the player.

3. Use an arrow trap to make a weapon – the arrow can be thrown like a rock but does more damage.

4. Levels with arrow traps become less dangerous over time – players need to be cautious when first exploring an area but can relax a bit when returning.

How do you achieve nice clear visual connections between items and their function for your game?

- First, be careful with what you add to the game. If something doesn't have an obvious function, it might not be worth including. Simple direct categories of things are best. If it's a game about inflicting violence, things that do damage make sense. If it's a game about planting and tending a garden, brass knuckles might not be a good thing to include. Adding weird machines to your game that do interesting things but have no visual connection to their function can be fun, but it's dangerous.

- Second, clear and consistent visual design can help make things make sense. Think through what the player needs to know and simple ways to get that across. Adding a face to the arrow trap is a great example – faces are something that everyone naturally perceives as oriented in a particular direction, and decorative statues make sense in the environment of *Spelunky*.

- Next, look at ways to enhance visual communication beyond just the look of the object itself. When something happens, add sound and visual effects to emphasize that action and call the player's attention there. Make the VFX persist for a little bit so the visual sticks around if the player doesn't notice it immediately. Have things flash different colors or outlines when they take damage. Decide what is important for the player to know, and spend your time and effort there.

- Finally, come up with clear and consistent visual communication that all objects share. When the arrow hits the player, there isn't a unique visual and sound to indicate that the player takes damage. All damage is communicated the same way. When other things later in the game shoot out other projectiles, use the same or similar sound and visual effects so the player associates them.

- Building to create consistent player expectations is true for visuals and also true for rules – other objects that shoot should follow the same shooting rules as arrow traps. They can break these established expectations, but only carefully. Ideally don't break more than one rule at a time. So future things should shoot a single projectile in a straight line triggered by motion in front of

the creation object. If you want to shoot lots of things that move erratically and trigger when anything gets near the creation object in any direction, that may be harder for the player to understand and require more careful tutorialization or difficulty balancing to make it work.

So, arrow traps make sense. Arrow traps follow a consistent set of rules that define their behavior, and lead to interesting dynamics. But that's just the start.

Procedural Fun

Procedural-level generation isn't just a fun party trick. When the player doesn't know what's next, and literally can't know what's next, they have to approach things differently. When the player dies in *Shovel Knight*, the player (hopefully) knows what killed them and what they did wrong. When they respawn at the save point, they are ready to try again. But in *Spelunky*, each challenge is unique and disappears when the player dies. The player can't just memorize what to do and then execute on that memory. The player has to analyze every situation as a new set of problems.

This puts a lot more pressure on the player to really understand what's going on. The player needs to be able to read the room and piece together how all the parts fit together, and then come up with a plan of attack that fits those problems. In *Shovel Knight*, the player can rely more on standard patterns of play – jump over everything – and correct their course when something new disrupts that pattern – a spike above the place you want to jump, for example. In *Spelunky*, the player only gets one shot and if they don't read it right the first time, it's game over.

To make this work, the player needs to be able to look at any combination of objects in the *Spelunky* universe and be able to predict what's going to happen with that combination in those precise positions. While this is possible in most games, *Shovel Knight* included, it's critical in a procedurally generated game like *Spelunky*. If there are combinations that are unpredictable or impossible, the game falls apart.

This means each element in the *Spelunky* universe needs to behave in consistent, predictable ways. And to complicate things even more, each thing needs to interact with each other thing in consistent, predictable

ways. This is true in all games – building the grid of "what happens when this touches that" is a big part of content design in many games. And many of those grid entries are going to be fun and interesting and lead to new types of gameplay and inspiration for levels. That's where most level ideas in *Where's My Water?* came from, for example. But some combinations just don't work right. Or aren't very fun. In a hand-crafted game like *Shovel Knight*, if there's a certain object interaction the game doesn't handle well, the level designer can just make sure those two elements aren't near each other. Problem solved! In a procedural game like *Spelunky*, everything needs to work with every other thing.

There's a great essay by Liz England called "The Door Problem". In it, she discusses all the things that a game designer needs to think about if their game has doors. Seems simple, but there's actually a surprising amount of nuance in even something seemingly obvious like doors. When you're playing a game, you focus on the interesting and complicated things. When you're making a game, everything is complicated. Simple things like doors are simple by themselves. Writing the code to make a door work is fairly straightforward and can be done quickly. But any element, doors included, may potentially interact with any other element. And all of those interactions only exist if the code knows what to do in that case. And the more interactivity and choice the game gives to the player, the more possible interactions that the development team needs to code. Freedom has a price.

Systems Thinking

What do we call a bunch of things that follow their own consistent rules, and also have consistent rules for how they interact with each other? We call that a system.

The study of systems as a whole – the shared understanding of how all systems work – is a new field that is just starting to make some big advancements in our understanding. If you're interested in this, I suggest starting with *Thinking in Systems: A Primer* by Donella Meadows as a good book to start with.

Once we have *Spelunky*'s arrow trap start interacting with everything around it, the game becomes a system. Individual rules for each object interact with individual rules for each other object to create new rules unique to the interactions. And since we know that rules create dynamics,

we also know that rules for object relationships are going to create dynamics unique to those interactions.

- Does the arrow trap trigger only when the player moves in front of it, or can other things trigger it?

 - If inanimate objects trigger it, then throw things to make the arrow trap fire without getting hurt. This increases the value of inanimate objects. In early levels where arrow traps are prevalent, a rock is a very useful thing.

 - If enemies trigger it, then knock an enemy into an arrow trap to kill two birds with one stone.

- What happens when an arrow hits a solid object?

 - If the arrow destroys itself, things are clean and simple but the player can't use it as a weapon later on.

 - If the arrow sticks in the wall and can be picked up after, it's a nice safe way to make it available to players later, but it might be a challenge to reach it.

 - If the arrow bounces off the wall, it's available for use later but may still be a threat while it's bouncing around. This is the actual answer in the published game.

- What can the arrow damage?

 - If the arrow only damages the player, that's simple and clear but removes the possibility of some fun dynamics.

 - If the arrow damages anything alive, that makes sense and allows players to use arrows to remove other threats like enemies.

 - If the arrow damages every type of object, then level design needs to consider that since placing a pot in front of an arrow trap basically removes the trap as a threat.

 - And if an arrow damages the terrain, that's interesting and opens up some interesting dynamics where the player can use an arrow trap to access new areas. But it doesn't really feel right for an arrow. And also might be too powerful if the player can pick up an arrow

and destroy any terrain anywhere. Maybe if it was a cannon, this would make more sense. That might be an interesting variant of the arrow trap to add in later levels.

Making the game rely more on system interactions opens up new possibilities. In a game like *Shovel Knight*, the game designers craft interesting and fun interactions that the player discovers and solves. In a game like *Spelunky*, the systems of the game allow for interesting and fun interaction that the player has to create on their own. This may sound like the game designer is less involved, but actually the opposite is true. The interactions between objects in a game like *Spelunky* are only interesting if they are carefully thought out to ensure that the player can find fun in almost any interaction. And the level design may be procedural, but there is a lot of thought put into how things are placed to ensure that they are fun and not too difficult or frustrating. Derek Yu's book talks about all the ways he ensures that players don't get stuck in dead ends or have exit doors in impossible-to-reach locations. Good game design doesn't happen by accident.

Dissecting Systems

To understand a game, you have to understand all the elements of the game. But the tricky part is understanding how all those elements fit together into systems.

Game development teams often talk about any collection of features and rules as a system. There's a combat system and a magic system and an AI system. This is a loose and casual use of the term, but it works. When you have a lot of elements that closely relate to each other, their rules are more likely to butt up against each other and lead to systematic interactions.

So, what are the systems in a game like *Spelunky*? We can do a big brainstorm like we did with verbs and other things before. The idea here is to think of any collection of smaller features that might affect each other. Anything that someone would have to code or build to make the game what it is today.

- Movement: The player's avatar can move around, including running.

- Jump: The player's avatar can jump and control their motion in the air. Depending on the purpose of my dissection, I might just group this in with movement.

- Terrain: There are platforms and other types of terrain that characters can stand on. Terrain can be destroyed.

- Items: The player can acquire items that basically act like powerups, giving the player different interactions with the game. This includes things like Bombs and Climbing Gloves.

- Traps: There are objects placed in the game world that actively try to harm the player. This includes things like Arrow Traps.

- Objects: There are objects placed in the game world that the player can pick up or otherwise interact with. This includes things like Rocks and Stone Blocks.

- Monsters: Enemies that try to harm the player.

- Bosses: Enemies with more complex behavior patterns and (often) specific levels built for them.

- Combat: The player can interact with enemies to defeat them or take damage.

- Damage: The player and monsters have defined health points that can be removed. When they reach zero, that thing dies.

- Death: What happens when the player's avatar dies?

- Time: The game tracks how long the player spends in each level.

- Specter of Death: If the player spends too long in a level, a ghost appears to encourage the player to move on.

- Money: When the player collects items, they are translated into a number. The player can spend this number at shops.

- Damsels: The player can find characters in the levels. Rescuing them earns hearts.

- Idol: The player can find special treasures in the levels. Picking this up triggers a boulder trap.

- Shops: The player can find shops where they can buy things. Attacking the shopkeeper has consequences.

- Altar: The player can find altars where things can be sacrificed for rewards.

- Level Generation: There is a system of rules that determine how levels are created.

- Tutorial: There is a tutorial that the player goes through the first time they play that introduces the basics of the game loop.

- Progression: The player advances through levels, heading toward the end.

- Game Modes – Daily Challenge, Deathmatch: There are different ways to play that this book isn't going to cover in detail.

- Customization: The player can select the appearance of key objects in the game.

- Cinematics: At key moments, the game presents non-interactive sequences of information. This includes things like the opening and the ending.

- User Interface (UI): The game lets players select things in menus to start games and select other things.

- Options Menu: There is an options menu where the player can set various things.

- Leaderboard: There is a leaderboard to track progress relative to friends.

- Achievements: There are achievements the player can unlock.

As with verbs, we can group these into meaningful categories (Figure 6.4).

We can start with the core loop. What can the player do? What has to exist for the player to be able to do anything?

- Movement
- Jump
- Terrain
- Items

Then we can add obstacles and challenges. What makes the player's progress uncertain and difficult?

- Traps
- Objects

Spelunky Systems Map

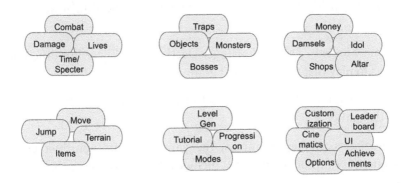

FIGURE 6.4 Diagram showing the features from the list as boxes.

- Monsters
- Bosses

What are the rules for how the player interacts with these challenges? What are the consequences for failure?

- Combat
- Damage
- Lives/Death
- Time/Specter of Death

Then there are goals – things the player wants, and ways to turn one resource into another.

- Money
- Damsels
- Idol
- Shops
- Altar

Once you have verbs, challenges, and goals, you have a full core loop.

The idol is interesting because it bakes risk into its reward. And the same can be said for many of the threats mentioned above – sometimes the risk and the reward are separate features that need good level design to fit together, but sometimes the risk and reward are baked into the feature itself. These features can defy simple categorization into binary good/bad buckets, but for a quick review I don't mind simplifying a bit. Just remember that these categories are not absolute.

Then there's the stuff you need to make the core loop work over multiple cycles.

- Level Generation

- Tutorial

- Progression

- Game Modes – Daily Challenge, Deathmatch

Finally, we have the stuff that happens outside the gameplay.

- Customization

- Cinematics

- UI

- Options Menu

- Leaderboard

- Achievements

This last list includes all the connective tissue to guide the player through and tie everything together (Figure 6.5). When we talk about the features or systems of the game, sometimes these are left out because they're not really the "game" in a technical sense. But they're very important to consider when you're thinking about building a game, as they take time and money and need thought. But when we're just trying to understand the gameplay, we can set these aside.

Similarly, I debated including "Game Engine" and "Graphic Engine" and "Sound Engine" and "Tools" in the above lists. These are a layer

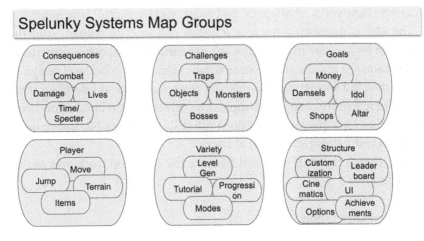

FIGURE 6.5 Diagram showing features grouped into categories.

removed from even the UI setup when considering the game itself but are important to the development process. When I started in the industry, these would be the first things to be considered and would require months of work. Nowadays, many games use off-the-shelf engines to completely bypass these issues. Most of the time, when I talk about the "systems of the game" I wouldn't include these, but if we're looking at the list as a to-do list for game development, these are important things to consider.

System Link

Identifying the systems is useful. Once we have a list, we can start to consider how these systems fit together.

1. Jump + Combat (Figure 6.6)

 a. To defeat an enemy, you need to position yourself in a place where you can damage them.

 b. When you land on an enemy from above, you damage the enemy.

2. Combat + Items (Figure 6.7)

 a. Items can be thrown to damage enemies.

 b. Items can contain enemies that are released when the item is destroyed.

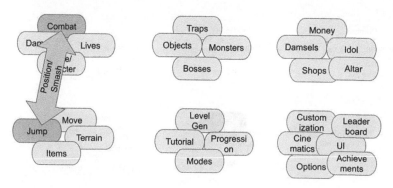

FIGURE 6.6 Diagram showing the previous feature list, focused on these two.

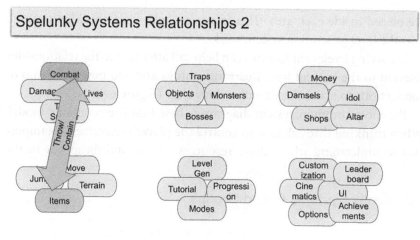

FIGURE 6.7 Diagram showing the previous feature list, focused on these two.

This can lead to nearly infinite possible combinations, so drawing out a complete diagram of every possible connection is an impossible task. When thinking through connections, it's often best to approach a diagram like this with a particular lens. For example, focusing your attention on Level Generation (Figure 6.8) allows you to consider how each other system is used to generate new levels. Some features determine the base terrain of each area, and some features determine the smaller items that

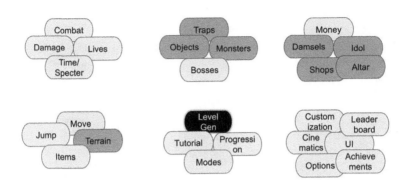

FIGURE 6.8 The system list from before, with items relevant to Level Generation called out.

are placed inside each area. This focus can help when thinking through how the level generation system works.

Removing irrelevant features can help call attention to the relationships relevant to the current lens. Rearrange things and add new groupings or connections to make these relationships clear (Figure 6.9).

The most common system diagram is based on the economic model. When thinking through how to control the player's resources, it's important to understand where those resources appear and disappear in the

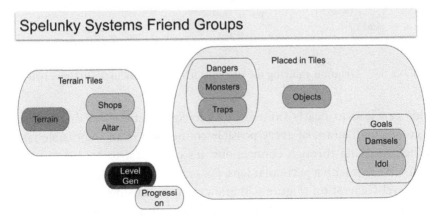

FIGURE 6.9 Level Generation systems grouped in the ways relevant to Level Generation.

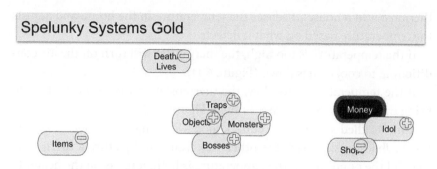

FIGURE 6.10 Diagram showing systems that add or remove Gold.

game. So, mapping out the possible economic impact of each feature is an important way to understand how the game's economy works. *Spelunky*'s economy is fairly simple, with Gold as the only real currency the player interacts with. There are a few other resources that can tie to Gold, such as when the player trades Health or Time (or the risk of losing Health or Time) for Gold by attempting a risky maneuver. But for the most part, analyzing where Gold is gained or lost is the key to the economy and thus a good place to start an economic analysis (Figure 6.10).

When designing a game, thinking through system connections can be a useful exercise – compare each system with each other system to see how they relate. This will often expose things that can easily be overlooked in a game design. This can also spark new ideas – what if this system related back to this other system? Small simple games often don't need a lot of systems or a lot of connections, but a robust dynamic game wants to give players ways to mix everything together. Systems that don't relate to other systems are often not really doing much in the game and sometimes are best removed.

Systems Thinking

Once you understand the systems of the game and how they start to fit together, you can start applying more advanced understanding of how systems work to better understand your game. There are rules that guide how systems work, and a strong game designer can use these rules to their advantage.

Systems Thinking – Feedback Loops

Cybernetic systems aren't robots or AI-based systems. It's a term for any system where one element can regulate another. The classic example is the

thermostat in a house. It senses the temperature in the house and adjusts the temperature based on what it detects.

If the temperature is too high, the thermostat will turn on the air conditioning to cool things down (Figure 6.11).

If the temperature is too low, the thermostat will turn on the heat to bring things back to the desired range (Figure 6.12).

This is called a negative feedback loop – if things go in one direction, the feedback pushes back the other way. You could picture a thermostat that did the opposite – if the temperature is high, it turns on the heater to

FIGURE 6.11 Too Hot: Diagram showing temperature pushed down.

FIGURE 6.12 Too Cold: Diagram showing temperature pushed up.

make things even hotter. That would be a positive feedback loop. This would not be desirable in a thermostat but has uses in other places.

How can you use feedback loops in your games?

The classic example of a negative feedback loop in games is the interactions between the powerup system and the race rank system in *Mario Kart* (and other similar racing games). Powerups are semi-randomly generated, but the range of options varies based on the player's current position in the race. Players who are doing well get only simple small items, while players in the back of the pack get much more powerful items. This creates a dynamic where players who are in the lead tend to fall back a bit and players who are in the back have a way to get back into the race. This is a desirable dynamic for the game designers, as a close race where you see your opponents near you is more exciting than a race where one player gets a huge lead at the start and never loses it.

There are lots of similar ways that system interactions can create negative feedback loops that make the game better:

- Give players who are behind ways to catch up. There's a *Magic: The Gathering* spinoff called *Duelmasters* (2002) or *Kaijudo* (2012) (I worked on a PS2 version) in which players don't have life points, they have shields. Shields are represented by face-down cards that the player puts in front of them at the start of the game. Whenever the opponent has a successful attack, the player loses one of their shields, and if the player has no shield when attacked they lose the game. But the genius game design is that when a player loses a shield, they pick up the card and put it in their hand. The player who is behind in victory gets a big resource advantage, which might enable them to come back and win, or at least make the game closer and more exciting.

- Any multiplayer game with a reasonable amount of information sharing will automatically have negative feedback loops. In *Catan*, when a player gets close to winning, other players notice and take action. Robbers are placed on that player's tiles. Trades with that player become much more punishing. In the start of the game, everyone is equal so everyone is happy to perform mutually beneficial actions. But if the mutually beneficial action gives you the victory but only gets me to the halfway mark, then it's not in my best interest to do so. Negative feedback is built into any system with a slight amount of politics.

And don't forget positive feedback loops. Positive feedback loops can be dangerous, because they feed on themselves and keep getting bigger. But sometimes you want that.

- Most progression systems have a bit of positive feedback built in. Players who collect enough resources to advance in stats or money or research or whatever are rewarded with powerful items or abilities that make it easier for them to collect more resources. Left unchecked, this can make a game way too easy once the player gets started. Which is why most games check progression by increasing the power and danger of the threats to match. In some cases, this is done naturally through level design, but open world games can struggle with this. Early Bethesda games got criticized for artificially increasing the power of enemies to match the player, which made players feel like advancing wasn't worth it.

- When you want a board game to end quickly, give the player who's in the lead an advantage. Many board games have powerful abilities players can acquire in the late game, which are meant to bring the game to a close.

- When you want a board game to feel out of control, a positive feedback loop is just the thing. *Pandemic* does a great job of using multiple positive feedback loops to ensure that players always feel like the world's about to end. And often, that's exactly what happens.

Deep Systems

One key lesson in *Thinking in Systems: A Primer* is the idea that changing a system is hard. And the mechanisms to make a change are often not the ones that people find intuitive. The book ranks the effectiveness of different leverage points on their ability to bring about real change. "Numbers" is the worst. Just changing around values in an existing system is unlikely to fix your problem. This is often the first place game designers (including myself) go when trying to fix things – can we rebalance the game by adjusting the hit points and damage of a few enemies? If it can work, it's quick and easy. But if the problem is more fundamental than just a local balance problem, these types of changes aren't going to be enough.

Delays are more important than values. If the impact of an action in one element isn't felt until multiple steps later, that can drastically change

how that action interacts with other things. You can see this in any game economy – long-term gains don't matter if the player dies on the next level, and players tend to understand that. Similarly, delayed benefits in a combat system are much harder to make valuable. Every *Pokémon* game ever has had various status effect that are supposed to be useful and meaningful. But the delayed benefit is hard to balance against the immediate benefit of doing more damage. Especially in a combat system where most fights only take a few turns. Spending a whole turn for a delayed benefit is rarely better than just attacking again and ending the combat earlier.

Feedback loops are fairly impactful – they rank around the middle of the list.

To really enact change, the change has to be fundamental to the system. Change the rules of the system. Change the goals of the system. Change how the system organizes itself. When you're looking at a problem in your game that involves the whole core loop or multiple elements in your progression system or other systematic issues, try to look deeper than some number changes. Look at how the system elements fit together. What are the system rules that guide that interaction? What are the dynamics that appear as a result? What dynamics would be better for the game design? How do I change the rules so those dynamics happen? That's where game design gets challenging and interesting and (in my opinion) fun.

Systems Are Fun

Understanding systems is understanding games. Games are systems and the systems are where many of the most important qualities of the game live. As a game designer, you're not trying to achieve certain rules, you're trying to achieve a feel or a strategy or make the player have an emotional response. These are all dynamic responses to sets of features, not one thing that the designer can mandate. Understanding how to create fun dynamics requires understanding systems more than anything.

Magic: The Gathering / Content

MAGIC: THE GATHERING

Magic: The Gathering (also known as just *Magic*) is a great game.

In *Magic*, players build decks of spells and duel as wizards. Decks are made from cards, and each card has its own self-contained set of rules that are printed on the card. Some cards are fairly simple, but others can radically change the rules or even the goal of the game. These cards are acquired in randomized packs, with new sets appearing on a regular basis, which add new cards and thus new rules.

Magic (Figure 7.1) is one of the most successful games of all time. It has sold billions of cards over the 30+ years it has been on sale. It has spawned the genre of collectible card games that continues on today, and inspired hugely successful digital games such as *Hearthstone* and *Marvel Snap*.

I have played *Magic* since it first came out, but I have never worked on it. The closest I've come is a PS2 version of *Duelmasters*, which was a slightly simplified version of *Magic* from the *Magic* developers. That card game took off in Japan but never managed to find the right niche in America, which is a shame since it was a fun game. Many of the ideas from Duelmasters are starting to appear in newer collectible card games like *One Piece Card Game* (2022) or *Star Wars Unlimited* (2024).

 DOI: 10.1201/9781003346586-7

FIGURE 7.1 *Magic: The Gathering* photo – my Griffin commander deck.

MAGIC: THE GATHERING – GAMEPLAY DISSECTION

Verbs

What do you do in this game?

Magic is a little tricky here. Since every card can have unique rules and abilities, it's hard to really say every possible action the player can take. So in a case like this, it's necessary to abstract a bit in order to have a clear discussion.

Abstracting a bit, the things a player can do in *Magic* are:

- Play Cards

 - Play lands (one per turn)

 - Play other cards (constrained by available mana, which generally comes from lands)

- Attack
 - Declare Attackers (and declare targets if there are planeswalkers or battles in play)
 - Declare Blockers
- Activate Abilities
 - Cards in play can do all sorts of crazy things, often requiring "tapping" so that card can only be used once per turn

There are other types of verbs that are the wrong type of action. "Tap" is just the mechanical representation of how activating abilities and attacking work. There are other types of verbs that state player goals rather than direct actions – "Gain Power", "Destroy Enemy Things", "Win". These are expressions of goals and we'll cover those in a minute.

So "Play Cards", "Combat", and "Activate Abilities" are the complete set of (abstracted) actions that the player can take in *Magic*. But that doesn't really tell us much about how the game works. As before, Verbs only really make sense in the context of Goals.

Goals

Why is the player performing these actions?

The goal of *Magic* is to win the game. There are a variety of ways to do that, and individual cards can create entirely new victory conditions. Similar to actions, it's hard to pin *Magic* down to just one interpretation. And you can go to higher levels of motivation that span across multiple games. Why does the player play *Magic*? What are they trying to get out of this as a hobby? If you're interested in this level, go read Mark Rosewater's essay "Timmy, Johnny, Spike" for an insightful discussion of player motivation.

When you look at the things the player wants in *Magic*, there are two main buckets, which align nicely with the actions they can take. And with things found in other games.

- Build: Gather resources, increase your ability to do whatever you want
 - Gain sources of mana (Land)
 - Enhance your board presence (Creatures, Artifacts, Enchantments)

- Make your things more powerful (Auras, Equipment)
- Attack: Various ways to reduce the opponent's life total
 - Initiating combat with creatures
 - Casting direct damage spells

To be clear, this is not complete. There are plenty of things you can do with cards in *Magic* that don't fit cleanly in these buckets. Cards have various abilities, and players might use an ability as part of a multistep process that leads to a positive result. Combo decks have clear Build actions but often use other paths to victory that skip Attack entirely. If you really want a complete list, you can rephrase "Attack" as "Win" and group non-combat victory conditions in there.

- Build: Gather resources
- Win: Progress toward a victory condition
 - Doing damage
 - Milling (removing cards from the opponent's deck – if there are no cards left, they lose)
 - Playing cards that change the win condition

That's more precise, but we're still missing a large category of *Magic* actions. Spells that kill creatures or counter spells are a key part of the game and aren't technically part of Build or Win actions. You could argue that these are part of Build since it's a zero-sum game, any action that reduces the enemy's power increases my power. Players can build winning decks that have very few positive build actions and lots of negative destroy actions. And this is a valid way to look at it. But there are definitely differences between ramp actions and removal actions that are worth considering.

- Build: Gather resources
- Destroy: Remove the opponent's resources
 - Kill creatures

- Counter spells

- Weaken creatures

- Make it harder for the opponent to do things

- Win: Progress toward a victory condition, such as doing damage

Similarly, if we want to dig a little deeper, we can break Build into two types of Build. Some building focuses on directly building ways to win – adding power to creatures, creating new ways to attack without being blocked, etc. Some building is focused on economic goals – increasing your ability to make more stuff. Building a strong mana base can be understood as a related but separate action from using that mana base to add creatures to the battlefield.

- Build Economy: Gain the ability to make more things.

 - Play lands.

 - Play artifacts and creatures that produce mana.

- Build Power: Gain the ability to win.

 - Play creatures.

 - Play auras and other power boosts.

- Destroy: Remove the opponent's resources.

- Win: Progress toward a victory condition, such as doing damage.

This seems like a good model for *Magic*'s actions in the context of their goals. We could keep going and finding more exceptions and breaking out sub-categories for everything. Once you start abstracting up from direct player actions like button presses, there's some level of subjectivity and interpretation that is inherent to the process. The "right" level of abstraction depends on a lot of things. Why are you dissecting? Are you building a similar game and want to compare how your competitors work? Are you trying to understand player psychology? The level of abstraction and the types of groups you create depend on your needs. Feel free to experiment with different approaches and different lenses until you find the perspective you need.

Challenges

Magic creates challenge and uncertainty through other players. *Magic* is (almost) always played with other players who have the same potential abilities and power as every other player. They might have a different deck, but nothing (other than money) is preventing them from having the same deck. Having a different deck is one of the choices that make up the game – "deckbuild" is an important and interesting verb. But during play, every player follows the same rules and has the same victory conditions available to them. It's like a video game deathmatch in this way.

Magic also creates challenges due to the economic systems of the game (Figure 7.2). The mana system is a very clever way to prevent players from playing all their best cards on the first turn. These rules create challenges players have to plan around and optimize in order to win. *Magic* resembles *Settlers of Catan* in this way – the biggest challenges are often the limitations created by the rules, not the creatures or players.

Magic also resembles *Settlers of Catan* in that randomness adds a lot of uncertainty. *Magic* generally frowns upon putting purely random effects on cards. But every turn starts with drawing a card from a randomized deck. Even when playing the same deck over and over, the player doesn't know what's going to happen next. Long-term strategies are possible, especially with the control provided by deck construction, but there is enough uncertainty that predicting the state of the game even a turn or two in the future is futile. This isn't *Chess* where every consequence of

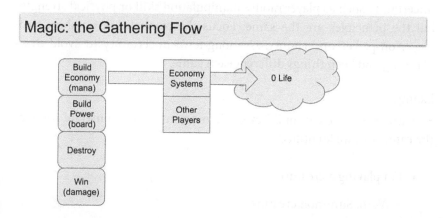

FIGURE 7.2 *Magic* Flow: Simple diagram of Actions, Challenges, and Goals for *Magic: The Gathering*.

every action can be thought through – randomness keeps players focused on the present.

Even beyond randomness, individual actions in *Magic* don't have any type of challenge or uncertainty to them. The rules are very clear and consistent and tell you what is going to happen for each player action, including all the crazy things that appear on specific cards. Most uncertainty is at the goal and strategy level – will this have the desired longer-term effect? How will the enemy respond? Any uncertainty on my action depends on the enemy player responding to it with their own action – instant speed cards like counterspells and protection spells mean my action might not happen, but that's enemy uncertainty, not uncertainty on the action itself. The big exception to this is attacking – when I attack, the opponent has the ability to block and I don't know how they're going to do that. So, attacking is a key moment with more uncertainty and challenge than other actions in *Magic*.

Magic focuses its uncertainty in two places: (1) other players and (2) the future. The player can safely plan out a turn worth of actions, including an attack, and the only unknowns are the other player. That doesn't work over many turns since drawing cards from the deck has a huge effect on those plans. But immediate plans are a duel between two players with access to the same resources and tools. This creates a highly competitive environment where players feel that their skill is what determines success or failure. *Magic* succeeds as a highly competitive space because the uncertainty is put in the right place to create that environment. Other highly competitive games like first-person shooters or sports might have different types of uncertainty such as player mouse manipulation skill or physical strength, but the principles are the same. Focus the competition on short-term player-on-player uncertainty. Use long-term uncertainty to avoid over-planning and keep things different each game.

Examples

So with *Magic*, we can build example moments to demonstrate some of the categories we identified.

- I'm playing a creature.
 - Verb: Summon creature
 - Goal: Build – Board Presence

- Challenge: No direct challenge, but limited by the mana system and can be countered or destroyed

- I'm attacking with all my creatures.

 - Verb: Attack

 - Goal: Victory Condition (damage)

 - Challenge: Opponent can block or otherwise prevent my attack from damaging them

- I chump block your attacking creature, sacrificing one of my small creatures to prevent the damage

 - Verb: Block

 - Goal: Build – in that you're trying to retain your resources (life)

 - Challenge: Opponent and anything they might do

- I block your attacking creature with a roughly equal creature, and they both will die

 - Verb: Block

 - Goal: Destroy – in that this removes their creature. But there also might be some Build going on at the same time, by maintaining your life total. Goals can overlap like that.

 - Challenge: Opponent and anything they might do

- I'm casting a spell to destroy your creature.

 - Verb: Cast spell (that destroys a creature)

 - Goal: Reduce opponent's power

 - Challenge: No direct challenge, but you might counter or otherwise respond

- I'm casting a spell that doesn't directly add to my power or reduce yours but sets up for something in the future (let's say it's an enchantment that changes some of the rules of the game)

 - Verb: Cast spell

- Goal: Build – but indirectly in the future, possibly overlapping with directly moving toward a combo-based Victory Condition.

- Challenge: No direct challenge

States

Similar to *Centipede*, we can identify some states to a game of *Magic*.

Players start with no resources, so every game has to start by gaining some resources such as playing lands. During this building phase, players are necessarily focused on Build actions. The length of this phase can vary greatly. Some decks try to make this as quick as possible to overwhelm an opponent before they're ready, while other decks focus on long-term Building and try to surpass their opponent in resources.

Once a player has creatures out, there are two options. The game can go into an attack state where one player is trying to damage the other. Or it can go into a stall state where both players have creatures out and neither has a strong attack. In this case, both players revert to Build actions until one gets enough of an edge to attack.

As this is *Magic*, there are plenty of exceptions to these general themes:

- A player may have a way to damage the opponent without attacking, so they can ping the opponent for damage during a stall state.

- A player may have an evasive creature that can attack during stall, such as a flying creature, so they can ping the opponent for damage during a stall state.

- A player may be trying to win through other means, so they prefer a stall while they gather the resources needed for their combo.

- A player with a combat trick may want the opponent to think that it's a good time to attack, then surprise them with an unexpected shift in power during the combat.

If you want to understand how individual games play out, understanding the states of the game and how they play out is key. These are important things to understand, but I'm not going to dig super-deep into this, because there are lots of people who can tell you a lot about these dynamics. *Magic* is a game that has been highly analyzed, and most of that is at this level where individual games are analyzed to help people become better players

(I like the podcast Limited Resources and videos from The Professor, but there are plenty of other good examples). This is a great example of a type of game dissection that is going strong already and can be found for most games with a robust tournament play community.

Systems
Mana
The mana system is a great example of a way to make Build actions interesting. The player has limited resources to use each turn. New resources are available, but they're heavily dependent on randomness and are limited to one per turn. The game generally follows a standard pace of one new mana per turn, but this is not guaranteed and stalls out at some point. The player can influence these factors via deckbuilding but doesn't have complete control.

Not to say that the mana system is perfect. In many games of *Magic*, one side loses quickly because they couldn't get enough resources or got too many. This leads to games where one side doesn't feel like they even got a fair chance to participate. This is not a feel-good moment, and many later collectible card games change up the mana system to make it more predictable.

The mana system touches every other system. There's not much you can do in a game of *Magic* without mana. This fundamental constraint creates a pace for the game. Small things happen first, and big things might not happen since the game could end before then.

Combat
Combat is a complex system with lots of moving parts of its own.

One reason *Magic* is fun is that each combat is like a new little puzzle that both players see from a different angle. Each player is trying to figure out how to optimize the damage dealt/taken and minimize the resources lost (usually creatures, but sometimes also mana and other things). Most combats have the right number of moving parts and options to be fun for most people. When the number of creatures gets large, it becomes a different type of fun – dealing with big numbers that get out of control.

Combat affects most other systems in *Magic*. Players can build a deck that doesn't use combat, but it's pretty rare. And even that deck needs a plan to deal with the enemy's combat phases. Most of the Build actions players take in a normal game of *Magic* are there to make combat better

for the player. Combat is the focus of the game, and the way that most games of *Magic* determine a victor.

Spells

One system that has changed over the 30 years of *Magic* is the spell system – how spells are cast and enter play. Old people like me remember the rules changes of Sixth Edition (1999), which introduced the Stack. Before the stack, part of the fun of playing *Magic* was arguing about the timing of conflicting cards – many pre-*Magic* games like *Wiz War* or *Cosmic Encounter* thrived on timing arguments. But that's not fun for everyone, just argumentative folk like me. Most people want clear rules that prevent arguments. When each card has its own rules, the core rules need to be extra-solid to handle all the conflicts. Pre-Sixth, the rules were manageable but led to a good number of counter-intuitive exceptions, which led to arguments. The Sixth Edition rules cleared most of this up, making timing rules simpler and easier to manage, which is good for the game but bad for the friends of mine who like to argue.

Deck Building

Deck building is a fascinating system that is part of how collectible card games became hugely successful.

Deck building has a big effect on each game. Since players can make all sorts of crazy decks, each session of *Magic* is very different from each other one. A fast Red Deck Wins deck against a slow Green Stompy deck is going to play very different from a controlling Blue Permission deck against a White Weenie swarm. This provides a great amount of variety, which is a goal for (almost) every game.

Deck building is also very important in that players can participate in the game when they're outside of the game. The hardest part of any board game is finding other players and getting them all in the same room. With *Magic*, even if you have no one else in the room you can still sort through cards and think about what they do and build interesting new decks. The *magic* circle of the game doesn't end when the other player leaves – I can be part of the game at any time. This keeps players thinking about and excited about the game even when they're not playing. This can also be seen in digital games – maximizing a *Diablo* or *World of Warcraft* build can take hours of planning, and in the modern era players can spend hours

poring over strategy guides and discussion forums to participate in the game even when outside of the game. As a game designer, try to spot these opportunities and encourage ways for players to be engaged even when they're not playing.

More Systems

Magic has lots of systems and a full systems analysis is worthy of its own book. Alas, this is not that book. I have to settle for just scratching the surface and showing some of the biggest examples, but hopefully this provides a starting point for further explorations of this game and other games.

MAGIC: THE GATHERING – NON-GAMEPLAY DISSECTION

History

Magic came out in 1993 and immediately rocked the board game world. Stores literally couldn't keep it in stock for years. Within a few months, there were countless competing collectible card games. Most of these were terrible games that didn't understand the quite clever ways that *Magic* worked, including the one I worked on when I was at Mayfair Games. A few were great and had large followings, at least for a few years.

Somehow, miraculously, *Magic* has survived as a continually published game with new content out regularly for the last 30 years. This is an amazing accomplishment. Think about how many games have a continual audience for that long. There are a few "classic" board games that can say that – chess and *Scrabble* and arguably *Monopoly*. But these are all static games with no new content (at least in a meaningful game design sense). And there are a few video games that get close to that, but only if you count some fairly radically different sequels as the same thing. With *Magic*, the core rules today are very similar to the ones that came out in 1993. Every card that came out then can still be played today.

Part of the reason that *Magic* has survived is that the team working on it has had all that time to think about what works and what doesn't in the game. Mark Rosewater has been a lead designer on *Magic* for most of those 30 years, and he is very public about the ways that they design and how they think about the game. His articles and blog and podcasts and other discussions are a great insight into how to do a 30-year-long deep dive into one game.

<div style="border:1px solid">

FOCUS

I'm jealous of Mark Rosewater. Mark Rosewater is the head designer of *Magic* and has been for many years. On one hand, that can be very restricting – sometimes you want to jump onto something new. But on the other hand, that means he's been able to think about how that game works and how to make it better and keep deepening his understanding of the game for decades. Most games don't have that luxury. A game is pitched, it takes a year or two to make, and if it's lucky it has a few years of live support. If it's a huge success, it might spawn a genre of similar games. But with *Magic*, it's been the same core rules for over 30 years, and Mark Rosewater has been able to learn things about that rule set that wouldn't normally be possible. He writes a column on their website, so he sometimes shares some of the insights they've learned over the decades, and I have a lot of respect for the depth of thought that has brought. There's a great piece on player types ("Timmy, Johnny, Spike"), my favorite starter piece on randomness ("Kind Acts of Randomness"), and a thoughtful redesign of the whole game to keep rampant difficulty creep in check ("New World Order"). Most games don't even have time for rampant difficulty creep to set it, much less time to identify it, and then come up with thoughtful solutions that propel the game forward additional decades.

</div>

Money

Magic's design is heavily based on a revolutionary monetization scheme. Randomized cards that are also game objects were (mostly) unheard of until 1993. This was the immediate hook that made people pay attention to *Magic* – it's like baseball cards that are also a game. That was a compelling hook back when baseball cards were a thing that everyone knew.

Magic revolutionized games in many ways, but this may be its most lasting legacy. *Magic* created a new genre of trading card games, which is still going strong in both print and digital. But the concept of randomized game content that players can assemble on their own has created multiple genres and re-shaped many more:

- The entire free-to-play category of games is based on loot boxes that are basically card packs.
- The deckbuilding genre of board games such as *Dominion* are deeply inspired by the way decks are built in *Magic*.

- The draft format is a popular way to play *Magic* that inspired board games like *Sushi Go!* (2013).

- *Diablo* was originally going to be a game like *Magic*, sold in booster packs. While that didn't happen, the idea of random rewards that players assemble into a single thing has been the focus of many role-playing games ever since. This style of RPG did exist before, but the emphasis on high levels of randomization and character building increases post-*Magic* and post-*Diablo*.

How does this affect game design?

It's easy to see how monetization affects the design of *Magic*. The entire game design is built around making sense of selling a randomized pack of cards. Everything starts there. Deckbuilding is a clever way to allow players to incorporate these new cards from purchased packs into their game. The rules of the game are flexible enough to allow all the cards that come out of the packs to work together.

It's also easy to see how the outrageous success of this monetization plan led to the history of *Magic* game design. The business plan of Wizards of the Coast is all about releasing more packs with more new cards. This requires constant exploration of new card mechanics and innovative new ways to get as much value as possible out of every mechanic that exists. And a continual near-impossible effort to keep all those cards balanced, especially once the tournament scene takes off. It's a great example of why game design matters – the core ideas of *Magic* are strong, but we wouldn't be talking about it 30+ years later unless the content design managed to keep that design fresh.

Technology

We don't really think of card games as a technology, but *Magic* wouldn't have happened without access to advances in printing that came about because of the non-game collectible card market. Carta Mundi in Belgium already had large printing presses that were able to sort and distribute cards into packs. In some ways, *Magic* was a logical extension of improvements in the collectible card industry.

How does this affect you, the clever game designer?

Many of the details of early collectible card games were decided by technology. Rarity levels only exist because the card sorters could handle them. Cards were sold in randomized packs and randomized decks because

that's what people knew how to do. Non-randomized decks were possible and came along a few years later. The limitations and costs of printing have a huge effect on decision-making in the board games world. Individual game designs can change based on the availability of specific types of pieces – either avoiding expensive or fragile pieces, or building a design around a cool new technological option. And costs and limitations have a huge effect on corporate decisions. *Magic: The Gathering* only exists because Richard Garfield first pitched *Robo Rally*, but Peter Adkison thought it would take too much effort to print all the parts and asked for something simpler, like a card game.

Senses

When it first appeared, *Magic* did a lot of things right. Randomized packs made every game different. The mana system balanced play. The different colors gave players different factions to align with. One key idea that gets less attention is the focus on art. Nearly half of every *Magic* card is pure art with no effect on the game rules. And this is critical to the success of the game – part of why *Magic* is fun is that the cards look so good.

Emotion

What does it feel like to play a game of *Magic*?

There's frustration. Usually the satisfying motivating frustration. The annoying discouraging frustration sometimes pops up, normally around either the mana system or other players' choices.

There's fiero, the excitement of victory (terminology from Lazzaro's 4 Keys 2 Fun). Winning a big game feels great.

There's the feeling of being clever that is common to many strategy and puzzle games.

But *Magic* takes this one even further by adding more layers to the cleverness.

- You can be clever in a particular choice at a particular moment. The combat puzzles as discussed above.

- You can be clever at the strategic level by maximizing the deck's strengths to pull out a win.

- You can be clever before the game even starts by building a good deck with the right cards to ensure victory.

That last one is especially important because *Magic* gives you all sorts of ways to make victory *your* victory. When you're playing with a certain deck, it's *yours* in a way that most other games can't manage. Sure, I like being the dog in *Monopoly*, but I don't feel clever for being the dog. And I don't go online to discuss what it's like to be the dog and how to do it better. Building a deck in *Magic* is a statement of identity and ownership and belonging that gives the player an emotional investment in the game.

This can be seen in other trading card games that go even further. *Legend of the Five Rings* (1995) was a collectible card game where different factions battle in a *magical* world inspired by Asian stories and myths. *Legend of the Five Rings* had a clever hook where the story of the world was being written alongside the game and players could influence the results. Winning a major tournament might win a certain reward for your faction, which would appear in a story on the website a few weeks later, and have narrative ramifications for years to come. This led to strong identification with the factions, and players taking on that identity in a way that drove strong loyalty to the game. There's a story of two Naga players at a major tournament at GenCon who refused to battle each other because their faction wouldn't do that (so they resolved the tournament win another way). The story is told in the Imperial Herald v2 no3, and mentioned in the *Way of the Naga* sourcebook. *Legend of the Five Rings* put this factionalization front and center by putting the faction on the box of the starter decks. So before you even played the game for the first time, you were making a choice that had an emotional impact.

Narrative

Magic: The Gathering is an interesting example of how hard storytelling is in interactive media. *Magic* works hard to build cohesive worlds and tell compelling stories. But instead of the luxury of hundreds of pages of text nicely arranged in a book, *Magic* has to tell a story one sentence at a time on randomly distributed cards. The writer has no way to control the order in which the reader/player experiences the story. As you might imagine, that can make it difficult to tell a coherent plot. As such, *Magic* writers often focus more on the worldbuilding side of storytelling, with key plot points told outside of the game itself through website short stories, books, and other supplemental material. It's an interesting and difficult challenge, and the extreme case of the problem of truly interactive storytelling.

Meaning

What is *Magic* about? What does *Magic* say about the world?

As is often the case, there are lots of possible answers to this.

To me, *Magic* is about Infinite Possibilities in Infinite Combinations (phrasing borrowed from Star Trek). Deckbuilding is about trying to find creative ways to combine different pieces together. Each piece may be weak on its own, but together they can be stronger than each piece is alone. Every card has value, it just has to find the right environment that embraces what makes it special.

CONTENT

Magic provides a clear demonstration of another way to dissect games. Games are made up of two things: rules and content.

Content is the stuff of the game – the enemies in a combat game, the player's powers in an RPG, the levels in a level-based game, the cards in a card game. Rules are how these fit together and relate to each other to make the game work.

An analogy I like here is cooking. When you're cooking, you have a bunch of ingredients: stuff, physical objects. And you have a recipe. A list of rules that tell you how to use the ingredients. When you're cooking, you need both. A good recipe with bad ingredients does not lead to good results. Neither does good ingredients with a bad recipe. The same is true in games – a good set of rules alone doesn't make a good game. Having the best possible first-person shooter mechanics doesn't matter much if you have terrible level design and bad values on the weapons. And vice versa – great card designs will never save a card game with bad or boring core mechanics.

One way to see this is to look at expansion packs. In most cases, expansions to existing games add content without adding rules. A new update to *Fortnite* doesn't change how *Fortnite* works or how weapons work or the goals of the game, but it adds more stuff. More items. More locations. More quests. *Magic: The Gathering* absolutely does this – for *Magic*, a new set means a bunch of new cards, not a new way to play the game. There may be a few new keywords or card types, but these are (generally) just new text on cards that interacts with the existing systems of the game, not new systems.

For a board or card game, this is the difference between the rulebook and the pieces. The board, the cards, the tokens are all content. Not only

because they are physical things but also because those physical things point to things in the fiction of the game. Within the *magic* circle, that token isn't a token, it's an enemy out to thwart you. The game piece is content, but so is the way the enemy works in the game. The enemy' stats are content. The rulebook explains what you do with those stats and powers.

For a digital game, the simplest distinction is the difference between code and art. Code determines the rules. Art provides the equivalent to the physical piece in a board game – the manifestation that the player manipulates to get to the thing in the fiction of the game. But there are lots of other types of content, too.

So some types of content are obvious – Magic cards, Halo levels, God of War enemies. Some types of content can be harder to disentangle. When an expansion pack adds a new enemy, it's not just art. The enemy also has a bunch of numbers to determine its damage and movement speed and so on. These are also content. And maybe the enemy has a new way of moving through the world – let's say it can teleport short distances to reach the player very quickly. This type of movement is a new feature that requires new code and functionality and rules. The ability for enemies to move this way is not content, it's rules. The specific ways that this particular enemy uses those rules is content. If another enemy in a later expansion uses the same type of movement, it might change up all the specifics of the teleport – the distance and speed and animations and visual effects would be new content. But the way a teleport works – the functionality of the teleport system – would be shared.

This can easily be seen in *Magic* cards. Most *Magic* cards are full of content. Yargle is a 9/3 Frog Spirit creature that costs 4 and a black mana (Figure 7.3). This is a new combination of numbers that hadn't been done before, but it just works. The current rules can handle this without any changes. Some *Magic* cards require new rules to make them work. The March of the Machine set added Battles, a new card type that needed new rules to explain it (Figure 7.4). But within the set, there were 36 different pieces of content that used these new rules.

Repeating Core Loops

Rules are where the moments of the game come from. To understand a game, you first have to understand the core gameplay loop and how that creates an enjoyable experience. But that's just the first step. Most games

FIGURE 7.3 Yargle.

FIGURE 7.4 Battle card.

last longer than a few loops. Creating a fun core loop is challenging, even for experienced designers. But a commercially released game needs to repeat that core loop hundreds or thousands or even millions of times and remain compelling and enjoyable. Most games these days are hoping for at least a few hours of fun, if not dozens or hundreds of hours of gameplay. While this sometimes can be done with just a core loop, like in chess, it's usually far easier to vary the core loop by adjusting the content.

God of War has a fun core loop. It's fun to destroy enemies. But if the game had the same enemies with the same player abilities from start to finish, it would get boring and repetitive very quickly. The bulk of *God of War* is a continual stream of new enemies, new abilities, and new situations that keep the player on their toes. Once the player gets used to how the core loop works, the game throws something new at the player and asks them to master it. The fun of games is challenge and content provides a stream of new challenges.

Magic: The Gathering has a fun core loop. Build up resources and attack with fun little battle puzzles. If there were only two decks with the same creatures over and over again, most players would play this game a few times, have a good time, and then move on. The influx of new cards and new combinations make *Magic* a game that has survived 30 years and is still going on strong.

Progression

Good game content is about providing that constant stream of challenge and variety.

Variety is hard. If you have a good core loop, you don't want to mess it up. You want that core fun to persist through the entire game. But you also want it to be different every time. How different is different enough? How different is too different?

Are vehicle level in a first-person shooter like *Halo* too different? Some people thought so, but others consider them to be the most fun in the game.

The secret is finding ways to make the core loop feel fresh and new without changing how it works. Vehicle levels in *Halo* are still about shooting enemies and moving through the level. You might be moving in a new way, but the experience still feels the same.

Difficulty Curves

When we talk about difficulty, we often talk about it as a curve.

The difficulty of the game should change over time. The first thing the player does shouldn't be as hard as the hardest boss. So, what should a good difficulty curve look like?

A good curve makes sure that every player is challenged, but not too challenged, at every moment. Which is literally impossible. Every player is different. Different players find different things to be difficult. No difficulty curve is perfect for all players. But a good curve keeps most players in the engaged part of flow for the majority of the game.

Generally, it's good if difficulty goes up over time. Start easy, let the player get their bearings, and make things a little harder at each step. We can graph this relationship, with time on one axis and difficulty on the other, as seen in Figure 7.5.

But this probably isn't ideal – you don't want the game to get too hard. So, we'll level it off at some point once we reach our desired difficulty for this game, as seen in Figure 7.6.

At the simplest level, this can describe many games. Just adjust the starting point, slope, and leveling-off point and you have a useful tool to talk about how different games manage difficulty. But this graph isn't perfect. Not everything is going to be a flat difficulty. In *Magic*, most turns are fairly straightforward, but occasionally there's a big battle that creates extra challenge for each player. And what about bosses? Many games want to have occasional moments when the difficulty peaks, when the player is pushed extra hard and has to really demonstrate their maximum skill. We can add some peaks to our diagram to show that., as in Figure 7.7.

FIGURE 7.5 Difficulty Curve A: Straight line.

FIGURE 7.6 Difficulty Curve B: Levels off after a while.

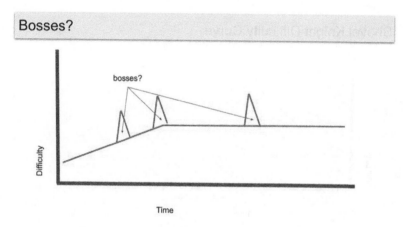

FIGURE 7.7 Difficulty Curve C: Add peaks.

And we don't want to make this too shocking and sudden, so maybe we should work our way up to those difficult peaks more gradually, like in Figure 7.8.

This leads us to what is commonly referred to as the "Rollercoaster Model" of difficulty (Figure 7.9). Like a rollercoaster, the game has peaks and valleys and the player goes up and down in a fun way that keeps them excited and engaged. After a big challenge, there is a resting period and then a gradual increase to a new peak.

Many games have curves that look a bit different than the default. This isn't a perfect goal for all games – you need to consider what you want your

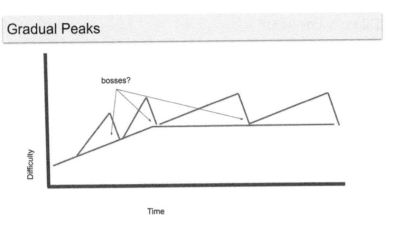

FIGURE 7.8 Difficulty Curve D: Gradually rise to peaks.

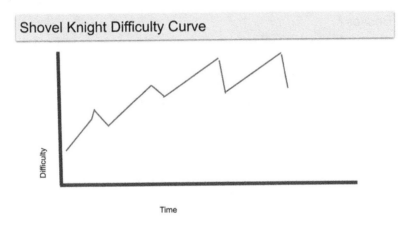

FIGURE 7.9 Difficulty Curve E: *Shovel Knight* is a rollercoaster.

difficulty curve to look like for your game's needs. For example, some games aren't about maintaining a peak of challenge and adrenaline. The recent growth of cozy games as a genre demonstrates that a game doesn't need to push difficulty curves to maintain player interest. Games like *Stardew Valley* (2016) or *Animal Crossing* succeed with their audience because they're gentle and forgiving, not because they are aggressive and challenging. These games provide uncertainty through exploration or dialog rather than challenge, so their curves might be something more like Figure 7.10.

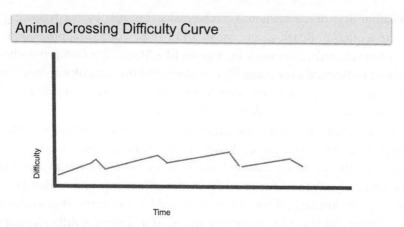

FIGURE 7.10 Difficulty Curve G: Animal Crossing is low and flat.

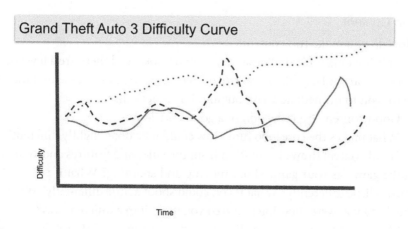

FIGURE 7.11 Difficulty Curve E: *Grand Theft Auto 3* has multiple lines.

Each game has a unique target curve. Some games start off hard and stay hard. Some have bigger or smaller peaks. The difficulty curve for an open world game like *Grand Theft Auto 3* (2001) is hard to plot because it's really up to the player (Figure 7.11). If they want an easier challenge, they will often choose to head to a different part of the game to get that. Giving players more agency gives players the ability to adjust this curve on their own, which is a powerful way to make sure the difficulty curve adjusts to each player's needs.

This form of difficulty tracking is mostly intended for video games where there is a long sequence of single-player content for the player to

consume in a linear fashion. GTA3 breaks this rule by not following a linear sequence. Board games break all of these rules. Mapping content over time doesn't really work for a game like *Magic: The Gathering* where content is digested over many play sessions and the difficulty comes from opponents' decks. There are ways to map the standard stages of a single session of *Magic*, but they don't use difficulty.

The real value in a difficulty curve when developing a game is identifying your target so you can evaluate how your content matches up. If you want a rollercoaster, say that up front so you can build levels to that goal. Then when you're reviewing levels in the game, you know what you're looking for. Similarly, if you're trying to build a cozy game, that gives you clear targets for the types of content you want to design. A difficulty curve can be a great way to get the team focused on a shared vision.

Fun Content

How do you make fun content?

This is a long topic that deserves its own book. And there are a few good ones – I particularly like *Level Up!* by Scott Rogers. But in case that didn't spark you to immediately run out and buy it, let's discuss.

Good content is a reflection of a good core loop.

What makes the core loop fun? How could it be done slightly differently?

Good content draws inspiration from the rules and features and systems of the game. Is your game about moving and shooting? What if you could move a little differently? What if you could shoot a little differently? What if the thing you were shooting required you to do it in a different way?

The goal of content is to diversify the core loop while retaining the qualities that make the core loop work.

Magic: The Gathering does this well.

The core loop of *Magic* is a combination of growth and combat. The cards provide countless variations on these themes.

- Growth is normally done through lands. There are lots of different lands that do this in slightly different ways.

- Growth is normally done through lands. What if it were done through artifacts instead? Figure 7.12. is an example of this.

- Growth is normally done through lands. What if it were done through creatures instead? Figure 7.13 is an example of this.

FIGURE 7.12 An artifact that produces mana.

- Combat normally shows you all the options ahead of time. What if there were surprises? Figure 7.14. is the token used for one ability that does this.

Magic is a game that also will provide ways to completely break the normal rules and patterns of play through card text. This works for *Magic* but needs to be handled carefully. Some games require more focus on the standard core loop to work. *Magic* has a core loop that is set up with lots of ways to swap out different content. Try to design core loops like that. *Scrabble* is a great game, but it doesn't have lots of ways to vary up the game and change it over time.

A great way to do this is to make content that makes other content shine in new and interesting ways. If your game gives the player special powers and abilities, then you often want to design the challenges to showcase specific powers and abilities.

FIGURE 7.13 A creature that produces mana.

In *Halo*, the shotgun is a fine weapon. Until you get to the Flood, and then it really shines. The flood is a very different style of enemies than you've seen before, which forces you to shift up your strategies. The core loop hasn't changed, but changing the content has made the game fresh and new again.

Good-level design and progression is built around this. Once the player masters one skill, give them a new skill. Let them play around with it for a bit, then introduce a new enemy or other challenge that requires skilled use of the new skill. Then add variants of the new enemy that require using the new skill in a slightly different way. And this isn't just a combat thing. *Where's My Water?* wasn't based on enemy progression, but it absolutely used this form of progression – each level pack was built around a new object in the game world, with a few levels to get used to it before combining

FIGURE 7.14 A creature that is a secret.

it with all the previous combat to create new and challenging puzzles. Then the next pack introduced something new. But every new thing followed the previously established rules.

The deepest form of content design is content that doesn't just build on the systems of the game, or the previously introduced content. The best content builds on the themes of the game.

- *Civilization* is about history and power. Each civilization has a different relationship with power, based on historical sources.

- *Bioshock* (2007) is about choices and free will. Each area of the game presents a different take on free will and how it affects the characters in the setting.

- *Magic* is about infinite diversity. *Magic* sets are constantly trying to come up with new ways to twist the rules and lead the player down new roads.

This is part of the reason to think about the meaning of your game. If you know what the game is about, you can design around that and think of interesting new content to show off the heart of the game.

KNOBS

One reason *Magic: The Gathering* has lasted as long as it has is that it's a very knobby game. "Knobbiness" is a term that refers to how many "knobs" the game designer has to adjust content. Games with lots of numbers and text that can change (like *Magic*) are "knobby", which is good. Games with few things that can change and a lot of restrictions on how those changes can be made interesting are "not knobby", which is bad. Look at *Scrabble* – the game is based on the alphabet, which the game designer can't really change, and a number value per letter, which can change but needs to make sense for word usage. If I had to make new levels for *Scrabble*, it would be hard to make them fun. I know – I tried. I worked on *Scrabble Go* (2017) for a bit before it was released.

With *Magic*, each card has lots of numbers that can be easily adjusted. The numbers really matter and change things. And then there's that big text box that can include anything (including more numbers that can be adjusted to make more cards). And more importantly, the vision of the game is that the text box can literally do anything (within the bounds of the main rules). So, there's a lot of freedom to experiment and try new things there, which isn't always the case for other games. Having lots of knobs and regularly changing them has made *Magic* one of the few (only?) games that has consistently released new content for over 30 years.

Content Flow

Good content is built to fit the meaning of the game, and the abilities of the player. It's also built to fit the rest of the content.

The difficulty curves discussed earlier are an example of this – every enemy should provide a new challenge that fits a nice curve compared to the challenge of the other content. But good content builds on other content in other ways, too.

Magic: The Gathering releases content in sets. Each set has many cards that are each a piece of content that needs to follow good design principles.

But the set itself is also a feat of game design. Players tend to experience each set as a cohesive whole, especially in limited play formats like draft or sealed. Each card needs to be well designed but also fit in well with the other cards in the same set. A card that is interesting in one set, such as a card that benefits from other enchantment cards, might not be very interesting in a set without many enchantments. Content is like systems – they don't exist in a void and depend on the content around them.

I experienced a lot of this working on *Where's My Water?* We designed each level to be fun and interesting on its own but also to fit into a pack of 20 levels around a consistent theme, usually a new feature added in that pack. Each level in the pack had a purpose. Most levels were demonstrating a new quality of the new feature, showing the player how the new feature interacts with the existing features. We spent a lot of time and effort making sure the levels were in the right order so the player wasn't overwhelmed with too many new ideas at once. We often had to go back and build new levels to fill in gaps of knowledge and build the player's expertise to master the final hard levels of each pack.

Good Ingredients

So while most of this book is about recipes – systems and other core game design issues that make a game work – don't neglect your content. The best systems in the world don't matter if there isn't good content (levels, cards, enemies, abilities) to show them off.

Royale High / Audience

ROYALE HIGH

Royale High is a great game.

Royale High (Figure 8.1) is one of the top games on the Roblox platform. It has had over 9.7 billion visits (as of April 2024) and was one of the ten most popular Roblox experiences in 2023.

If you're not familiar with Roblox, it is a platform where anyone can create games and easily publish them for anyone to play. It has grown over the years to become one of the biggest places for games and other virtual experiences, with over 70 million users a day (as reported in Roblox's Jan 2024 financial reports). Roblox's focus on user-generated content has resulted in a different gaming ecosystem than console or PC games, with a different mix of successful genres than anywhere else. There are genres in Roblox with millions of daily users across hundreds of games that simply don't exist anywhere else. I like to compare Roblox to Australia – a self-contained ecosystem that has resulted in fascinating divergent evolution. See, Mom, I'm putting my biology degree to good use.

I work at Roblox now, mostly on educational games and assessment games, but I've never worked on *Royale High* or directly worked with the team that creates it. And everything you read here is all me – this book is not sponsored or affiliated with Roblox other than indirectly due to the fact I work there.

DOI: 10.1201/9781003346586-8

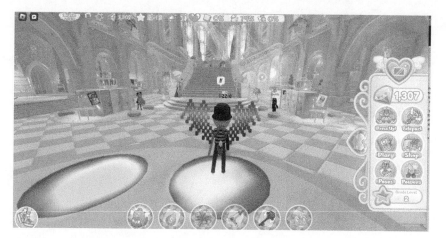

FIGURE 8.1 *Royale High* screenshot, from March 2024.

ROYALE HIGH – GAMEPLAY DISSECTION

Verbs

Royale High is a little different than most of the games we've talked about. To start off, *Royale High* has a lot of verbs. And most of them have bonus alternate forms.

- Move
 - Players have an avatar and can walk around the world.
 - Players can teleport to various places to get around more quickly.
 - There are also vehicles and a few other modes of transportation.
- Buy
 - Players can directly buy many things.
 - Most of these are decorations, either for the player's avatar or room or other things.
 - Some are powerups that make other things easier.
- Customize
 - Each player has an avatar that is separate from their normal Roblox avatar. Players can buy new items for their *Royale High* avatar.

- Similarly, players can dress their pets with cute little clothes.

- Each player gets a house that they can decorate with furniture that they purchase. This includes a number of sub-verbs to move, rotate, and otherwise manipulate furniture.

- Trade

 - Players can trade items with other players.

- Action

 - Tidy

 - Adventure

 - Login

 - Wash

 - There are various things in the world or the player's inventory that players can select and activate. Most of these show a brief passage of time and then the action is declared complete.

 - This is used mostly for quest completion. A quest tells the player to check their locker. When the player clicks on the locker, they get a reward. The player is then given a new quest, or shown a timer and can do the quest again when the timer completes.

- Mini-Games

 - "Classes" in the school are represented with mini-games. Mini-games give the player a focused goal and (depending on the game) new controls to achieve that goal. These are often drawn from traditional classroom activities such as musical chairs but can also be scavenger hunts or other types of mini-games.

 - There are also some loose mini-games, such as the locker book-stacking games.

 - Mini-games can be incorporated into the quest system similar to actions.

- Spin the Wheel

 - There is a reward wheel in the world that acts as a special type of quest with different rewards.

Royale High Verbs

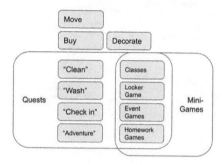

FIGURE 8.2 Lots of verbs with some groupings.

- Events

 - There are frequent events that add new things to do, but they generally fall into new twists on the above options.

Goals

Royale High has lots of different verbs but organizes them into quests (Figure 8.2). So while the above list may make it sound like there's a lot going on, it really boils down to a simple to-do list plus a few optional bonus activities. While the verbs are all over the place, the goal is consistent and easy to process.

Completing quests levels up the player, which provides various rewards. The primary reward is diamonds, which are used to buy things. Buying things is the real motivating goal. There are all sorts of things to buy – clothes and accessories for your avatar, furniture and other items for your dorm room, and so on. There are special limited-time items to purchase, some of which are given out through loot boxes where the rewards are randomized and players are incentivized to buy many times to get the rarest items.

This is a very standard motivational loop (Figure 8.3). Players do things to get money, which they can use to customize their experience and unlock more things to do for more money. It's basically the same loop as *Settlers of Catan* – get stuff to make stuff to get more stuff. This works partially because it's a loop humans are accustomed to. Go to work. Get money. Spend money on things. Go to work to get more things.

Royale High

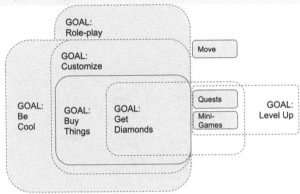

FIGURE 8.3 Core game loop with lots of verbs leading to diamonds, which lead to bigger goals.

This gameplay loop is especially successful in social settings. People like buying things and customizing their experiences. They really like buying things and showing off those things to other people. *Royale High* has players navigating through public spaces where they can show off their costuming choices, and players will notice and chat about what everyone is wearing. Roblox is an inherently social platform, so this sort of socially motivated display of stuff makes perfect sense.

This motivation loop works well on Roblox, where many of the players are teens or kids. Many of the top games on Roblox are aspirational, allowing teens to try out adult-style behaviors – owning homes in Brookhaven, having jobs in Work at a Pizza Place, doing scary things in Piggy. And nothing is more adult than showing off your wealth. But this motivation is not unique to kids. Social displays were a big motivator for gameplay during the "social games" phase on Facebook and other social media platforms. Farmville was all about building and maintaining an impressive space to show off to your friends (or at least not embarrass yourself). *Royale High* is just the latest evolution of this trend.

The Past

While the current (2024) version of *Royale High* has a successful game loop that ties back to classic social games, it has not always been this way. The school theme was stronger – most quests were tied to classes, to the

point of requiring students to bring the right books to each class. Most of the systems and loops discussed above existed but in much simpler forms.

Many games today, especially on online platforms like Roblox, are not a single unchanging thing. "Game as service" is a common model these days, where a game is expected to constantly be adding features and content and events and constantly be changing. This is very different from when old people like me started making games. When making games for older console systems, whatever you put on the "gold master" disk was the only game that anyone outside of the development team was ever going to play.

As a small side note, this makes certain types of game dissection essentially impossible these days. You can't dissect every version of something that's constantly changing. You can only describe the current state at a slice of time. When you're using dissection as a tool to understand the market or design your own games, that's fine – you don't care about the past or the future, just what does or doesn't work today. But when you're trying to write something for posterity (like, let's say, a book) that can be more problematic.

So *Royale High* used to be much simpler. The player was still about customizing and building a student in a magical school, so the emotional core of the gameplay was the same. But the daily loop was different, and many things that make the game huge today didn't exist. The skeleton of the game was the same, but lots of smaller things were radically different.

Challenges

Royale High is not a difficult game.

The quests generally don't have any enemies or randomization or player skill moments or difficult choices. The player doesn't have to manage multiple resources and balance between multiple quest choices to optimize carefully. The only real challenge in the quest system is time management – the player can choose to focus their time on the basic quests or doing other activities for other rewards. But this only provides minor optimization over just doing each quest as it comes up.

Similarly, the customization and decorating features are much more about personal expression than they are about personal challenge. There are no stats to balance or competitions to win based on how you customize. Games like *Covet Fashion* (2013) or *Dress to Impress* (2023) build very strong gameplay loops out of nothing but customization. (If you haven't

tried these games, I recommend taking a look. There are lots of good inspiration to be had in these games.) These features are rewarding in and of themselves, with the only challenge coming from personal goals the player sets for themselves. Loot boxes add some randomness, but this is not randomness that the player has any control over, so it doesn't really enter into the decision-making other than requiring more resources to get all the rewards. The only place where challenges really exists is in trading with other players, which isn't something players get into until they've been playing a bit.

This may seem odd at first. We've talked about how challenge is important for games. How uncertainty is necessary for a game to matter. You could argue that a game like *Royale High* that doesn't have a lot of challenges isn't really a game; it's more of a toy or an interactive experience. Which is fine. A movie doesn't have a lot of challenge, and we still value them for their artistic merit and entertainment value.

There's a growing appreciation of low-challenge games such as *The Sims* or *Animal Crossing* where the difficulty curve is more of a difficulty slant. These "cozy games" don't push players to make tough decisions or demonstrate difficult skills. Players have choices that affect the space and make progress through their actions, but the actions and choices aren't difficult or stressful. They still have Sid Meier's "interesting choices", but they're interesting in other ways. Customization is interesting as a form of personal expression. Completing simple quests is interesting as a way to feel completion. And while a traditional flow state requires some challenge to keep people engaged, I posit that different people have different targets. Some people require high levels of challenge to maintain their flow, while others only need a little push. A *Royale High* player working through their list of quests to level up is just as in the zone as the top Halo player, even if their experiences are very different.

Cozy games and other low-challenge low-stress games attract a different audience than traditional gamers. For most of the history of video games, competition has been king. High score lists and multiplayer deathmatch modes attract people who like to dominate and be the best at something. But not everyone is motivated by that desire. Some people just want the satisfaction of a job well done. Some people just want to find cool things and show them off. Some people just want to express themselves creatively. The artist who creates interesting spaces in *Royale High* (or *The Sims* or *Animal Crossing*) is no less a success than the deathmatch

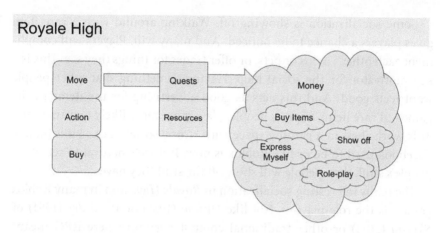

FIGURE 8.4 *Royale High* Flow 1: Simple diagram of Actions, Challenges, and Goals for *Royale High*.

dominator. And no less a gamer. This has always been true to a certain extent with games like *SimCity* and *Mario Paint*, but it's becoming a bigger and bigger part of gaming. The games industry has been learning this gradually over time as social games and mobile games bring new types of players and require new types of game designs to appeal to these new motivations (Figure 8.4).

Dynamics

Royale High's core gameplay flow starts with two main states.

The player completes quests by navigating around the environment and selecting the right objects or characters to meet their current needs. The player then switches into customization mode, buying things and using them to decorate themselves, their pet, and their house.

Royale High also has a few states that exist outside of these core loops. These are worth dissecting as they are key to the success of this game.

Players will often spend time in the big public spaces without completing quests or customizing. They will engage with other players through Roblox's chat or voice system. Some of this ties back to the customization and rewards systems, as players will chat with other players to discuss the best outfits or trade items. Some of this is just using other players as a resource for information, asking questions about how to acquire special pets or equipment. But there are other uses for socialization that really matter to players.

Some socialization is showing off. Walking around with a rare item gives players a chance to be noticed. And many will. Players will compliment each other's items or pets, or offer trades for things they see. This is a key motivator for the social loop. Having something that other people want feels good. And this acts as good advertising for the items in the game – if rare items impress people, players are more likely to want them. This works best in a gaming space with strong social hooks built in, like Facebook used to be or like Roblox is now. If it feels natural to see other people's stuff, then people will show off the stuff they have.

The really interesting socialization in *Royale High*, and in many Roblox games, is the role-playing. Not like *Ultima* (1981) or *Wizardry* (1981) or *Skyrim* (2011) or other traditional computer games where RPG means stats and equipment and monsters. This is actual role-playing like playing a role. Pretending to be something and acting out improvised interactions is a key part of tabletop role-playing like *Dungeons & Dragons*, and is also a key to the success of Roblox.

Players in *Royale High* often enjoy playing pretend. But not as an elven warrior or vampire mage. *Royale High* role-play might be a wealthy socialite with the most expensive items. Or just a happy student who is hanging out with their friend and navigating classes. This isn't as complicated or elaborate as playing pretend in *Dungeons & Dragons*. Most *Royale High* players don't write out elaborate backstories to explain how their character relates to the history of the realm. But they do engage in the same storytelling and fantasy play that motivates tabletop role-players. They just do it in short stints without the long-term progression that stats and equipment provide. A *Royale High* player might try on a role for a single statement, or a quick exchange with a friend. Deeper role-play in public with strangers is rarer, but it does happen.

Royale High is built to maximize this style of play. In addition to the basic social and customization experiences that are built into Roblox, *Royale High* adds features specifically intended to heighten the role-play experience. The deep customization system allows players to have a unique persona on *Royale High* separate from their normal Roblox avatar. And customization extends into the player's space – players can create their own dorm rooms and show them off, too.

Royale High is not the only experience on Roblox where this happens. Many games on Roblox encourage and support this style of play, and some

are entirely built for it. Games like *Miraculous RP: Ladybug & Cat Noir* (2021) actively encourage players to role-play existing characters by giving them costumes and locations built for it. And games like *Brookhaven RP* (2020) (RP for Role-play) or *Roblox High School* actively encourage kids to role-play aspirational roles based on being older and more successful than their reality. Games like *Untamed Animals* (2020) or *Holocene* (2019) let you role-play as things you can't possibly be in real life.

As an old-school tabletop role-player and a long-time video gamer, it's great to see video games embracing actual imagination play. I love some of the great digital RPGs, and many of the best of them go to great lengths to provide players the flexibility of choices and deep narrative that a good game of *Dungeons & Dragons* can provide. But I see great potential in digital games that give players complete freedom to pretend whatever they want to pretend. Imagination is the heart of all games, so seeing how new types of imagination flourish on new platforms like Roblox makes me excited to see the future of games.

Systems

Royale High starts the player off with an experience progression system, a character customization system, and a related room decorating system. These set up the player for long-term goals and long-term systems. Start by making the player know what they should want. *Royale High* is a good example of a key idea when setting up Goals – don't tell the player that they want something, show them something that they naturally will want. *Royale High* doesn't tell the player that they need a better dorm room. *Royale High* shows the player a tiny room, then lets you walk down a hallway where you see better rooms. Wanting a better room is a natural human impulse in this situation, and the game doesn't feel like it's forcing the player to want anything.

Wanting better things motivates the player to engage in the core economic systems of the game. If you want to customize, you need things. And if you need things, you need diamonds. This guides players very naturally to the quest system. Quests are the best and most obvious way to make money in the game, and they do a good job of tying into the core school fiction to make quests fun.

Royale High has lots of systems, but they all feed back into the core economic systems (Figure 8.5).

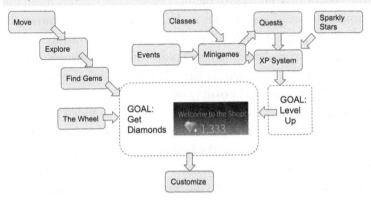

FIGURE 8.5 A lot of different systems all leading to the economic system.

ROYALE HIGH – NON-GAMEPLAY DISSECTION

Technology

Royale High is built on Roblox.

Roblox Studio is a powerful set of tools that makes it easy for anyone to generate, publish, and maintain experiences, which are often games. "Easy" is of course a relative term – building anything with rules or goals or interaction requires setting up a bit of code. But that's part of the fun – beginning creators can create empty spaces that players can walk around and enjoy, creators who want to learn code can start with simple-to-create games like *Obbies* (short for obstacle courses, but many of the players who use the term "Obby" all the time probably don't even know that), and advanced creators can build nearly anything they can imagine.

The platform has a big effect on the design of any game. Roblox is inherently multiplayer – you have to work a bit to make an experience with only one player. So the experiences that succeed on the platform are the ones that craft a fun multiplayer experience. *Royale High* is a good example of this – the core loop and core systems of the game don't require the player to interact with other players, but they are all enhanced by it. Showing off your possessions – your room and your locker – is a powerful motivator in any game where other players can see your stuff (see: *Farmville* and many other Facebook games).

FIGURE 8.6 Listing the creators of individual items.

Senses

Royale High feels like you're living in a fancy castle. The visuals enhance the aspirational nature of the core loop. Players want fancy things because they see fancy things. But there are a lot of different ways to be fancy, allowing for personal expression. As a UGC (user-generated content) game, *Royale High* has a lot of respect for the individual creators who make these items – many items list the creator so players can track down artists they like (Figure 8.6). Players like to see Roblox experiences as individual creations of people like them, rather than faceless corporate creations. At this point, a game like *Royale High* is actually being built by a larger team, but that personal style still influences what the game looks like.

Narrative

Royale High has a simple but effective narrative (Figure 8.7).

There is a full tutorial that introduces the concepts of the fantasy world and the player's role in it. But most players aren't motivated by the story.

The real role of the story is to provide a compelling setting. The space is interesting and has lots of fun little moments of personality. These provide great hooks for players to build their own role-play experiences around. Or just pretty scenery for players who aren't motivated by role-play. There is enough narrative to explain what's going on (magic high school) and the

FIGURE 8.7 Story in *Royale High*.

motivations for the player's in-world goals (you are a student). That's all
most games need.

For the players who do role-play, even a little, having a strong backdrop
is a great help. But they go beyond those starting points and build their
own story. The game doesn't tell them which friend should play which
game with whom, or what fashions to wear. The players make up their own
motivations, often mixing real-world and in-world motivations. The real
stories are the stories the players tell about themselves and their actions
and (most importantly) their relationships with each other. And the game
embraces this and gives them the tools to make this easy.

Emotion

The core loop of the game depends on player's desire to be a good student
and part of the community. Social play hits on a few different emotions.
As discussed, the desire to have nice things to show off to others is a strong
motivator. This taps into deep emotions based on our social desires as a
species – pride in accomplishments, shame at not meeting society's stan-
dards, and coveting that which one does not have.

Royale High does also have some narrative pulls at emotion. Characters
in the world talk to the player and ask them for help and encourage them
to do things. These are important to driving the player through the con-
tent and they work, but they are much less powerful than the social

drivers. When walking around *Royale High*, there are always more people talking about who has what halo rather than what the NPC Guards are up to.

Money

How does *Royale High* make money?

Roblox as a whole is based on Robux. On the platform, players can buy Robux which they can spend on cosmetics or in any experience. Robux spent in an experience are shared with the developer. Developers also earn Robux when a player who is paying for a subscription spends time in their game, even if they don't spend anything.

The developer can then cash out their earned Robux as real-world currency. Roblox takes a cut of the currency, similar to how distribution-only services like Apple or Steam take a cut. The percentages that developers get on Roblox are different than the percentages distributed on distribution-only systems, but the services provided are also different. Roblox also provides a lot more – the tools to build games, servers to host the data of the game, and moderation and safety controls to ensure your game is in a safe space for players of all ages. And when Roblox appears on other platforms like Apple or Google, they get their normal cut on top of Roblox's. So Roblox takes a larger cut than other platforms but also provides more services.

How to monetize within this system is determined by each Roblox developer. *Royale High* creates its own internal economy that players can earn and spend for customizations and other things. The real driver of the in-game economy is the customization system.

History

Royale High was launched in 2017. Roblox was a smaller platform at the time, and *Royale High* did well in that smaller ecosystem. At first, *Royale High* was very focused on the magical school role-play. The first versions of *Royale High* were strongly based on the TV show Winx, but after some discussions with Winx's lawyers those elements were removed. But the role-playing focus didn't change. *Royale High* didn't invent the Roblox role-play genre – other games like *Robloxian High School* (2009) or *Welcome to the Town of Robloxia* (2010) have similar themes and some of the gameplay. But *Royale High* built a strong game from those ideas, and there's enough room in Roblox for multiple success stories.

Meaning

There are two ways to look at *Royale High*.

Royale High is about stuff. Wanting stuff, showing off stuff, and acquiring new stuff. Commercialism for the sake of commercialism is generally frowned upon, but *Royale High* isn't just commercialism.

Royale High is also about aspirational role-play. Being someone else. Exploring who you want to be. Playful imagination with friends.

Just like in real life, these two somewhat contradictory meanings can live together and both be true. I would argue that the role-play goals elevate the commercialism, at least somewhat. Wanting things can be dangerous, but wanting things with friends is a better place to be in life.

AUDIENCE

Interactivity

Games are about interactivity.

Games are about wanting things. Striving toward goals.

Game designers work hard to craft goal systems that make sense and guide a player through a positive experience.

What happens when the player doesn't want that experience?

Players are diverse and crazy and want weird things. If you doubt this, run a few sessions of a tabletop role-playing game. You will quickly find that no matter how much you construct a beautiful and elegant plot, the players will choose to focus on something else. Why battle the Ancient Evil Necromancer when there's a peasant girl who could use a new doll? Do you know where the best doll maker in the land is? Oh, and the doll maker made a joke to me? Now I need to spend a full game session on finding the right gift to woo him. These sorts of distractions always happen in tabletop role-playing games, and good players and leaders know how to roll with it and craft a fun experience around whatever crazy thing the players may want to do.

This isn't really an option in a digital game. In a digital game, the player is interacting with the code and if the code doesn't know how to woo a toymaker, it's not going to happen. Many games just accept this – there is one thing to do and if you don't want to do that, you should be playing a different game. If I want to make friends with the goombas in *Super Mario Bros*, there's not a button to do that.

The early exception to this was Infocom. Infocom was a company that created weird games entirely out of text, such as *Zork* (1977). The player

would type a command into the game, and the game would respond with text saying what happened as a result. These are still around and are known as interactive fiction. Text is a lot easier to generate than images, so these games could get away with giving the player a lot of freedom. Most of Infocom's games had a single plot that you'd eventually be guided toward, but if you wanted to try silly things for a while, the game would let you jump up and down or play with the leaves and would respond with cute little snarky commentary while you did.

This sense of freedom was lacking in 3D worlds until *Grand Theft Auto 3*. *GTA* gets a lot of attention for its adult themes and urban style, but it really grabbed gamers because it gave them freedom. *GTA* has a plot you're supposed to follow, but the vast majority of time in *GTA* is spent wandering the city and doing goofy things. If you see a ramp, you can jump off it in a motorcycle. If you see a long stretch of road, you can race down it. If you think "what will happen if I do that?", the game generally has an answer, and that answer is generally fun to do. *GTA* was the first game that gave the player a wide range of agency in a 3D space and had the 3D space respond to anything the player wanted to do. This was huge and led to the whole genre of wildly popular open world games, including hits like *Skyrim* and *Legend of Zelda: Breath of the Wild* (2017).

These games build freedom by having flexible systems that allow varied responses to player input, allowing for emergent gameplay. *Royale High* reaches the same goal in a different way. In many ways, *Royale High* is more like a tabletop role-playing game or a MUD (multi-user dungeon) than a digital open world game. MUDs were early online games where players could move through digital spaces and interact with other players. Most MUDs use text interfaces similar to interactive fiction. But you can type things to other people and engage socially. Some MUDs had strict rules that mirrored Dungeons and Dragons or other tabletop systems, but many of them were more free-form, allowing players to type anything. Other players could choose to run with that idea, or just ignore it.

Royale High gives players freedom by opening the experience up to true role-playing. The game doesn't respond to players' agency, but other players do. Players can make up their own stories and live them in the 3D world that the game provides. Other players can join into the make-believe and play along. The game doesn't control this or moderate it, but it encourages it and (as previously discussed) has the right setting and features to allow this to work. If you want to pretend to be a princess or a businessman

or a duck, the game doesn't stop you. The game doesn't insist that you run to the right and jump, it just lets you hang out and say whatever you want (within the limits of the trust and safety filters Roblox uses).

Dissecting Audience

To truly dissect a game, you need to dissect its audience. Not literally, of course.

Games are built from actions and goals and challenges, but none of this matters if the player doesn't want to interact with those systems. Games are interactive, so the player has a lot of input into the experience. The game offers the player a lot of choices, but the player decides what to put into that choice. A good game gives the player the freedom to make those choices meaningful. Meaningful to that player in that moment and what they want.

Understanding the players of a game is hard. A popular game will attract many different people who enjoy the game for many different reasons. Even a single feature may be seen very differently by different players. The players themselves may not really understand why they like something, so even if you bring players into a room and ask them questions there may be no clear answer. And players are weird. As mentioned, players often want to do strange things that don't make any sense.

If you're dissecting an existing game, it's good to talk to the existing players. They may not always know what they want, but sometimes they do. And if not, you can find out what they do. If players are having unexpected interactions with a system, it's often a sign that the players are experiencing unexpected goals. And those goals are driven by emotional desires that the game is not fulfilling. As a game designer, if you can find a way to tap into that desire, you can make your game better.

PLAYER CREATIVITY

In the class I teach, I've been running the same D&D module (Fishing for Gods In Strade's Gallows) for groups of college kids for years now. It's a simple classic starting point – the players' characters are hanging out in a tavern, and someone offers them money to deliver a package to a dangerous location. But I'd estimate only about half of the time do the students actually make any progress on the actual quest.

One time they decided to kidnap the person who gave them the quest, since they must know useful information. The city guard didn't like that.

One time they met a random kid on the road and made it their mission to improve the life of the kid.

One time they got into a fight with other people in the tavern, who I'd previously decided were mobsters. That didn't go well.

Multiple times, the group decided to fight among themselves, stealing the package back and forth between players even though they don't get any reward unless the package makes it there safely.

After we play, I always stress to the students that all the strange desires and goals that they saw at the tabletop are also things that players of digital games want. The digital players just don't have a good way to tell the designer what they want.

Understanding Audiences

Game designers over the years have attempted to define their audiences.

The best-known example of this is Bartle's taxonomy of MMO players (Massively Multiplayer Online). He breaks players down into four groups (Socializer, Explorer, Achiever, and Killer) based on what he'd seen in talking to many players of early MMOs. This particular taxonomy has become popular, to the point where people try to apply Bartle's categories to every type of game. To me, this is missing the point. Bartle did a great job of breaking down the types of players who enjoy a particular genre at a particular time. The secret sauce there is not his final results, but his methodology. Don't think about how many Killers you have in your game, think about what your players want to do and what they get from the game emotionally.

Mark Rosewater, the lead designer of *Magic: The Gathering*, created a similar taxonomy of *Magic: The Gathering* players. *Tammy/Timmy* players want big experiences, *Johnny/Jenny* players want to express themselves through the game, and *Spike* players want to excel. These are great categorizations as they get at not just what the players do differently in the game, but the root motivations that drive them to play this way.

These are good examples of how to think about an existing player base. What do they want? What do they enjoy? How can the game design make them happy? How do you get to this level of understanding for your game? Especially if you're not the target audience?

Understanding Other People

Understanding audiences is harder when you're not part of that audience. Many game designers start by building a game that they want to play. Which is a great source of inspiration and often leads to a great game. And in the end the game is guaranteed at least one fan.

But what about when the target audience is someone different from the game designer?

I made games for kids for many years. And while I consider myself to have a healthy inner child, I haven't been a kid for many, many years. I can remember what it was like and think back on the joy I had playing Atari 2600 games on holiday breaks. But I don't know what kids today want. I don't know how kids today interact with technology. I don't know how today's games interact with the complex and ever-changing lives of kids.

This can be especially hard in a new space like Roblox. I did not have Roblox around when I was a kid. There are whole systems of interaction that I will never directly experience in the same way. Roblox is an inherently social experience, so kids tend to travel in packs. They pop into a game, devour as much fun as they can as quickly as they can, then pop to another experience. Sometimes these roving bands of kids only spend a few minutes in a game, even a game that they like and plan to come back to later.

As a game designer, this can be difficult to design around. Tutorials need to be non-existent or built into the feature only when encountered. Players like some permanence and enjoy building things, but those things need to be quick and easy to access (and show off) at any time. Players decide whether or not to stick with a game in a few seconds, so those first few seconds are key. If the game is trying to make the roving bands of kids read text boxes in that time, the game may have trouble finding an audience.

As a game designer, it's even harder to build around these play patterns if you don't know they're there. None of this is obvious just looking at Roblox or the games (or non-game experiences) on the platform. Even talking to a few random players inside popular games doesn't provide a complete picture. Most players in most games aren't looking to have a random discussion with a stranger. Roblox is social but it's also safe, and many kids today are savvy enough on internet safety to avoid conversations with people they don't know. Much of the Roblox audience doesn't want to talk to you because they're fully engaged with their friends.

Talking to People

So, as a game designer, how do you figure this out? How do you under-stand groups of players who are motivated by different goals and different experiences and different relationships?

The most important thing is to talk to the actual audience. If you're interested in an existing audience that likes to gather online and discuss games they like on Reddit or Discord, this is easy. Go there, engage with people, and you'll learn a lot.

But many games have audiences that don't want to talk about gaming online. Roblox is popular with kids and teens who might be talking online but not in public forums. Many mobile games are played largely by adults who don't have the time or inclination to talk about their gaming lives online. *Candy Crush Saga* does not have a wildly popular Reddit subforum or a big presence on TikTok (yet). How do you talk to these people?

The rise of influencers can be a boon for understanding certain audi-ences. I don't often get to talk to Roblox players directly, but I can learn about the games they're playing indirectly through YouTube and other social media. This is where many players on Roblox and other platforms get their information about what games are interesting, so it can be a valu-able place for indirect insights.

If you're working for a larger studio, you can pay to talk to the players directly. Focus groups and playtest sessions are great ways to learn about your audience or related audiences.

As a game designer without access to these resources, you need to be scrappy. Talk to everyone you know who fits your target audience. I have a nephew who loves Roblox and has taught me a lot about his play styles. But they're very different than the play styles of other kids I know. I talk to every family member who plays and try to understand how they play and why they play. Information like this is gold and insights from the actual audience are often what makes games in these spaces succeed or fail.

NO DEMOGRAPHICS

When talking about audiences, people often discuss demographics – the age, gender, race, and other basic physical properties of their audience.

I don't think demographics are very useful. Defining an audience by these traits usually only hits on the simplest, most superficial qualities of

the audience. Pick a specific age, gender, and race and you still haven't really narrowed it down. My kids are Americans aged 15–25 but between them and their friends there are many different stories and desires and purchasing patterns.

I don't want to know how old they are, I want to know what they want. I want to understand their desires better than they do so I can make something that delights them.

Demographics are a very sloppy shorthand to talk about audiences. I admit I'll use the terms sometimes, but only as a starting point. Dig deeper. The understanding you need is not on the surface, it's deeper.

Understanding Non-Existent Audiences

Understanding a game's audience is even harder when the game doesn't exist yet.

Understanding the audience for a game that only exists in your head can be done in two main ways. First, pretend like your game is a different game. Second, pretend like there are players.

Every game is built on the shoulders of giants. A new pitch generally fits into an established genre, or at least has strong connections to games that already exist. This helps for many reasons. First, companies want their new games to sell to the audience of those old games. To understand how to design for a new game, look at how previous games have done it. Find the closest analogues to your idea and see what their audience wants. If you can find something that they want but current games don't provide, that's a great place to start your ideation.

Second, you can define what your theoretical audience would look like. This is especially useful if you're trying to create a new audience or combine multiple existing audiences around something new. In the world of UI/UX, this is known as creating a user profile. Don't just say "my game will appeal to kids", but break down exactly what sort of kid your game will appeal to. Think about specific examples of the sorts of kids you want to play your game. What is their experience in the game likely to be? How will it be different from the experience of another kid? Your target audience should include a diversity of experiences and desires and fulfill them all in ways that might be different but are all based on the same game. Creating user profiles is fairly common in UI/UX and fits games well, but the practice hasn't become common yet. It will.

Understanding Goals

For a game designer, the important things to know about the players include the following:

- What do players want?

- What excites players?

- What turns players against the game?

If all you know about *Royale High* players is that they like to complete quests, that doesn't tell you enough to design around them. Just adding more quests wouldn't satisfy the players' goal. You need to understand that players are really doing quests in order to get money to buy clothes and other customization options. And even then, there's a big difference between role-players, and players who are customizing to express themselves artistically, and players who are customizing to impress in social situations. Role-players might like more narrative hooks and special events and ways to take on meaningful items temporarily. Artists might want more freedom to customize things themselves. Social players might want exclusive items that they can earn based on things other than just in-game currency to make their wardrobe more elite. The more you know about your audience, the better you can design things that delight them and keep them excited about your game.

Papers, Please / Meaning

PAPERS, PLEASE

Papers, Please is a great game.

Papers, Please (Figure 9.1) is a unique game about bureaucracy and balancing difficult choices, which came out in 2013 for PCs and mobile in 2014. *Papers, Please* was hailed as a critical success immediately and (along with other games like *Spelunky*) helped grow the indie scene and respect for games as an art form.

PAPERS, PLEASE – GAMEPLAY DISSECTION

Verbs

Papers, Please is a less active game than many of the others discussed in this book. There is no variant of the "Move" verb. The player never directly controls an avatar. The player's direct actions are very simple:

- **Stamp**: Pass or Deny each applicant. In some cases, the game asks you to click on a supporting piece of evidence to show why you're rejecting.

- **Allocate**: Choose where to spend money at the end of the day.

There are a few other special actions that are used for specific story points later in the game, but these aren't core to the game, so they will be avoided to avoid spoilers.

DOI: 10.1201/9781003346586-9

FIGURE 9.1 *Papers, Please* screen.

While playing the game, it's clear that there's more going on here than just that. This is a good example of why it's important to play the game yourself when dissecting, not just watch other people play it. YouTube is a valuable resource, but nothing compares to the feeling of actually pressing buttons yourself. When you play the game, you see that "Stamp" is not a complete statement of what the player is doing. The actual experience is much more than that. There are a lot of player actions that are important but don't result in their own final decision or physical action, similar to *Candy Crush Saga* where we called these "secret verbs". Many of these use separate clicks through separate User Interface (UI) systems but are building toward the "Stamp" decision rather than leading to their own separate actions.

- **Examine**: Read over the papers that are presented.

- **Research**: Flip through the rulebook to check the current rules and the other supplied data.

- **Link**: Click on the error and cross-reference against the broken rule.

- **Question**: Discuss the discrepancy with the person.

- **Weigh**: Make a moral judgment comparing the infraction (or lack thereof) against the moral qualities of the person, as expressed in their words.

At minimum, "Review" can be used as a general verb to define all of the analysis going on behind the "Stamp" action.

Goals

The game starts with a simple goal to review the incoming people and stamp them. This is very directly tied to the player actions in the core gameplay loop, so it's easy to pick up and start doing and feel good about completing. People like the satisfaction of a job well done, especially when there's a sense of a checkbox being ticked at the end of it.

Then the end of each day makes another goal clear: each time the player stamps a person correctly, they get money. Money is necessary to keep the player's family alive and healthy. The player needs to stamp as many people as possible each day to earn money to keep their family alive. There is a big emotional reward to rapid (but accurate) stamping.

As the game continues, the people who come up to the border crossing start to present interesting little self-contained goals. The conversation pieces make it clear that the player's actions have large consequences on the NPC citizens of this world. The player can help the people they like and hurt the people they don't. There is no direct material or economic benefit to these actions, but goals don't have to be economic. These interactions provide another layer of goal for the player to consider.

This is an interesting set of goals, as the players need to feed their family conflicts with the core narrative goal of helping out the people coming through the border crossing. Analyzing and understanding their needs sometimes takes time. And some later scenarios sometimes require unsuccessful stamping in order to perform the morally correct action. This creates a nice tension where the player has to consider the moral implications to their family versus the moral implications to strangers. This friction is what makes this an interesting game – too many games that claim to be about morality don't make the moral questions difficult. Morality in games is only interesting if the player has to struggle a little with the choices.

Finally, as the game goes on for a few in-game days, the player starts to become aware of the larger story. There are narrative threads that drive the player to larger goals. As with the smaller narrative goals, these often require the player to toss out previously important goal structures in order to succeed. The core gameplay loop rewards the player for taking part in the system. The narrative encourages the player to ask if the system should even exist.

Challenges

The challenges of *Papers, Please* are different than many other games. There are no enemies. Nothing to jump on or destroy. The player is presented with a series of people trying to get through a border crossing. Each person presents a self-contained little puzzle for the player to solve – is their paperwork correct? Is anything showing the wrong date or wrong gender or wrong haircut? This is a different type of challenge than jumping from platform to platform, in that this requires attention to detail and rapid visual processing of information. It stretches the same muscles as a hidden object game or those old "find six problems in this picture" puzzles in newspapers.

The game keeps this simple premise fresh by changing things every day. There's always a new form or new restriction that the player has to consider. And each new piece of bureaucracy is layered on top of all the previous ones. So, the player is always pushed a little harder to stretch their memory and attention. The difficulty curve keeps going up.

These core gameplay challenges aren't the only challenges, though. The game also offers moral challenges through the narrative framing each petitioning person offers. Do you help the husband and wife who appear to have a simple typo on their form? Do you deny the evil jerk who endangers others even though his paperwork is all in order? Even if you successfully complete the cognitive challenge, the game adds another interesting decision on top of that.

The flow diagram for *Papers, Please* can start off fairly simple, as seen in Figure 9.2.

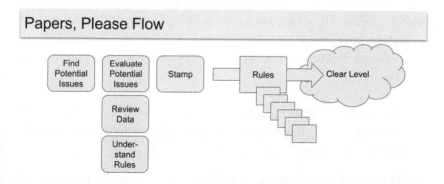

FIGURE 9.2 *Papers, Please* flow: Simple diagram of the Actions, Challenges, and Goals of *Papers, Please*.

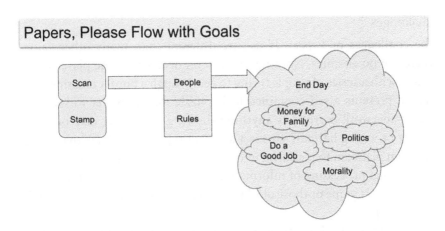

FIGURE 9.3 *Papers, Please* flow: Same diagram, but with expanded goals.

But there's really more depth to the goals than this captures (Figure 9.3). Everyone wants to get to the end of the day, but some players are motivated by the narrative goal of feeding their family while others are motivated by the moral goal of doing the right thing. The game doesn't really differentiate – there's not a different choice or outcome for those two players, but they will end up having very different experiences. This is a great example of why it's important to not just analyze the systems and rules of the game but to consider how the player experiences them. *Papers, Please* is a fairly simple game in its features and rules but uses those simple combinations to lead to complex results in the player's perception.

Systems

Papers, Please has relatively simple core gameplay but a number of supporting systems. This is a good example of how systems depend on your perspective. Let's look at it in detail first.

A close examination of the core gameplay involves a few different systems (Figure 9.4):

- **The Book**: The player has a book that contains the current rules and some supporting information. The player has to understand the rules in order to perform their actions successfully.

- **The Documents**: The player needs to analyze the documents given to them by each person. This is where most of the gameplay actually happens.

Papers, Please

FIGURE 9.4 Grouping verbs.

- **The Interface**: The player needs to know how to manipulate things on the screen, including stamping passports, riffling through documents, and flipping through the book. The game incentivizes optimizing within this system, and players often develop heuristics such as placing things in certain locations and navigating the book via the table of contents for quick flipping.

- **The Person**: There is a 2D representation of the person that is part of some forms of analysis, to confirm that this is the right person.

- **The Chat**: The person chats with the player, providing more information that needs review. The player can prompt this with the speaker to gather more information, which is encouraged when there is a discrepancy. The player can also pull up a transcript of the full text to double-check things and refer to them.

- **The Clock**: The UI includes a display that gives the current time and date, which is cross-referenced for some documents. This is simple and static information, so this might be considered more of a piece of data rather than a full system.

These systems are all elements of the core gameplay loop and inform the actions the player takes. As noted, some of these might be considered data points or specific features rather than full systems. When taking a close

look at gameplay, this line can get blurry. And at some level, a strict definition doesn't really matter here. The important thing for our current goal is to note all the factors that affect the player's actions. A closer examination of each of those factors will reveal differences and relationships between different factors. Sometimes labeling these things into different buckets is a useful way to understand what's happening. Sometimes it's not. It depends on the goals of the investigation.

- If the goal is to help with a new game concept with some similar ideas, then the focus is really on player choices. That suggests breaking things down by a strongly player-based perspective – what does the player see and where can they change it? This is basically the perspective taken in the example up above.

- If the goal is to understand the narrative and how the story is constructed, then the focus becomes the unique qualities of each person that appears. Breaking out these differences is more relevant and deserves more expansion and thought. Thinking about every factor in the player's decision is less important and things like economics can be hand-waved away.

- If the goal is to understand difficulty and progression, then the daily rules changes need more analysis. It might be worth considering each new rule as a node in the system and see how they layer on each other.

All of this is focused on the core gameplay loop of *Papers, Please*. This is just one part of the overall game. There are bigger systems that provide another possible avenue for dissection.

- Gameplay. Perspectives on papers to process people.

- Economy. Based on the player's actions in gameplay, they receive money. In the daily post-gameplay UI, the player has to allocate this money to satisfy the needs of their family. This creates a separate interaction that puts the player's gameplay choices in context.

- Progression. Each day has different gameplay. New rules, new characters, new difficulty.

- Narrative. There is a story that evolves across the progression. Story events generally occur in a simple pre-set linear progression, but the story can branch and change based on player choices. The story has many possible endings depending on these branches.

The Economy is important to Gameplay because it drives the player's longer-term goals and incentivizes rapid processing of people for a strong narrative reward (your family lives). The Progression is important to the Narrative as they generally flow along together, with the narrative stakes increasing as the gameplay challenge increases (Figure 9.5).

Papers, Please works well because each NPC that comes along forces the player to make interesting decisions about each of the systems (Figure 9.6).

- The player needs to evaluate purely along gameplay lines – what are the facts of the case and how do they line up with the bureaucracy?

- Each choice has an economic impact on the player, and the nature of this impact encourages fast play.

- The narrative and progression are closely linked, and determine the flow of difficulty for the gameplay.

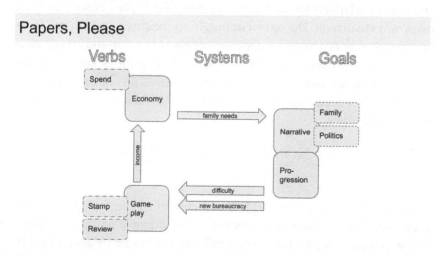

FIGURE 9.5 *Papers, Please* system flow with systems instead of challenge, showing connections.

Papers, Please

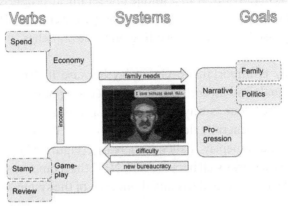

FIGURE 9.6 *Papers, Please* system diagram plus an NPC's face.

- Some NPC choices have larger impacts on narrative, which can then affect long-term progression.

- Some NPC choices don't have large story or narrative impacts but still present interesting moral choices.

So even in a relatively focused and clear game like *Papers, Please*, there are many ways to dissect. Do you focus purely on the core loop? Do you focus on narrative or economy or decisions or the player or something else? These are all valid dissections. It really does just depend on your goals and needs. Even as we near the end of the book, there is no one answer to how to do this. You need to understand your own goals and create your own personal dissection.

PAPERS, PLEASE – NON-GAMEPLAY DISSECTION

History

Papers, Please came out in 2013. It was created by Lucas Pope as a solo developer. *Papers, Please* is a very successful example of an indie game. "Indie" is not a precise term but generally applies to smaller games built by smaller teams with more focus on artistic expression than on commercial success. *Papers, Please* had moderate commercial success, but nothing on

the scale of the large AAA games that sell millions and millions of copies. *Papers, Please* was a huge critical success, winning multiple major awards and quickly becoming a standard example of what artistic games can accomplish.

Indie games as a separate defined category didn't really exist until the conditions for small successful games existed.

- The rise of multiple digital distribution channels. When the only way to sell a game is by getting a box into a big retail store, it's hard to make a living by making artistic games with a smaller audience. Most indie game studios don't have a marketing team.

- The rise of game engines like Unity or Unreal made the task of programming much easier, allowing artists to focus more on expressing an idea and less on getting pixels to animate.

- The growth of the game industry and the expansion of gaming into more audiences opened up indie games to appeal to people who don't play first-person shooters or whatever else is popular these days. People who like personal quirky games have always existed, but it took a certain critical mass to sell more than a few artistic games.

Papers, Please came out after this Indie revolution had already become a thing. Games like *Braid* and *World of Goo* and *Super Meat Boy* (2010) had shown that smaller games could succeed and could explore innovative creative ideas that bigger commercial releases generally avoided. *Papers, Please* is a great example of how this can be done.

Senses

Papers, Please has a strong and pronounced visual style that permeates everything in the game. Colors are gray and faded. Fonts evoke Eastern European themes. The player's view of everything is a little detached and distant and separated by glass or other barriers. The player's avatar isn't immersed in the world even when the player's UI is.

Emotion

Papers, Please is a game that works hard on the player's heartstrings. The player doesn't just look at paperwork; they talk to the people. At first, this

is just adding a little spice – someone will complain about all the paperwork in a way that resonates with the player. An NPC will be nervous, emphasizing the stakes for their virtual life. But later NPC interactions build complex and deep moral dilemmas out of a few lines of text.

How does this work? *Papers, Please* has a strong emotional foundation. Players are familiar with this sort of interaction, and understand the tensions and frustrations and relief that people are likely to experience in this situation. Normally, players will have seen this from the other side, so thinking about how it makes the border guard feel might be a new experience. But the game's ability to put the player in those shoes is one of its greatest strengths (Figure 9.7).

Similarly, bureaucracy and paperwork are things people have a familiarity with and a strong emotional connection to. Ask people about their last trip to the DMV and many people will have opinions. This is a game about working at the worst possible DMV at the worst possible time. Games that resonate with existing feelings have an easier time building emotional strength.

Papers, Please also builds emotion out of repetition by establishing baseline emotions. All of the encounters the player has are in the same context, so once an emotion like fear or frustration is established by an NPC, it permeates to all future NPC interactions. The game doesn't have to emphasize fear and confusion every time, as that's already been established.

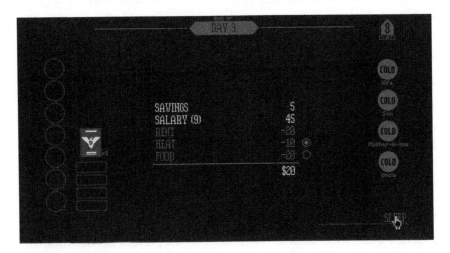

FIGURE 9.7 Screenshot of the character's family, as presented in the daily results screen.

Money

How does *Papers, Please* make money?

Papers, Please is generally sold as a complete game in a digital download. The rise of digital download is one of the factors that allows the indie scene to exist. Steam is a much easier (and cheaper) platform to manage than consoles or even PC games in boxes. By cutting out the middleman and skipping the store experiences, indie developers can get smaller games to customers in ways that never existed before.

Papers, Please did release on tablet and mobile devices, but not until many years later.

Because *Papers, Please* is meant to be downloaded as a complete game, the game can focus on telling a single complete story. Because players expect to get hours of gameplay out of a complete game like this, the game can take time and build on themes without worrying about players leaving at the drop of a hat. Players are invested, literally. That wouldn't work in an arcade or even in a world of free games.

Meaning

Papers, Please is different from many of the games discussed in this book in that it clearly has a meaning that it wants the player to experience. The game is about bureaucracy and empathy and the challenges of working within a flawed system.

Let's talk about that more.

GAMES ARE ABOUT SOMETHING

Papers, Please is a game that is about something. Every game is about something, even if it's not trying to be, but *Papers, Please* is trying to say something. Just by playing *Papers, Please*, you can see that there is a driving vision that guides many of the decisions about how this game was made. Everything – the core gameplay, the visuals, the story, the long-term resource goals, the music, the little character moments – is all about creating this empathic connection between the player and a fictional bureaucrat in a fictional 1980s Cold War dystopia.

How Does *Papers, Please* Do This?

Papers, Please *Works because There Is a Message That Makes Sense*

Papers, Please has a strong setting that supports its vision. A 1980s-era Soviet bloc country is not a common location for a game, but it's familiar

to many people. Some people lived through it, while others have seen it in history books or the popular media of its time. The choice of setting sets the tone for the rest of the vision – dark, bureaucratic, soul-crushing, but with moments for individuals to shine.

Most people these days don't live in a 1980s Soviet bloc country, but the themes that the setting evoke resonate with modern problems. Random pointless bureaucracy that makes even simple tasks needlessly complex. Soul-crushing jobs that ask you to deny both your basic humanity and the basic humanity of others. A societal system that asks everyday people to turn against each other in order to keep their families safe and fed. These are all disturbingly familiar topics for many people. These topics can be seen in other media (the movie *Parasite*, Terry Gilliam's dystopia *Brazil*, the show "Severance", etc.).

Papers, Please takes the themes that are found in this setting and stays true to them throughout the game. The message remains the same whether the player is immersed in gameplay, setting up in the UI, watching a bit of story, or plotting their long-term plan. Every piece of the game aligns with the same bureaucracy and hopelessness and personal tragedy. Different moments emphasize different aspects of the theme:

- Music establishes the setting.

- Resource management is (strangely) more personal in how it related to the family needs.

- Narrative moments with individual petitioners provide discrete moral choices.

But all the moments tie together into a coherent whole that builds on the focus of each one.

Papers, Please *Works because There Is Consistent Attention to Detail*
Papers, Please is an endless stream of well-crafted little touches that emphasize its vision. The theme is never forgotten and used to enhance even small moments.

- Music

- Color

- Font

- Character

- Dialog

- Story Moments

- Endings

- Short-Term Goals

- Long-Term Goals

- Player Actions

- Rule Structures

Papers, Please Works because *It Has Sub-themes*
Papers, Please is about bureaucracy. But it's also about managing and surviving in desperate times. And it's also about the little guy stepping up. And it's about dealing with a terrible job because you need the money. And it's about family. And fascism. And a number of other modern social issues. These themes all weave together nicely and play off each other.

A theme shouldn't be a monolithic single statement. Part of the value of a theme is that it can be explored in different ways from slightly different angles.

Papers, Please Works because *Its Theme Evokes Emotion*
A good theme ties into the emotions of the game. As discussed above, *Papers, Please* has a strong emotional foundation. Because the themes resonate with people, there are clear emotional responses that players can easily tap into. Everyone knows what it's like to wait in a long pointless line only to be turned away for some stupid meaningless reason. That has a certain emotional feel to it that players can easily summon up in themselves.

Papers, Please doesn't present the player with much of a window into the world of Arstotzka. The player doesn't see anything outside of their border station. The player never even sees the family that provides the emotional bedrock of the game. But the game does show the player the NPCs. The player sees their faces. The player hears what they say, whether it's important exposition or nervous fumblings. The game chooses to focus the player's

attention on the NPCs so that the player builds rapport with them. Then when the bureaucracy tries to crush them, the player feels something.

Papers, Please *Works because the Message Is Well-suited to the Medium*
Games are about choices. Games give the player a chance to experience something not as an observer, but as a participant. Games can immerse the player in a role and then prompt the player to see how they would respond in that role. This is a great tool for empathy. Watching someone experience a problem or challenge in a movie or television program provides a valuable perspective on that problem. But playing a game about the problem forces the player to consider the problem on their own, inserting their own values into the perspective that the game provides.

Papers, Please does this well. The setting is clearly established from the moment the game starts. The player is given a clear role with a personal perspective. The player is given a simple repetitive task that fits expectations from other types of games. The structure of games primes the player to accept arbitrary goals and rewards as natural. Bureaucracy is a system, and games are systems, so it's easy to present the ridiculous rules of bureaucracy as just another part of the game. Players are used to be told to abide by various arbitrary rules in games, so it's a natural fit here.

But as the game progresses, the player sees how these systems are set up for him to fail. The player is going to have to make difficult personal choices, both in the resource management side of things and also in the narrative side of things. The game sets up a simple structure, then undermines it through narrative moments. The player knows that the game is telling them to do one thing (process people as quickly and accurately as possible) but the moral dilemmas presented through the petitioners pull the player in another way (are you going to separate the husband and wife over a minor infraction?). *Papers, Please* does a great job of balancing these two needs – the player is given clear benefits and costs and has to weigh them based on traditional game values but also has to decide personally how they want to weigh larger moral values. The moral choices are clear and interesting without being preachy. Many games fall into the trap of using moral choices to make the player feel praised, but *Papers, Please* instead provides actual moral challenges that are much more interesting.

Watching a movie about a bureaucrat who has to choose between feeding his family and helping strangers would be compelling and interesting (see: *To Kill a Mockingbird*). But having the player make that decision

forces an even deeper understanding. Games are about interesting decisions. By making the moral decisions interesting, it forces the player to evaluate those moral decisions in more detail. The player has to pause and think about how much they value helping a certain stranger, and quantify that decision. Is it worth saving someone's life if it means my child might have to go without medicine and thus might die? What if there's enough ambiguity that I can look the other way and hope that they won't actually die? What if the stranger whose life I can save is kind of a jerk about it? How much does that change my calculation?

Papers, Please can be seen as a long string of interesting moral dilemmas. With the added depth provided by a connective resource management game and associated narrative. Not every game goes this far with their moral themes, but many games dip their toe in this water. Many games force the player to decide how to balance moral narrative choices against clearly defined resource gains. This is what draws many players to games like *Life is Strange*, *Bioshock*, or even *Civilization*. There's a philosophy book I like called *Games: Agency as Art* that discusses this – using player decisions as the canvas to create artistic expression is something interesting that artists haven't really focused on before. But in a game like *Papers, Please* it can lead to fascinating revelations.

How Can <u>You</u> Do This?
Know Your Themes
Making a game with a theme only works if you know the theme. Themes come together from many places and take some time to pin down. When you're first thinking about what games you want to make, you may not be able to articulate why a certain combination of rules and backstory and player actions appeal to you. It takes some time and introspection to connect the dots that make up a theme. The reason these things "feel right" together is often because they say the same thing about the world. Look for that and embrace it.

Once you start to connect the dots, it may take a little massaging to turn "feels right" into a coherent theme. The act of defining the theme often requires some changes to make the direction work for the game as a whole.

- A theme like "choices" is very broad and applies to most games – it may need to be refined to add more detail and specificity, turning it into something like "even little choices matter" or "the obvious

choices aren't always the right ones" or "even when you think you have a choice, you might not".

- A theme like "love" may be great for the story you want to tell but has nothing to do with the gameplay you want. Is *Super Mario Bros* about the love between a plumber and a princess? Maybe, but it's not something the player ever has to think about. You can make a game where the story and the gameplay are focused on different things, but it's never going to be as strong as one where they align. Clint Hocking even came up with a name for this – ludonarrative dissonance – because it happens so often (Hocking 2007). If you find yourself starting down this road, consider ways to align the two. Usually changing story is easier than changing gameplay, but sometimes exciting new gameplay ideas come from trying to fit to a story theme. Games that are actually about love are rare but interesting (see: *Florence* (2018) or *Consentacle* (2014)).

- A theme like "it's fun to be powerful" may fit your gameplay but not be very interesting or unique. What can you do to tweak this into something new? "Protecting others makes me feel powerful" could lead to interesting gameplay and story elements. Or play with other directions – "power corrupts, absolute power corrupts absolutely" or "there's always a bigger fish". Marvel comics became the world leader in superheroes by tweaking the traditional power fantasy into "With great power there must also come – great responsibility" (Lee & Ditko, 1962).

Once you identify and massage your theme, it's worth spending a little time to find the right phrasing. A good theme is a key part of a game's vision, and as such it's worth communication throughout the production process and in the marketing. Writing it up in a short pithy easy-to-remember phrase makes it easier to transmit and discuss and share.

Theme Everything
Once you identify and name your theme, make it a lens that you consider with everything you do. This can be applied in all sorts of cases to make decision-making easier. If you're debating between two UI color palettes, think of your theme. If you're writing up notes to the composer who is going to create background music for you, tell them about your theme. If

you're not sure which feature to prioritize, think about how they support your theme. A theme won't make all your decisions for you (what color palette says "even little choices matter"?), but it will help.

This becomes more important the more people working on the game. A clear well-phrased theme can be easily shared with the whole team. If everyone knows the theme, everyone can use the theme. This is especially valuable on larger teams where team members are not all in constant communication. Having a unified theme is hard on these teams. Every team member makes choices every day about how to build things or tweak things. Having a shared understanding of the theme helps those decisions line up to point at the same goal. Sure, theme is going to have the most impact on the big fundamental decisions – core gameplay loop, story, visual style – but if you want every little thing to align in the same way then every person working on the project needs to be thinking about the same things. The person making the street signs that the player will walk past while on their quest will make better street signs that better fit your game if they understand the theme.

This may sound arduous and oppressive and restrictive, but it's actually the opposite. The random junior sign-maker may want to put their creative stamp on their work, but it's actually easier to do that when they know that their creative stamp aligns with everyone else's. Having a shared vision is a great and powerful thing. This is what bonds teams together and makes them stronger. When a team aligns and agrees on a theme, it becomes a goal that drives them together in shared and glorious purpose.

Vision

What if you don't want to make a statement?

What if you just want to make a fun game and maybe make some money?

There's nothing wrong with that. Games can be used for many things. Not all games are about getting a message across.

Even if your game is not about getting a message across, you're still going to be getting a message across. Every game is about something. Every game says something about the world. If you're not thinking about it when you start work on the game, it's still there but you have no control over it. I don't think the creators of *Pac-Man* were trying to make a perfect summary of the 1980s, but they chose to include a core gameplay loop of

endless consumption, overvalued power fantasies, and bright neon colors. It bubbled up even without being intended.

The same principles that apply to a game's message can also be applied to other qualities of the game. In addition to thinking about what the game is trying to say, it's good to start off thinking about other "why" questions about the game:

- Why do these features fit together?

- Why would someone want to play this?

- Why do I want to make this?

- Why is this game great?

Understanding why this game is interesting and deserves to exist is an important first step in making any game. This book starts off saying that the player's actions are the first thing you need to understand a game. And this is true. But when you're making a game, it's often better to start off with an understanding of why you want to make it.

Similar to theme, it's good to crystalize these why thoughts into something that can be easily shared amongst the team. A team with a shared vision of why their game exists is going to produce a much better final product than a team with multiple or conflicting visions. Writing this down and discussing it early allows for adjustments and corrections before a lot of time and money are invested. Defining a shared vision for the game is worth the effort.

There are many ways to communicate vision. Find the methods that work for the needs of your game.

- Vision Statements (aka Pillars). Write out a carefully worded statement that guides development. Keep it short and memorable so everyone on the team knows it and repeats it.

 - The *Where's My Water?* team often said that our goal was to "Make the player feel smart"

- Vision Points. Write out a few Vision Statements to emphasize multiple important why statements. Prioritize them so everyone on the team can make meaningful decisions based on them.

- We did this consciously on games like *Hunter: the Reckoning*, and it helped. For that game, our specific list was something like:

 - It's fun to kill things

 - Enemies show off player abilities

 - The world is dark and Gothic

- Mood Boards. Select a few different examples from existing media to show what you want the game to look and feel like.

 - This is often better for defining visual style than for gameplay but can be used for all sorts of things.

- Prototypes. Build out the things that you think are important and then anyone who plays that sample has something to point to.

A clear vision is great for the game as a whole but can also work for individual features and content. Knowing why each piece of the game is there helps everyone align on how to implement it.

- Why can the character spin around?

 - The spin move allows for 360 attacks, which are useful to clear out large numbers of enemies and give the player a quick breather in big fights.

 - Spinning is also used during long traversal areas. Breaking small objects for small rewards gives the player something to do when getting from point A to point B.

- Why should a player care about this enemy?

 - The big dude with a shield is here to guide the player to use their heavy attack instead of just spamming the light attack.

- Why is this level in the game?

 - This level introduces the player's gliding ability and gives them lots of ways to play around with it and learn how to use it.

 - This level is also where the character first meets an annoying rival who later turns out to be their long-lost sibling, so that character should be a keynote throughout the visual design of the level.

This sort of information is often as important as functional specifications in design documentation. When a programmer is implementing small scenery objects in the game, they may need to make decisions. Knowing how those objects fit into the game helps guide those decisions. Even if the design documents already say that they need to break and sometimes have rewards in them, the specific details about how to do that are different when you want them as small traversal rewards versus mid-boss-fight health replenishes or post-battle randomized rewards. Knowing the why for each piece of functionality helps understand the what and the how.

Games Matter

Papers, Please is an excellent example of how games can matter. Games can have something to say. Games can change how people view the world and think about problems. I know I have a little bit more empathy for every airport security guard I meet these days because of the game.

I work with the Education team at Roblox (but, as previously mentioned, I don't speak for them or the larger Roblox corporate entity). We're trying to use the capabilities of the Roblox platform to build new exciting interactive tools for teachers. I believe that the future of education is going to be shaped by games. Game developers have spent a long time teaching people how to do silly things like jump on turtles and help alligators take showers. But those same principles can be used to teach people important things about the real world. It's not easy, but it can be done.

When you're making games, think about how to make them fun. Think about how to keep people engaged and excited. But also think about what you're doing to the world. Can you make the world a better place, even in small ways? Adding joy to people's lives is a good. I'm proud of the games I've made that are simple escapist fun. But games that add more than just joy are even better.

Post Mortem

1. Every game is unique.

When trying to understand games, each game requires its own separate analysis. The same tools can be used, but they need to be recalibrated and re-examined. A feature that works in one game won't necessarily work for another. A good dissection will help you see why that is the case. Games are complicated systems, so a small change in one place can have large unintended ripples throughout the rest of the design.

2. Every game is the same.

Every game shares many of the same elements. Every game has things the player can do. Without interactivity, it's not a game. Every game has things the player wants. Without goals, it's a toy. Every game has challenges. Without obstacles, a game is no fun. Identifying this shared connective tissue is the first step toward understanding games. Further examination of these factors usually leads to interesting insights. Does the game have lots of multifaceted goals but one simple action the player repeats? Does the game give the player lots of tools but keep them focused on the same goal throughout? Or does the game present lots of everything for the player to explore? There's no right or wrong way to set these things up.

3. Know your goal when dissecting.

There are lots of ways to understand games. There are lots of different ways to think about how to break down a game, and how to view the parts.

DOI: 10.1201/9781003346586-10

If you try to have a complete unlimited understanding of a game, you will never reach that goal. When you start your dissection, understand what you're trying to get out of the experience. Are you building something similar? Trying to understand the genre? Want to know why one game succeeded and another failed? Just trying to get at the psychology of the players? Just want to understand why you like it? There are many reasons to dissect, and they're all valid. But they require different tools and lead to different results.

4. Games are systems.

I love systems. Systems are interesting and complicated and fun to look at. Dynamics are a great example of this – combining simple rules to create something complex. Game design requires not only understanding how each feature works but also understanding how each feature relates to each other. As mentioned, this quickly gets infinitely complicated. That's why no game designer fully 100% understands even their own games.

5. Game development is iteration.

Game development is done iteratively because no one can predict every consequence of every decision in a complex system. A good game designer can develop some understanding and some rules or even just intuition about which changes are better than others. But there's no better way to understand a game than to play it.

6. Systems are about relationships.

The best games are the games that have tightly connected systems. Players have interesting decisions to make because every decision affects so many things across the game. Each action the player takes ripples across multiple systems, changing the actions, challenges, and goals that the player experiences next. Building relationships that work this way is hard, but that's the heart of game design.

7. Always think of the player.

Game design is about creating a player experience. Every game design decision needs to be evaluated in the context of how it affects the player. If you

have a great game design idea but can't translate that into something that delights the player, it's not worth adding to your game. The first test of any game design idea is "how does this make the player's experience better?".

Game design is hard. Games are complex systems that are impossible to predict. But it gets worse. In addition to designing interesting complex systems that relate to every other system, game designers need to make each of those systems and relationships make sense to the player. The player needs to be able to jump in and experience the game with only the information the game gives them. And still have fun every moment of that experience. Every game needs to go through an extensive teaching process to get the player up to speed on their abilities and goals and obstacles. And if that learning process isn't fun for every moment of the player's experience, that player is gone.

8. Game design decisions are often due to non-gameplay factors.

Games are more than just the gameplay. Games are visuals. Games are sounds. Games are part of a larger history. Games are stories. Games are products. The team developing the game may not be focusing on each of these things, but they are affecting how decisions are made about the game. Video games are constrained by technology and how many polygons can be displayed at one time. Video games are equally constrained by the games that came before them. Genres exist because people build on what worked before.

Most games are commercial products. Most development teams want to make something fun that players will enjoy, but they also want to pay their bills. Monetization features are added to just about every game, and this changes the game designs. This has always been true. The classic arcade games that are honored today are designed to suck quarters from players. Classic console and PC games are designed to sell boxes and make players so excited that they tell their friends to buy new hardware to play. Modern games are designed for streaming and social media. Understanding these influences is critical to understanding why those games are the way they are.

9. Games have meaning.

Some games are clearly "About Something". *Papers, Please* wants you to think about bureaucracy and empathy and spend some time viewing the

world from someone else's perspective. *Papers, Please* was designed to emphasize this meaning through every decision – gameplay, visuals, story, progression, etc.

Many games are not designed with a clear goal like this. *Candy Crush Saga* did not start with the idea of "Unexpected Consequences" and build from there. I don't think the creators of *Centipede* sat down to have discussions about how to bring out the "frantic nature of the times" in their visuals, story, or progression. But regardless of the creators' intent, these things are present in the games.

Games are art. Art has meaning. It's not always the meaning the author intended. The meaning may change over time. But just like a great book or movie or painting, games say something about the world and the human condition. When you finish playing a game, you are a changed person. Your perspective on the world has changed. At least a little.

10. Everyone should analyze games.

Everyone plays games. Self-proclaimed "gamers" make it a key part of their identity, but they're not the only ones playing games. Plenty of self-proclaimed "non-gamers" spend an hour or two every few days on *Candy Crush Saga* or similar games. Lots of people pull out a board game when family or friends come over to visit. Almost everyone played a variety of board, card, sport, playground, or other games growing up. Games are an integral part of the human condition.

Many parts of the book are intended for game designers, game developers, and people who view games as part of their identity. But just like any art, critical analysis of the things that influence us as humans is inherently valuable. I took a wide range of classes in college on reading works of literature or analyzing pieces of art. I believe those experiences made me a better person. Or at least a more thoughtful person. I look at books and movies and paintings differently now than I did before those classes. I like to think that I get more out of them now – more pleasure or value or depth (whatever those words might mean). The same truth can apply to games. Everyone plays games, at least a little. Understanding how they work and how they affect us humans can only enrich our lives.

Games are fun.

Games are interesting.

Pay attention to how they work.

Bibliography – Games

Adopt Me!, (2017) [Roblox game] Bethink, Uplift Games

Agricola, (2007) [Board game] Uwe Rosenberg, Lookout Games

Angry Birds, (2009) [iOS, Nokia N900 game] Rovio, Chillingo

Animal Crossing, (2001) [GameCube game] Katsuya Eguchi, Hisashi Nogami, Nintendo

Axis & Allies, (1984) [Board game] Larry Harris, Milton Bradley

Battle Cards, (1993) [Card game] Merlin Publishing

Bejeweled Blitz, (2010) [Facebook game] Jason Kapalka, PopCap Games

Bejeweled, (2001) [PC game] Jason Kapalka, PopCap Games, Electronic Arts

Bioshock, (2007) [PC, Xbox 360 game] Ken Levine, 2K Boston

BIRD, (2019) [Roblox game] Roblox BIRD Community

Braid, (2008) [Xbox 360 game] Jonathan Blow, Number None, Microsoft Game Studios

Brookhaven RP, (2020) [Roblox game] Wolfpaq, Roblox

Bubble Witch Saga, (2012) [iOS, Android game] Sebastian Knutsson, King

Candy Crush Saga, (2012) [Facebook, iOS, Android, Windows Phone game] King/ Microsoft

Candy Land, (1949) [Board game] Elanor Abbott, Milton Bradley

Carcassonne, (2000) [Board game] Klaus-Jürgen Wrede, Hans im Glück

Castle Crashers, (2008) [Xbox Arcade game] Dan Paladin, The Behemoth, Microsoft Game Studios

Castlevania, (1986) [Famicom game] Hitoshi Akamatsu, Konami

Catan, (1995) [Board game] Klaus Teuber, Kosmos

Cave Story, (2004) [PC game] Daisuke Amaya, Studio Pixel

Centipede Recharged, (2021). [PlayStation5, Nintendo Switch, Xbox One, PlayStation4, PC, Mac, Atari VCS game] Adamvision Studios, SneakyBox, Atari

Centipede, (1981). [Arcade game] Dona Bailey, Ed Logg, Atari

Commander Keen in Invasion of the Vorticons, (1990) [PC game] Tom Hall, Ideas from the Deep, Apogee Software

Consentacle, (2014) [board game] Naomi Clark, (self-published)

Cosmic Encounter, (1977) [Board game] Eon Games

Crazy Cake Swap, (2016) [iOS, Android game] Tom Smith, Zindagi Studio, Zynga

Diablo, (1997) [PC game] Blizzard Entertainment

Dominion, (2008) [Board game] Donald X. Vaccarino, Rio Grande Games

Duelmasters, (2002) [Card game] Takara Tomy, Wizards of the Coast

Dungeons & Dragons, (1974) [Table-top role-playing game] Gary Gygax, Dave Arneson, TSR

El Grande, (1996) [Board game] Wolfgang Kramer, Richard Ulrich, Hans im Glück

Elder Scrolls V: Skyrim, (2011) [PC, PlayStation 3, Xbox 360 game] Todd Howard, Bethesda Game Studios, Bethesda Softworks

Farmville, (2009) [Facebook game] Zynga

Flight Control, (2009) [iOS game] Firemint, Namco

Florence, (2018) [mobile game] Ken Wong, Mountains, Annapurna Interactive

Fluxx, (1996) [Card game] Andrew Looney, Looney Labs

FTL: Faster than Light, (2012) [PC, Mac, Linux game] Subset Games

God of War, (2005) [PlayStation 2 game] David Jaffe, Sony Santa Monica Studio, Sony Computer Entertainment

Grand Theft Auto 3, (2001) [PlayStation2 game] DMA Design, Rockstar Games

Grand Theft Auto: Chinatown Wars, (2010) [iOS port of a DS/PSP game from 2009] Rockstar Games

Hades, (2020) [PC, Mac, Nintendo Switch game] Supergiant Games

Halo: Combat Evolved (2001) [Xbox game] Jason Jones, Bungie, Microsoft Game Studios

Hearthstone, (2014) [PC, Mac, iOS, Android game] Blizzard Entertainment

Hunter: the Reckoning (2002) [Xbox game] Dave Rodriguez, High Voltage Software, Interplay Entertainment

Infinity Blade, (2010) [iOS game] Donald Mustard, Chair Entertainment, Epic Games

Kaijudo (see *Duelmasters*)

Legend of the Five Rings, (1995) [Card game] Alderac Entertainment Group

Life is Strange, (2017) [PlayStation 3, PlayStation 4, Windows, Xbox 360, and Xbox One game] Raoul Barbet, Michel Koch, Dontnod Entertainment, Square Enix

Lode Runner, (1983) [Apple II, Atari 800, VIC-20, Commodore 64, PC game] Doug Smith, Broderbund

Magic: The Gathering, (1993) [Card game] Richard Garfield, Wizards of the Coast

Manhattan, (1994) [Board game] Andreas Seyfarth, Hans im Glück

Mario Bros, (1983) [Arcade game] Shigeru Miyamoto, Gunpei Yokoi, Nintendo

Mario Paint, (1992) [SNES game] Hirofumi Matsuoka, Nintendo

Mario Party, (1998) [Nintendo 64 game] Kenji Kikuchi, Hudson Soft, Nintendo

Marvel Snap, (2023) [iOS, Android game] Second Dinner, Nuverse

Medici, (1995) [Board game] Reiner Knizia, AMIGO

Metroid, (1986) [NES game] Nintendo

Minecraft, (2009) [PC game] Markus Persson, Mojang Studios

Monopoly, (1935) [Board game] Lizzie Magie, Waddingtons, Parker Brothers

Munchkin, (2001) [Card game] Steve Jackson, Steve Jackson Games

Museum of Mechanics: Lockpicking, (2022) [PC game] Johnnemann Nordhagen, Dim Bulb Games

Nethack, (1987) [PC game] NetHack DevTeam

Nintendogs, (2005) [Nintendo DS game] Kiyoshi Mizui, Nintendo

Pac-Man, (1980) [Arcade game] Toru Iwatani, Namco

Pandemic, (2008) [Board game] Matt Leacock, Z-Man Games

Papers, Please, (2013) [PC, Mac game] Lucas Pope, 3909 LLC

Pet Simulator 99, (2023) [Roblox game] Preston "BuildIntoGames" Arsement, Big Games

Pocket God, (2009) [iOS game] Bolt Creative

RoboRally, (1994) [Board game] Richard Garfield, Wizards of the Coast

Rogue, (1980) [Unix game] Michel Toy, Glenn Wichman, Ken Arnold

Roller Coaster Tycoon, (1999) [PC game] Chris Sawyer, Hasbro Interactive

Royale High, (2017) [Roblox game] callmehbob, Roblox

Scrabble, (1948) [Board game] Alfred Mosher Butts, Hasbro

Settlers of Catan (see *Catan*)

Shariki, (1994) [PC game] Eugene "Zhenya" Alemzhin

Shovel Knight: Shovel of Hope, (2014). [3DS, WiiU, PC, Mac game] Sean Velasco, Yacht Club Games

Sid Meier's Civilization, (1991) [PC game] Sid Meier, MicroProse

SimCity, (1989) [Amiga, Mac, PC, Commodore 64 game] Will Wright, Maxis, Electronic Arts

Slay the Spire, (2019) [PC, Mac, Linux game] Clark Aboud, Mega Crit, Humble Bundle

Space Panic, (1980) [Arcade game] Universal Coleco

Spelunky, (2012) [Xbox 360 game] Derek Yu, Mossmouth, LLC, Microsoft Studios

Stardew Valley, (2016) [PC game] Barone, Eric

Street Fighter 2, (1991) [Arcade game] Yoshiki Okamoto, Capcom

Super Mario Bros, (1985) [NES game] Shigeru Miyamoto, Nintendo

Super Meat Boy, (2010) [Xbox 360 game] Edmund McMillen, Tommy Refenes, Team Meat

Sushi Go!, (2013) [Card game] Phil Walker-Harding, Gamewright Games

Tamigochi, (1996) [Physical game] Aki Maita, Bandai

The Elder Scrolls IV: Oblivion, (2006) [PC, Xbox 360, PlayStation 3 game] Ken Rolston, Bethesda Game Studios, 2K Games

The Game of Life, (1960) [Board game] Bill Markham, Reuben Klamer, Milton Bradley

The Legend of Zelda: Breath of the Wild, (2017) [Nintendo Switch game] Hidemaro Fujibayashi, Nintendo

The Secret of Monkey Island, (1990) [Amiga, Atari ST, PC, Mac game] Ron Gilbert, Lucasfilm Games

The Secret of Monkey Island: Special Edition, (2009) [iOS, PC, Xbox 360 game] Ron Gilbert, Lucasfilm Games

The Sims, (2000) [PC, Mac game] Will Wright, Maxis, Electronic Arts

Ticket to Ride, (2004) [Board game] Alan R. Moon, Days of Wonder

Tigris and Euphrates, (1997) [Board game] Reiner Knizia, Hans im Glück

Tomeko's Great Adventure: Mystery Dungeon, (1993) [Super Famicom game] Tadashi Fukuzawa, Chunsoft

Track and Field, (1983) [Arcade game] Konami

Triple Town, (2010) [Amazon Kindle, Facebook game] Dan Cook, Spry Fox

Ultima 1: The First Age of Darkness, (1981) [Apple II game] Richard Garriott, Kenneth W. Arnold, Origin Systems, California Pacific

Where's My Water?, (2011) [iOS, Android game] Tim FitzRandolph, Creature Feep, Disney Mobile

Wiz War, (1985) [Board game] Tom Jolly, Jolly Games

Wizardry: Proving Grounds of the Mad Overlord, (1981) [Apple II game] Andrew C. Greenberg, Robert Woodhead, Sir-Tech Software

Work at a Pizza Place, (2008) [Roblox game] Dued1, Roblox

World of Goo, (2008) [PC and Wii game] Kyle Gabler, 2D Boy

World of Warcraft, (2004) [PC, Mac game] Blizzard Entertainment

XCom: Enemy Unknown, (2013) [iOS port of a PC game from 2012] Firaxis Games, 2k Games

Bibliography – Non-Game

(2024). (n.d.) *Roblox Reports Fourth Quarter and Full Year 2023 Financial Results*. Roblox.com. https://ir.roblox.com/news/news-details/2024/Roblox-Reports-Fourth-Quarter-and-Full-Year-2023-Financial-Results/default.aspx

Bartle, R., "Hearts, Clubs, Diamonds, Spades: Players Who Suit MUDs" (1996).

Cabera, P., & Soesbee, R. (1999). *The Way of the Naga* (p. 2). Alderac Entertainment Group.

Curry, D. (2024). "Candy Crush Revenue and Usage Statistics." https://www.businessofapps.com/data/candy-crush-statistics/

Csikszentmihalyi, M. (1996). *Creativity: flow and the psychology of discovery and invention*. HarperCollinsPublishers.

England, L. (21 April 2014). "The Door Problem" – "Liz England". lizengland.com

Faidutti, B. (2017). "Postcolonial Catan." Boardgame Design by Bruno Faidutti. February 6, 2017. https://faidutti.com/blog/blog/2017/06/02/postcolonial-catan/

Friedman, T. (1999). "Civilization and Its Discontents: Simulation, Subjectivity, and Space" in *On a Silver Platter*, ed. Greg M. Smith, New York University Press, 1999.

Gamma, E., Helm, R., Johnson, R., & Vlissides, J. (1994). *Design Patterns: Elements of Reusable Object-Oriented Software* (1st edition). Pearson Education, Limited.

Griesemer, J. (2010). "Changing the Time Between Shots for the Sniper Rifle from 0.5 to 0.7 Seconds for Halo 3" *GDC Talk*.

Guide, C., & Gary, K. M. (1982). *How to win video games*.

Hocking, Clint (October 7, 2007). "Ludonarrative Dissonance in Bioshock". Click Nothing. Archived from the original on January 14, 2020).

Huizinga, J. (2014). *Homo Ludens: A Study of the Play-Element of Culture*. Mansfield Centre, CT: Martino Publishing ISBN 978-1-61427-706-4.

L, D. (2018). *Fishing for Gods in Strade's Gallows*. [Downloadable game module] Dungeon Masters Guild.

Lazzaro, N. (2012). Why We Play: Affect and the Fun of Games—Designing Emotions for Games, Entertainment Interfaces, and Interactive Products. In *Human Factors and Ergonomics*. CRC Press. https://doi.org/10.1201/b11963-36

Loring-Albright, G. (2015). "The First Nations of Catan: Practices in Critical Modification" *Analog Game Studies 2*.

Lee, S. and Ditko, S. (1962). Amazing Fantasy #15, Marvel Comics, NYC.

Meadows, D. (2008). *Thinking In Systems: A Primer*. Chelsea Green Publishing. ISBN 978-1844077250.

Meier, S., & Noonan, J. L. (2021). *Sid Meier's memoir!: a life in computer games*. W. W. Norton & Company, Inc.

Miller, G. A. (1956). The magical number seven, plus or minus two: Some limits on our capacity for processing information. *Psychological Review, 63*(2), 81–97.

Nguyen, C. Thi (2020). *Games: Agency as Art*. New York: Oxford University Press.

Raphel, A. (2017). "The Man Who Built Catan." *The New Yorker*, https://www.newyorker.com/business/currency/the-man-who-built-catan

Rogers, S. (2014). *Level up!: the guide to great video game design* (2nd ed.). Wiley.

Rosewater, M. (2002). *Timmy, Johnny, and Spike*. Wizards of the Coast. https://magic.wizards.com/en/news/making-magic/timmy-johnny-and-spike

Rosewater, M. (2009). *Kind Acts of Randomness*. Wizards of the Coast. https://magic.wizards.com/en/news/making-magic/kind-acts-randomness-2009-12-14

Rosewater, M. (2011). *New World Order*. Wizards of the Coast. https://magic.wizards.com/en/news/making-magic/new-world-order-2011-12-05

Rosewater, M. (2014). *Lenticular Design*. Wizards of the Coast. https://magic.wizards.com/en/articles/archive/making-magic/lenticular-design-2014-12-15

Schell, J. (2015). *The art of game design: a book of lenses* (2nd ed.). Taylor & Francis.

Shakespeare, W., 1564–1616 author. (1954). *The tragedy of Hamlet, Prince of Denmark*. [London]: The Folio Society.

Suits, B. (1978). *The grasshopper: games, life, and Utopia*. University of Toronto Press.

Tekinbaş, K. Salen, & Zimmerman, E. (2003). *Rules of play: game design fundamentals*. MIT Press.

Winkie, L. (2021). "The Board Games That Ask You to Reenact Colonialism" *The Atlantic* https://www.theatlantic.com/culture/archive/2021/07/board-games-have-colonialism-problem/619518/

Wolf-Meyer, M. (2019). "Everything I needed to Unlearn I learned from Sid Meier's Civilization" https://matthewwolfmeyer.com/2019/05/22/everything-i-needed-to-unlearn-i-learned-from-sid-meiers-civilization/

Raphel, A. (2014). "The Man Who Built Catan." *The New Yorker*, February 12, 2014. https://www.newyorker.com/business/currency/the-man-who-built-catan

Wright, W. (2011). *The Replay Interviews: Will Wright*. Game Developer. https://www.gamedeveloper.com/business/the-replay-interviews-will-wright

Yu, D. (2016). *Spelunky*. Boss Fight Books. ISBN 9781940535111.

Index

Pages in *italics* refer to figures.